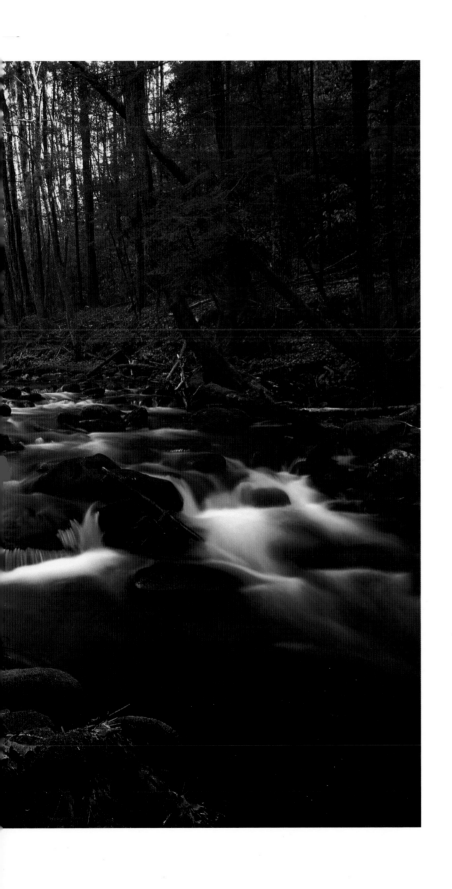

Our National Parks and Wildlife Refuges

*Capturing the Rhythms of
Light and Land*

Dave & Julie,

All the Best

Jim Jamieson

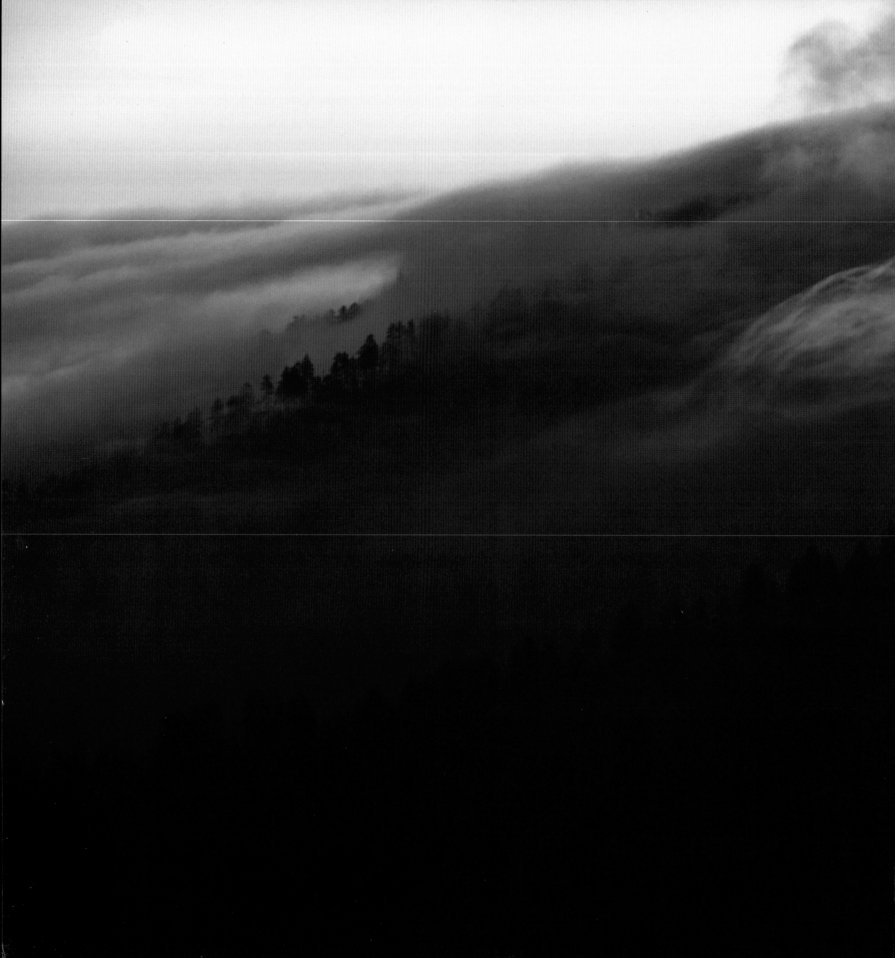

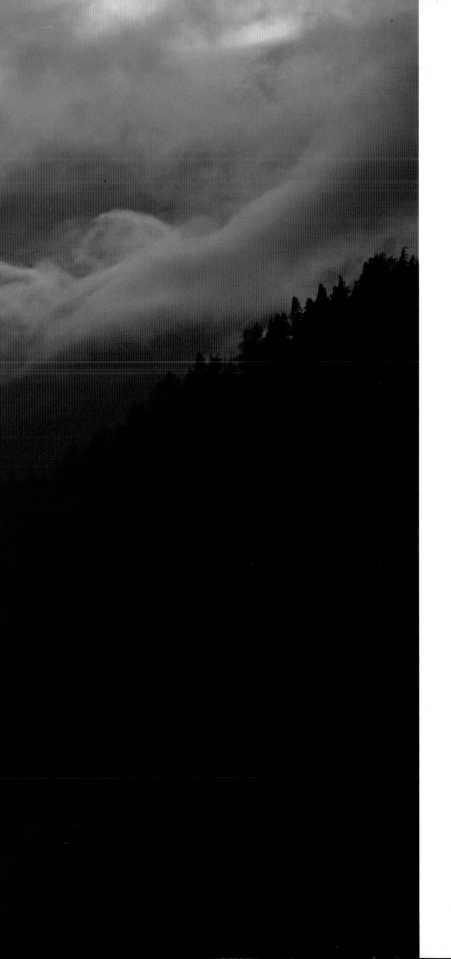

Our National Parks and Wildlife Refuges
Capturing the Rhythms of Light and Land

JIM JAMIESON

IMAGESTREAM PRESS
SAVAGE, MINNESOTA

Typeset in Adobe Garamond

First published in 2004 by ImageStream Press
8339 Carriage Hill Alcove
Savage, MN 55378
jjamieson@compuserve.com

For extra copies of this book please check with your preferred bookstore, or
write ImageStream Press.

Printed in China
by C & C Offset Printing Co., LTD.

Illustrations
Cover: View from Signal Mountain, Grand Teton National Park
Page 1: Quiet Stream, Great Smoky Mountains National Park
Page 2-3: Veiled in Smoke, Great Smoky Mountains National Park
Page 12: Image AS11-44-6552 courtesy of Earth Sciences and Image Analysis
Laboratory, NASA Johnson Space Center
Page 167: View of Greenland from 40,000 ft

This book is dedicated to my wife Julie, and sons Ian and Wesley whose endless
patience and understanding helped to make this work become a reality. Special
thanks to those who conserve and preserve our national park and wildlife refuge
systems.

In celebration of the 101th anniversary of the U.S. Fish and Wildlife Service
National Wildlife Refuge System.

Publisher's Cataloging-in-Publication
 (Provided by Quality Books, Inc.)

Jamieson, Jim, 1965-
 Our national parks and wildlife refuges : capturing
the rhythms of light and land / Jim Jamieson.
 p. cm.
 Includes index.
 LCCN 2003097823
 ISBN 0-9729126-1-4

 1. National parks and reserves--United States--
Pictorial works. 2. Wildlife refuges--United States--
Pictorial works. I. Title

E160.J27 2004 917.3'0022'2
 QBI03-200868

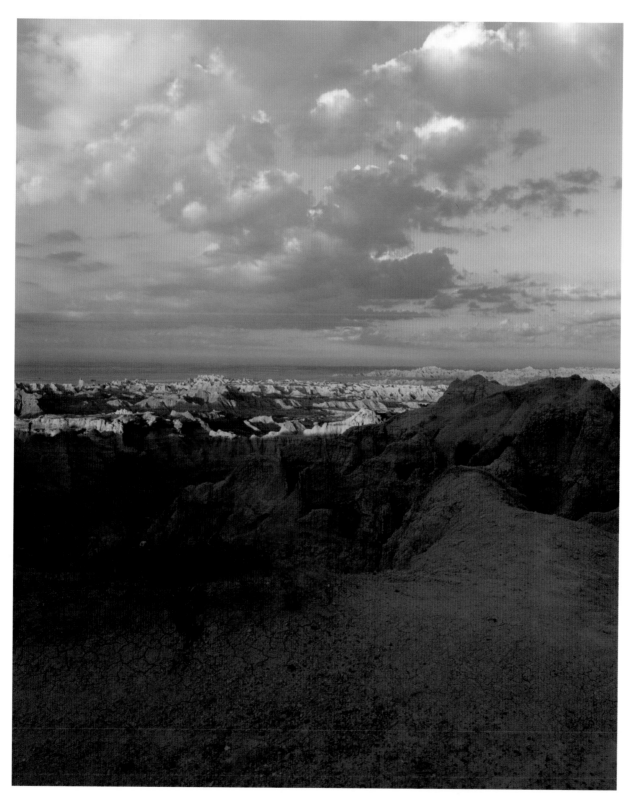

Bringing life to the land, the sun breaks over the vast, untouched wilderness area of the Badlands National Park.

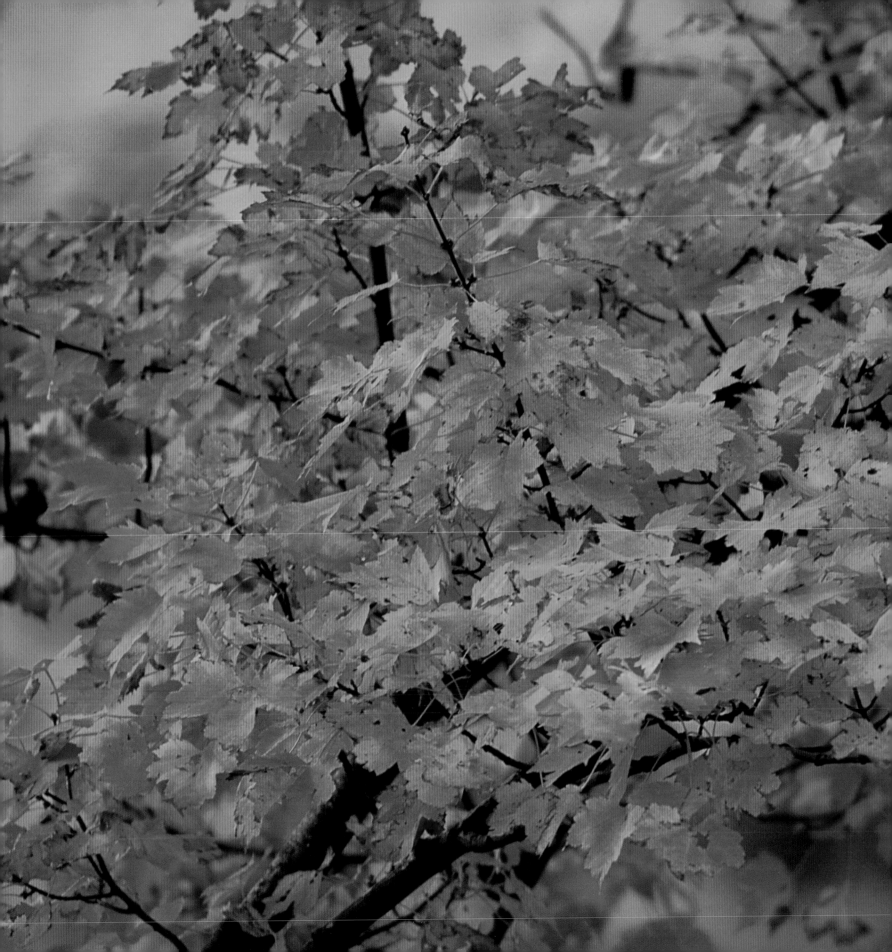

Contents

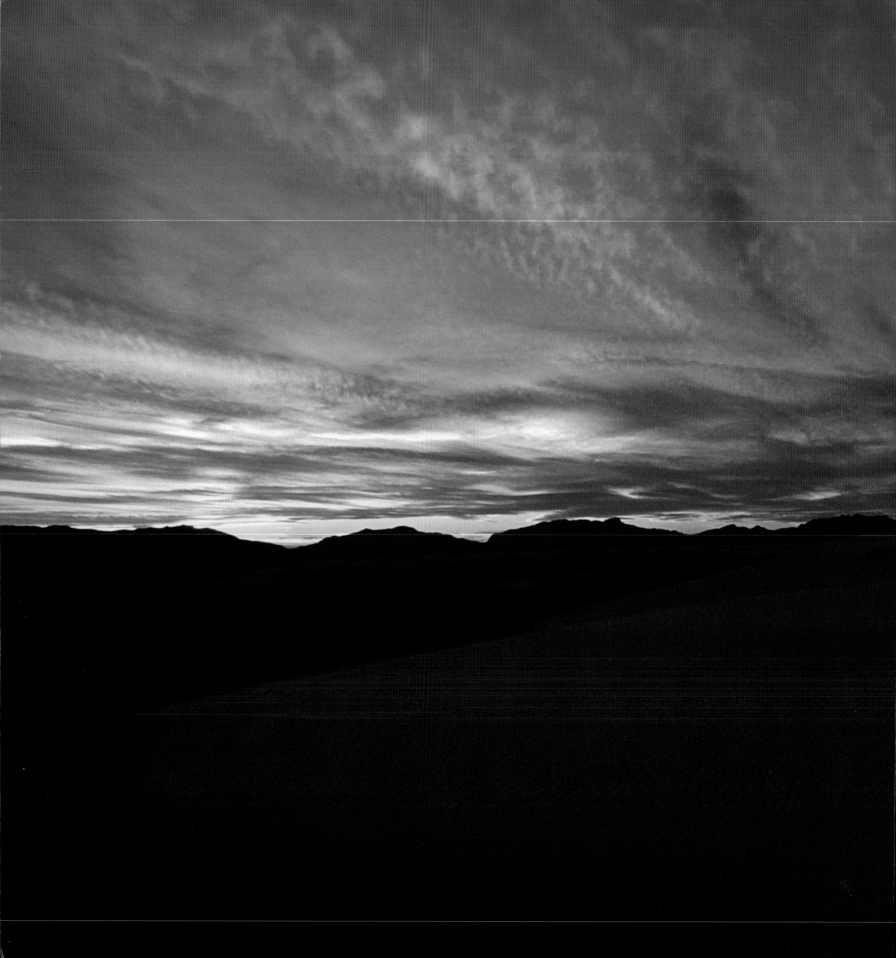

Introduction

Introduction

In less than twenty seconds, all of the photographs contained within these pages were captured on film. That's astonishing considering the hours spent in preparation, traveling and backpacking to a location, film processing, selecting images, scanning, and pre-press layout. A third of a minute, a mere blink of an eye. In taking on such a book I realized early on there simply is no practical way to do justice to all of our magnificent parks, wildlife refuges, and eco-systems. Our vast national parks and wildlife refuges are in constant change right before our eyes, a change that has continued for billions of years. To really appreciate what is before the lens, it's essential to take a look at the geologic record, develop an understanding of the physics of our world, and examine the behavior of wildlife up close to only begin to see how our world has arrived at this moment in time. Capturing the rhythms of light and land through the lens over the last six years, I have had the privilege to view some unbelievable landscapes and wildlife. It's hard to imagine that what I only have to show for it is a twenty second summary of the world.

For millions of years leading up to the formation of our modern civilization, the bio-diversity present on plant Earth was governed by the natural ebb and flow of life. Our environment was defined by continually changing geologic features and species. The land and oceans remained in a natural form, constantly reshaped by global forces. The natural processes of life and death, the uplifting of new mountains, volcanic eruptions forming new lands, climate changes, and meteor impacts, all occurred as today - independent of the life present on Earth.

During these natural cycles of climatology, species evolution, and the evolving universe, planet Earth has continued to undergo significant transformation. Although physical theories and religion help guide our understanding of the world, we cannot describe precisely why we are here nor can we replicate the process in the laboratory. Modern science offers clues into genetic structures, DNA sequencing, and the fundamental building blocks of life. We have arrived here via a process that has unfolded over the last 4 billion years and we are only beginning to scratch the surface of understanding. Formed by genetics, our environment, and divine guidance, the human species is like no other on Earth.

As a result of our unique ability to study the world around us we can observe species evolution through the fossil record, sediment formations, surface erosions, and global plate tectonics. We are capable of establishing the science that supports our theories about these subjects, but we cannot describe in its entirety why these things have occurred and in some cases the underlying mechanics of what is happening. Today, as a result of our critical thinking and ability to learn, we can begin to piece together a timeline tracing back some 4 billion years. But in this timeline much has occurred. Not long ago, people dreamed of flying. Today, only ninety years later millions fly daily. Twenty seconds on film, hardly enough time to tell the story of our natural resources and development of humankind.

As our world has evolved, so too has come the good and bad. We can prevent ravaging diseases such as polio, yet we cannot control the senseless death by gun violence occurring everyday. We have developed a system of values and religion, diverse cultures with wide ranging languages and customs, yet human suffering continues. We can engineer medicines and genes to cure disease or unleash horrific harm using chemical and biological weapons of mass destruction.

We live today in a world that in no small part is vastly different than our predecessors. We can now begin to control the comforts of our lives through agriculture, genetics, engineering, science, and mathematics. We are extending our life span. The demands on society and the world around us are increasing at an exponential rate.

Unfortunately our journey as a species has placed a heavy burden on the world in which we live. We are a society of consumers. Like no time before us, we are seeking out, purchasing, fabricating, enjoying, and discarding typically without regard or consequence. In many cases, we have spoiled the environment in which we live. We've poisoned the water we drink, introduced horrific diseases and chemicals, and unleashed the power of the atom for human destruction. We have erected huge mountains of garbage and produced millions of old cars and tires. We have stockpiled deadly materials and weapons of mass destruction so powerful that our existence today is linked to the reliability of advanced weapon systems and trust in our fellow man. All of this has occurred in just the last few hundred years.

Moreover, our skill at engineering and science has reshaped the Earth, erected dams to control floods, moved mountains for highways, and reclaimed the sea with new airports. Throughout all of our modern age engineering, our success at helping society has also come at the price of hurting the environment and its people—it's a trade-off. Whether it was DDT, mercury and other heavy metals, solvents, or pesticides, our ability to help one situation usually is inexorably linked to hurting another. We live in a non-perfect world and few things come free.

Despite the pitfalls of our existence, there is a purpose to our lives. Whether it is helping someone in need, discovering a cure for cancer, or working to make the world a little safer each day, we, like no other species on Earth, are endowed with a unique gift to leverage our intellect. How we use this intellect determines what type of civilization we will become.

As an engineer, nature, and wildlife photographer, I am continually amazed by the world in which we live. Grand views, microscopic structures, or the intense morning light, we live in an incredible and vast universe far beyond our capability to describe it, understand it, control it, much less capture it on film. So much of our survival is linked to the world in which we live. We, like no other species in the existence of Earth, have the ability to radically alter this world irreversibly. This is all too apparent when watching Sandhill Crane migrations or studying the hunting characteristics of the Great Blue Heron behind a telephoto lens. I am always surprised at the complexity of the species and land I have had the opportunity to see and photograph.

This book is organized by examining the rhythms of light, landscape, and wildlife against a backdrop of photographic techniques and design concepts. Using these tools, our state, national parks and wildlife refuges are explored through film. For most of us, our state parks and wildlife areas are local jewels in an otherwise sprawl of urban development and encroachment. Early on, community leaders and citizens recognized the importance our environment carries in our daily lives. At the turn of the century, numerous local parks were established to protect our natural resources for generations to come. One hundred years later, these areas form the core of our conservation and preservation efforts.

Likewise, conservation stepped well beyond preserving local natural resources from assured destruction, it also took key steps to protect our wildlife on a national level. Today 540 National Wildlife Refuges covering 95 million acres have been set aside to protect and conserve birds, wildlife, trees, and plants. Each refuge within the U.S. Fish and Wildlife Service has offered great benefits in furthering protected and endangered species. I've selected a few of these refuges to see up close the natural interaction of wildlife with the environment.

Finally, the crown jewels of our parks are those specifically set aside by the federal government and given national park or monument status. These parks stand alone in significance of natural resources, wildlife diversity, unique geologic features, or shear open land. Set aside for the generations to come, these parks no longer need names. Their features such as Old Faithful, Lake Jackson, or the Smokies invoke sweet memories of family vacations, stunning views, and an overwhelming experience with our environment. They are known to all of us.

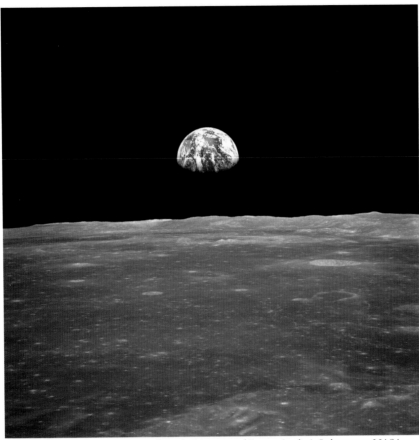

How can a photographer do justice to 4 billion years of change, or millions of square miles of amazing landscapes? You simply can't. Maybe that is exactly what draws us closer to our environment, the complexity, ever changing landscape, seasons, and migrating wildlife. I've been to Yellowstone countless times, yet each time I go, I arrive home with an entirely new set of images, most of which I never anticipated collecting but certainly am excited to have captured.

Photography offers the ability to capture these fleeting moments, to study, appreciate, and share with others. Through photography the impressions of thousands can be changed, the decisions by policymakers affected, and national priorities redefined. Using the technological wonders of today, we can now capture these events with incredible color, detail, and speed. Like no time before us, we can capture these moments in a way that is true to the event. We can even alter it with enhancing filters, infrared films, or digital image processing to convey a different message. If done correctly, the viewer is left with a timeless impression.

Lunar Limb, Earthrise, courtesy of Earth Sciences and Image Analysis Laboratory, NASA Johnson Space Center. Apollo 11

A third of a minute, hardly worth a book given the fast pace of our lives today. Over the 4 billion years our Earth has been changing, there has undoubtedly been events so significant that even one photograph, one eighth of a second, would help us understand our world significantly better. This is an incredible world in which we live. The ebb and flow of boundaries between our naturally occurring environment and our urban development are in constant flux every day. As they evolve over the next year, century, or millennium, the challenge will be to ensure what has been protected in the past continues to flourish so that those who follow us can continue to connect with their past and project their future.

There are a number of wonderful local, state, and national parks and wildlife refuges not featured in this book. Does that mean they are in someway less significant? Quite the contrary. In fact, as a photographer I've chosen images in this book that speak to our past and future that I have been able to capture. I've been to a number of parks and for various reasons simply did not walk away with images that spoke to me as these do. That's not to the detriment of the park or refuge, rather my inability as a photographer to capture the fleeting moments of light, landscape, and life. It's also the motivation that drives a photographer to return again and again.

Our natural resources, parks and refuges form the core of our civilization. They have existed under different names, had different laws and boundaries, shapes and features. But today, as did in the past, represent in the purest possible form our world as it has evolved. This living history is critical in our current and future understanding of humankind and the world in which we live. I feel fortunate to have walked and photographed these brief moments in time.

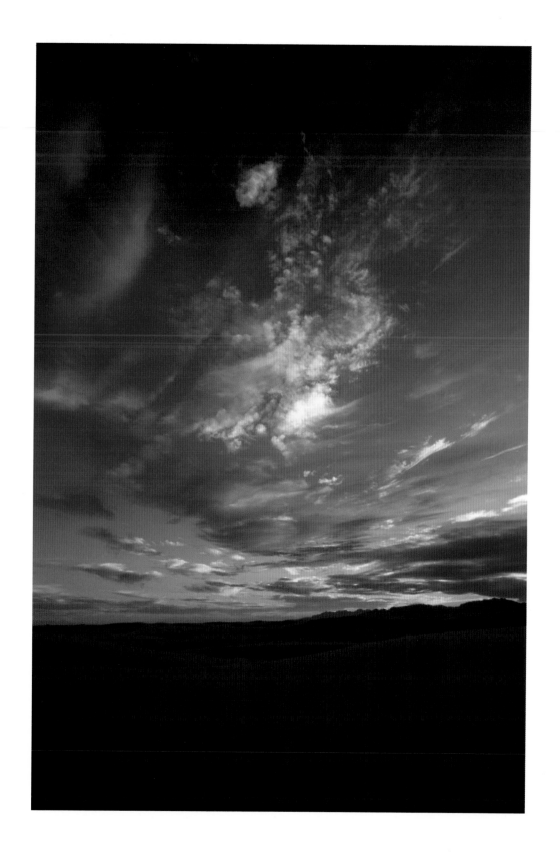

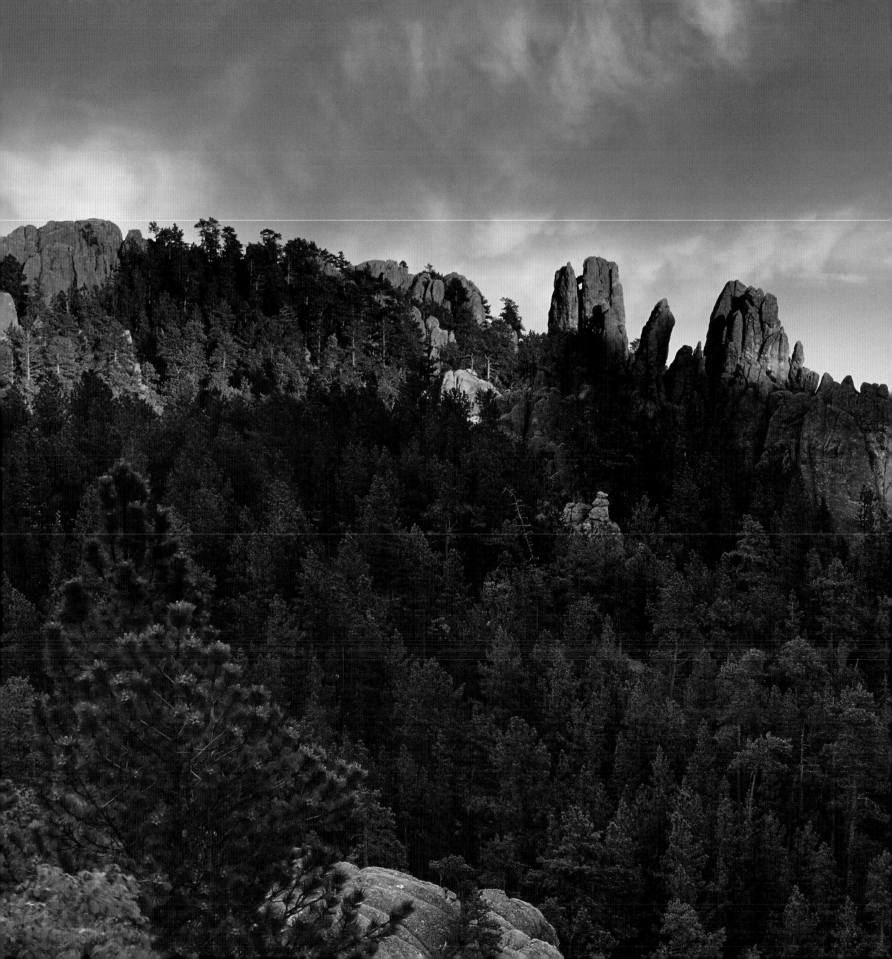

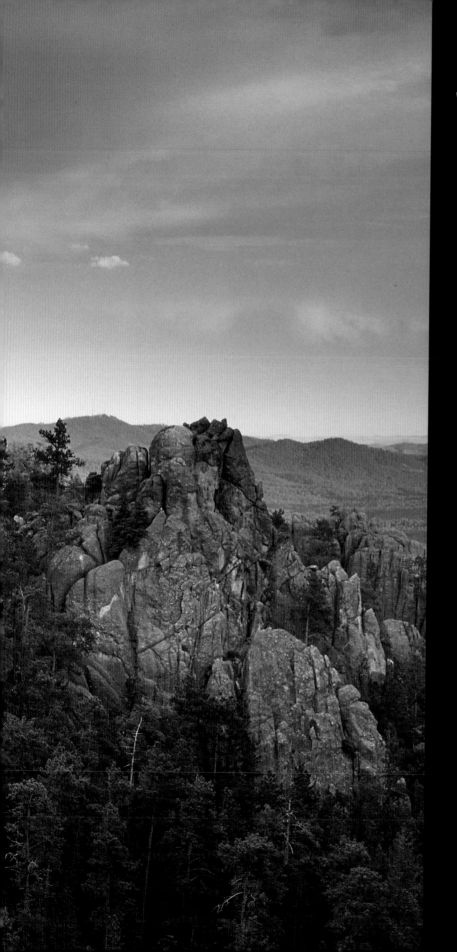

State Parks

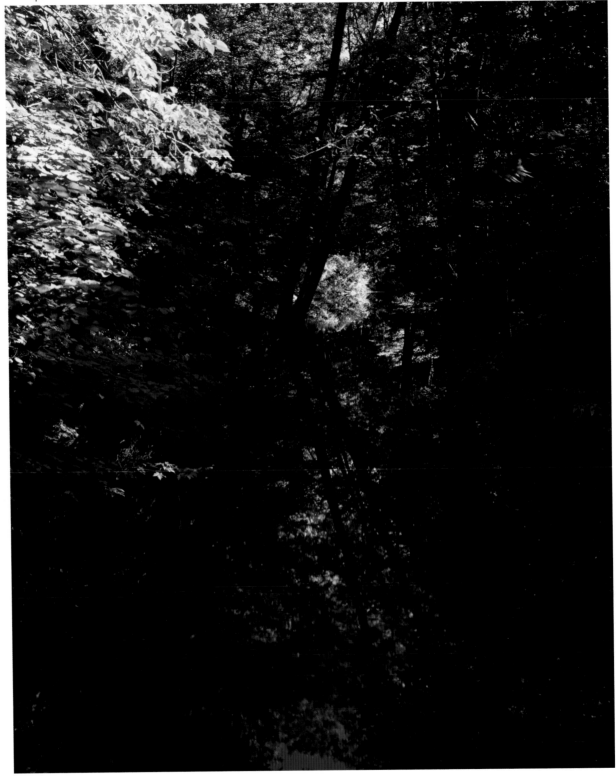

Formed by receding glaciers during the Pleistocene period 14,000 years ago, small streams link a series of lakes at the Chain O'Lakes State Park in Indiana. Paddling through with a stealthy folding kayak, the landscape is alive with light and wildlife.

Reflections

Over the years I have found that it can be very easy to overlook reflecting images in the water. When we are moving, either by kayak or on the trail, our visual acuity takes a back seat to our peripheral vision. The wider field of view offered by our peripheral vision allows us to move through the environment without running into things - an important attribute.

Slowing down, our visual acuity takes over and we can begin to see and register details allowing us to better visualize the final image before taking a photograph.

Reflecting surfaces can come in many forms connecting shapes across the landscape, providing texture or illuminating the forest in vivid color. Whenever near water, it is important to slow down and visualize the image before picking up the camera. First impressions can often lead to new ideas and timeless images.

Mamiya 7 camera with 80mm f/4 lens

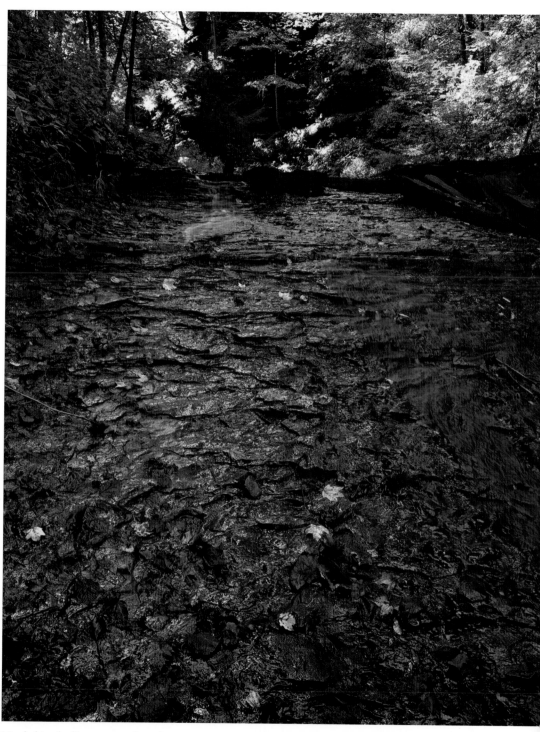

Nestled in the limestone and sandstone outcroppings of southern Indiana, the Upper Falls of the Silver Cascade reflect a late summer afternoon sky. Shades State Park, Indiana.

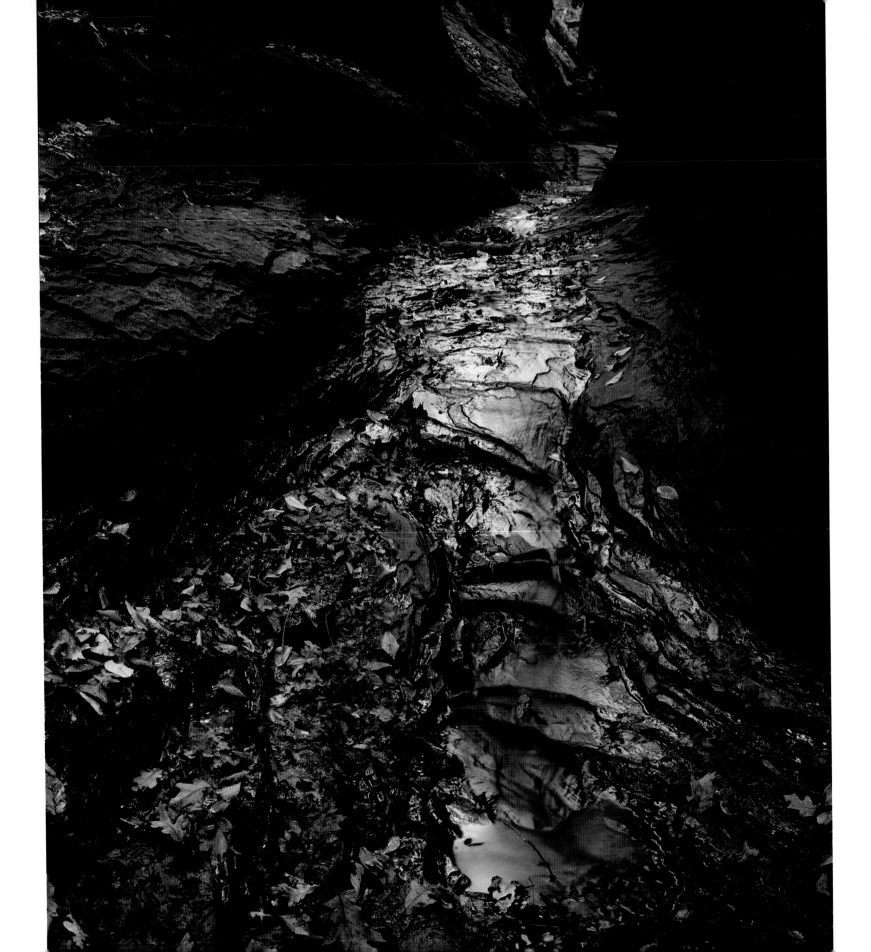

Mamiya 7 camera
with 80mm f/4
lens

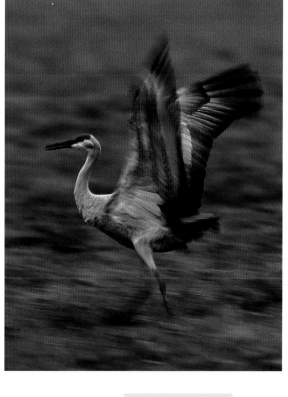

During the same period glacial run-off was forming lakes in northern Indiana, the shale and sandstone formations of Turkey Run State Park were also being shaped. Today, these slot canyons are reminders of the torrents of water that once flowed through this area as massive glaciers receded north.

Motion

Water, birds, or wildlife, things in motion create interesting opportunities. Increasing the shutter speed freezes motion, stretching it out blurs the image. With the image blurred, suddenly the dynamics of motion come to life. For these situations, careful attention to available light, exposure, and film speed are critical.

As if occurring thousands of years ago on a cold October morning, a lone Sandhill Crane quietly circled the Jasper-Pulaski State Fish and Wildlife Area before landing. An eerie sight for sure, the crane descended into the harvest moonlit field in front of me. Minutes later with daybreak nearing, suddenly thousands are in pursuit for the morning fly-in.

Nikon N90s camera
with 500mm f/4
Nikkor lens

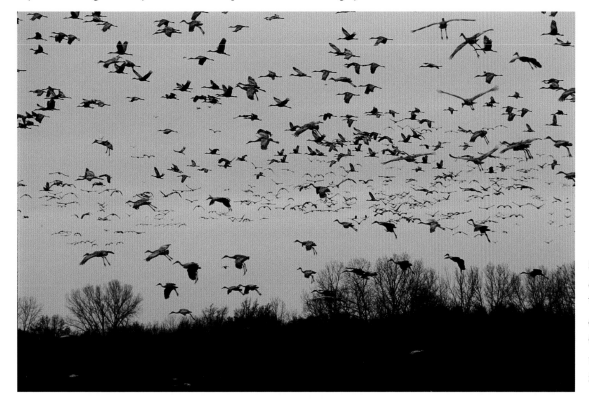

Streams of Sandhill Cranes descend on the Jasper-Pulaski State Fish and Wildlife Area in central Indiana during the annual migration. Overwhelmed by the sound and utter confusion, the birds quickly fill the field.

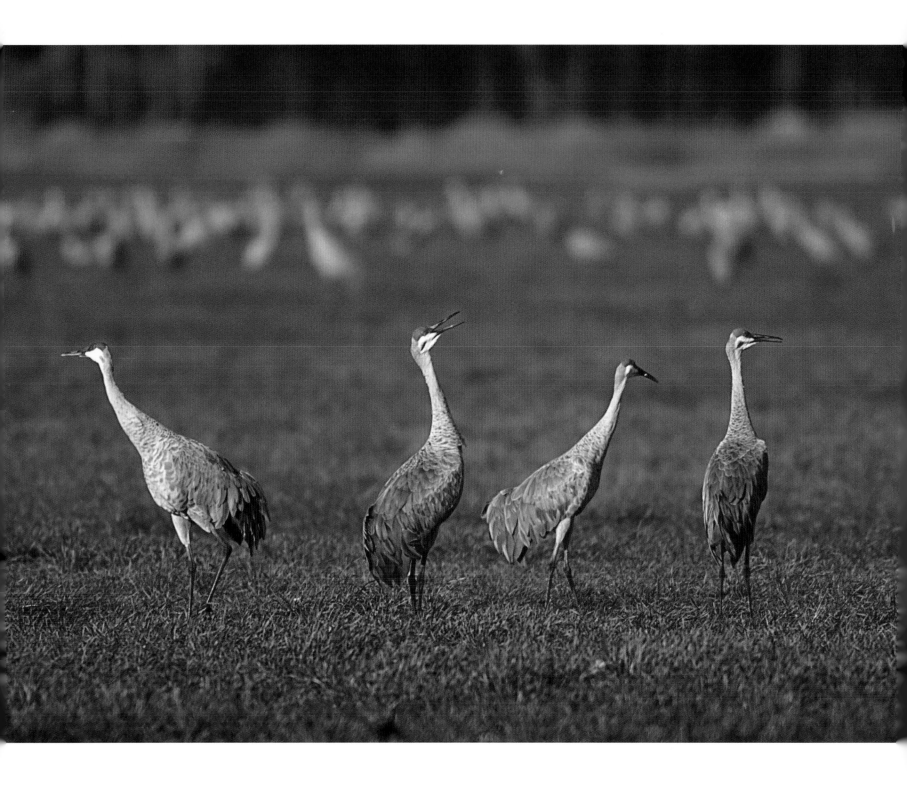

Left: Once on the ground, the call to flight occurs again as the sun breaks the horizon. Mating for life, Sandhill Cranes carry on a very social interaction with the flock. As recently as 100 years ago, the Great Kankakee Marsh was one of the largest marshes in the United States covering much of Illinois and Indiana supporting thousands of waterfowl species. Today, the majority of this marsh has been replaced with farmland and urban development. Despite this loss of habitat, Sandhill Cranes continue to trace their migration through this area as they travel from the upper Midwest to the southeastern United States.

Nikon N90s camera with 500mm f/4 Nikkor lens

Wildlife Behavior

Wildlife photography is more than just taking a photograph, it's critical to get to know your subject. After years of photographing Sandhill Cranes at Jasper, flight patterns, seasonal migrations, weather, and wildlife behavior are no longer so mysterious. This allows me to return year after year at just the right moment.

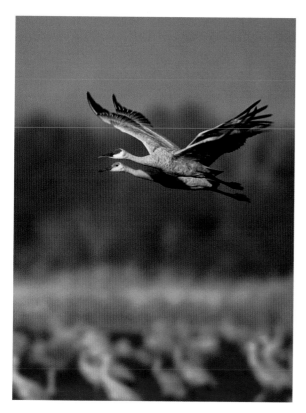

A pair of Sandhill Cranes launch into flight.

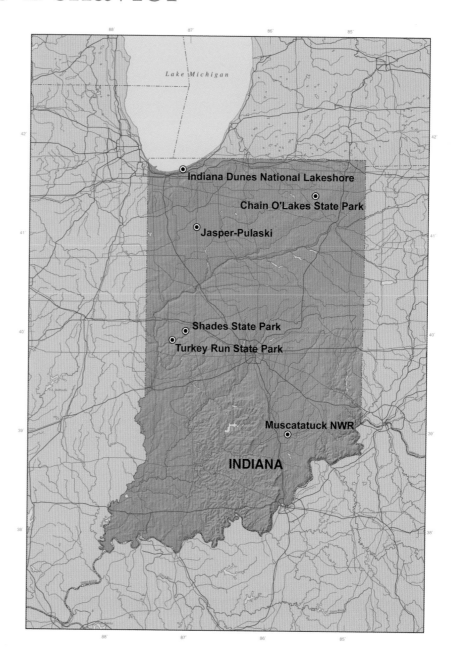

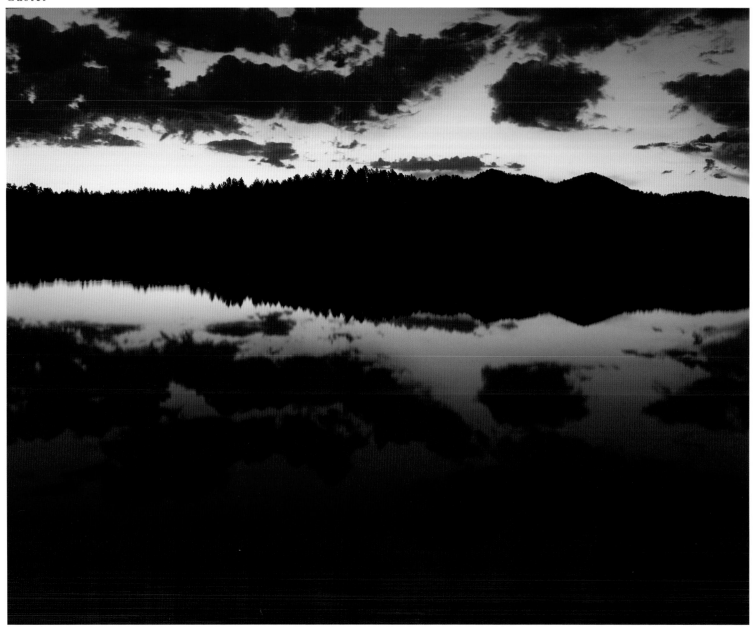

Seventy million years ago as the uplifting of the Rocky Mountains was occurring, the Black Hills of South Dakota were also taking shape. Here in the midst of massive granite outcroppings, the sun slowly rises over a quiet lake in Custer State Park.

Mamiya RZ67 Pro II camera with 65 mm f/4 lens

Symmetrical Balance

This small lake during the day is often filled with boats and plenty of surface waves. At daybreak, the calm winds through the night have setup a glassy surface reflecting the sky and land with more than 5 stops of exposure separating highlights and shadows. Using a Sekonic L-608 zoom spot meter, I metered the average clouds reflected on the water pushing the mountains completely black. Only lasting minutes, soon subtle winds rippled the surface for the remainder of the day.

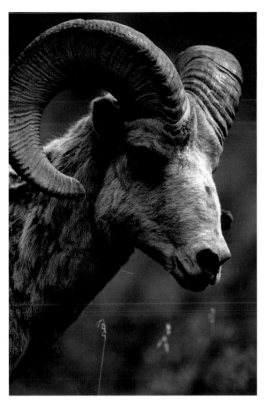

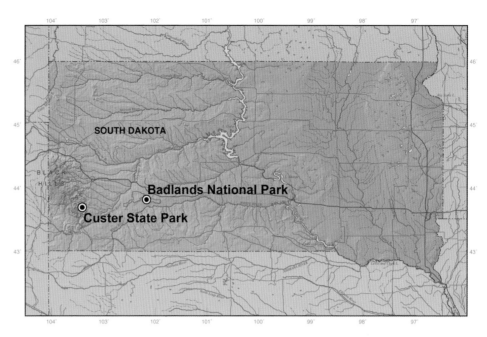

Majestic Bighorn Sheep find ample protection and habitat at Custer State Park in South Dakota.

Nikon N90s camera
with 500mm f/4
Nikkor lens

Getting Close

I shoot a number of images with a 500mm Nikkor and 500mm APO Mamiya lens. Large and very heavy, both lenses pull in details that otherwise are not possible due to access or the risk of approaching dangerous wildlife.

Mamiya RZ67 Pro II
camera with 500 mm
f/6 lens

Frozen in time. Formed millions of years ago, granite spires squeezed through openings in the Earth's surface. Once cooled, they have remained citadels of stone.

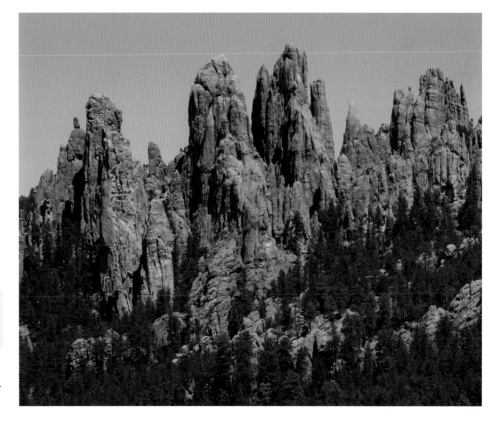

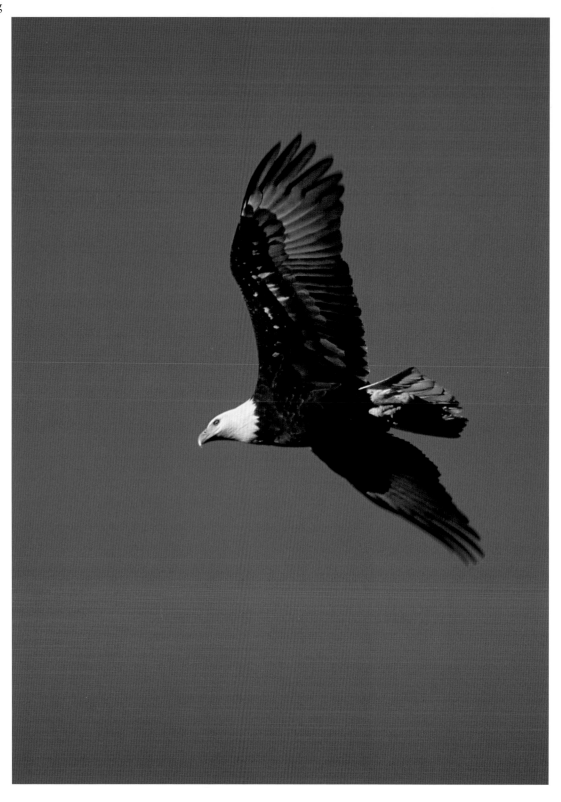

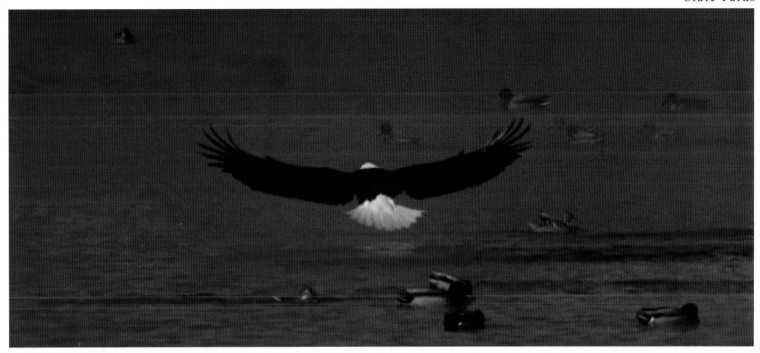

Nikon N90s camera with 500mm f/4 Nikkor lens

As spring approaches unlocking waterways along the Mississippi, hundreds of Bald Eagles are on the move. Launching from a tree along the river, this Bald Eagle moves in for the strike. Although not officially a state park in Minnesota, this delicate area continues to play a critical role in maintaining wintering Bald Eagles.

Finding the Action

Seasonal changes, migration, and other factors require flexibility and adaptation. A mile away, these waterways were frozen solid - no birds. Often the best answer is just to the left or right of my initial plan.

Left: Tracing along the Mississippi from Red Wing, Minnesota south to Reads Landing, hundreds of Bald Eagles take up residence along a several mile stretch of open water.

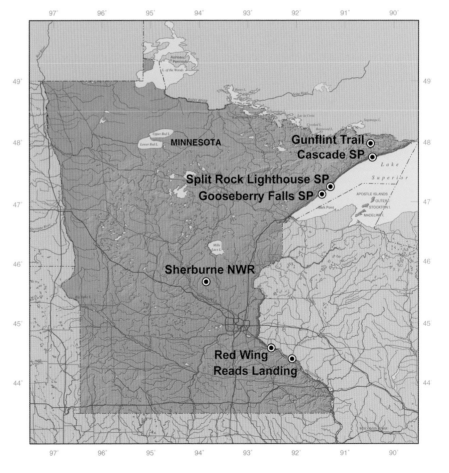

MINNESOTA

Gunflint Trail
Cascade SP

Split Rock Lighthouse SP
Gooseberry Falls SP

Sherburne NWR

Red Wing
Reads Landing

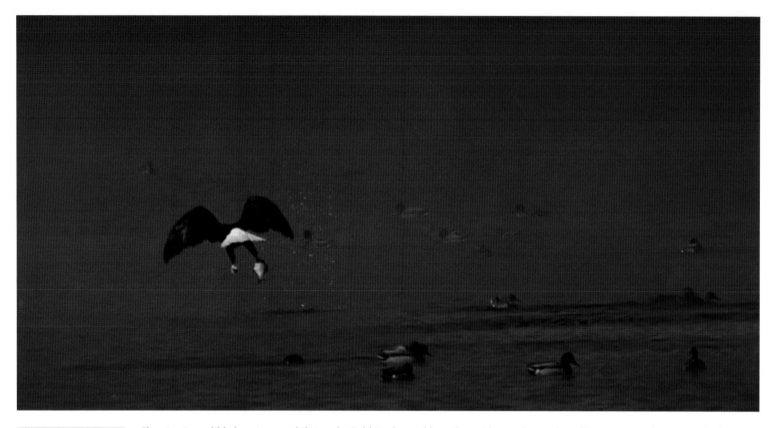

Nikon N90s camera
with 500mm f/4
Nikkor lens

Showing incredible hunting capabilities, the Bald Eagle quickly strikes with one claw and swiftly returns to the trees to feed on the fish.

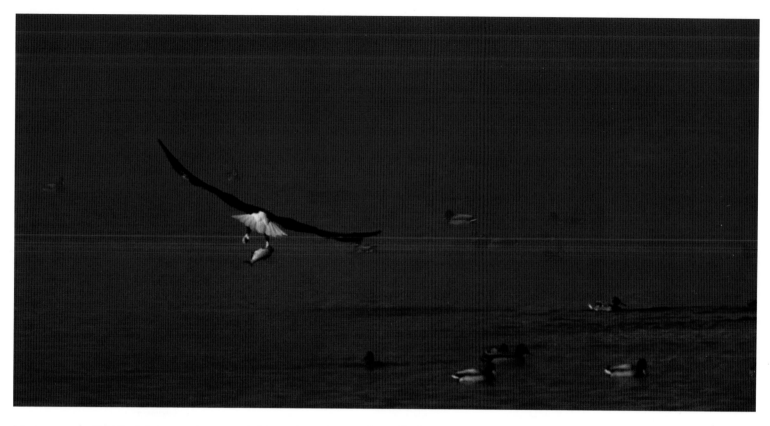

Moving out, the Bald Eagle is in complete control. Happening so fast, nearby Mallards seem unaware of what just occurred.

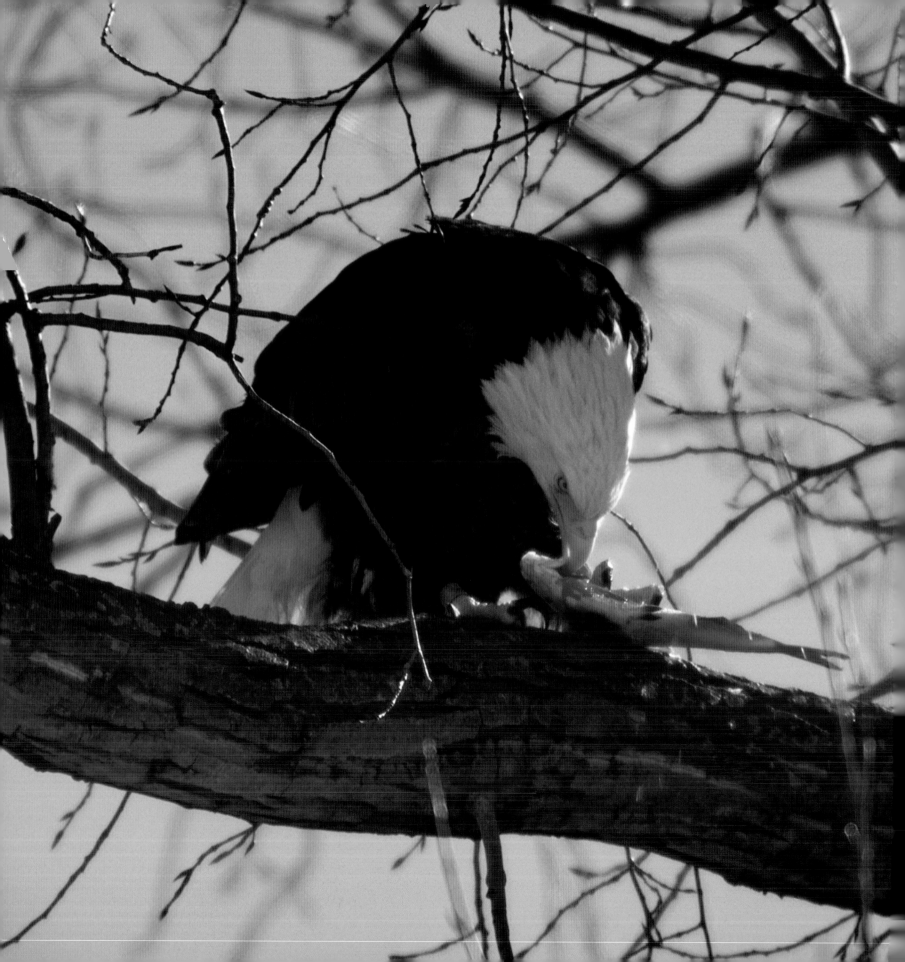

Left: Fresh from the icy waters of the Mississippi, the Bald Eagle sits down for a meal. Although sunny, this photograph was taken on a very cold winter day. I can recall seeing the steam rise from the fish as it was eaten.

Interaction

Being able to anticipate the movement of wildlife can only be derived by knowing how these birds interact with others and their environment.

From vantage points all along the river, hundreds of Bald Eagles take up residence in the trees lining the river. Formed by the confluence of the Chippewa River and the Mississippi, this section of water remains open year round. With open water, Bald Eagles have a chance to survive in the frigid winters of Minnesota.

Nikon N90s camera
with 500mm f/4
Nikkor lens

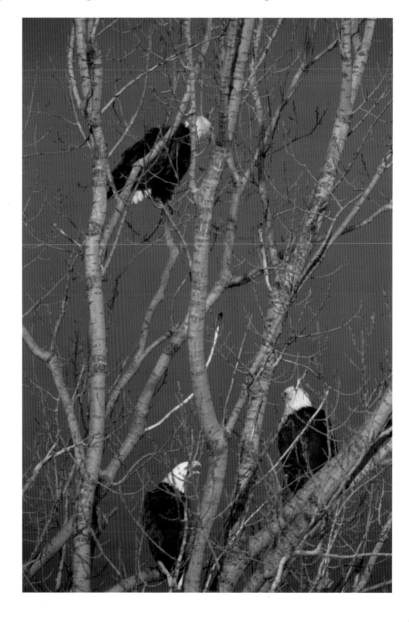

Nikon N90s camera
with 17-35 mm
f/2.8 Nikkor lens

Depth of Field

Our three-dimensional world of depth, horizontal and vertical position can make it difficult to represent on a two-dimensional image. Closing down the lens aperture, more of the image comes into focus. Adding foreground and background elements such as a tree or distant waterfall adds a three-dimensional perspective leading the viewer's eye into the photograph.

At the end of the day, it is the responsibility of the photographer to hold the attention of the viewer. Adding depth of field to an image is just one technique to do that.

As summer quickly turns to fall in the north country of Minnesota, the leaf-stained waters of the Cascade River race down to Lake Superior.

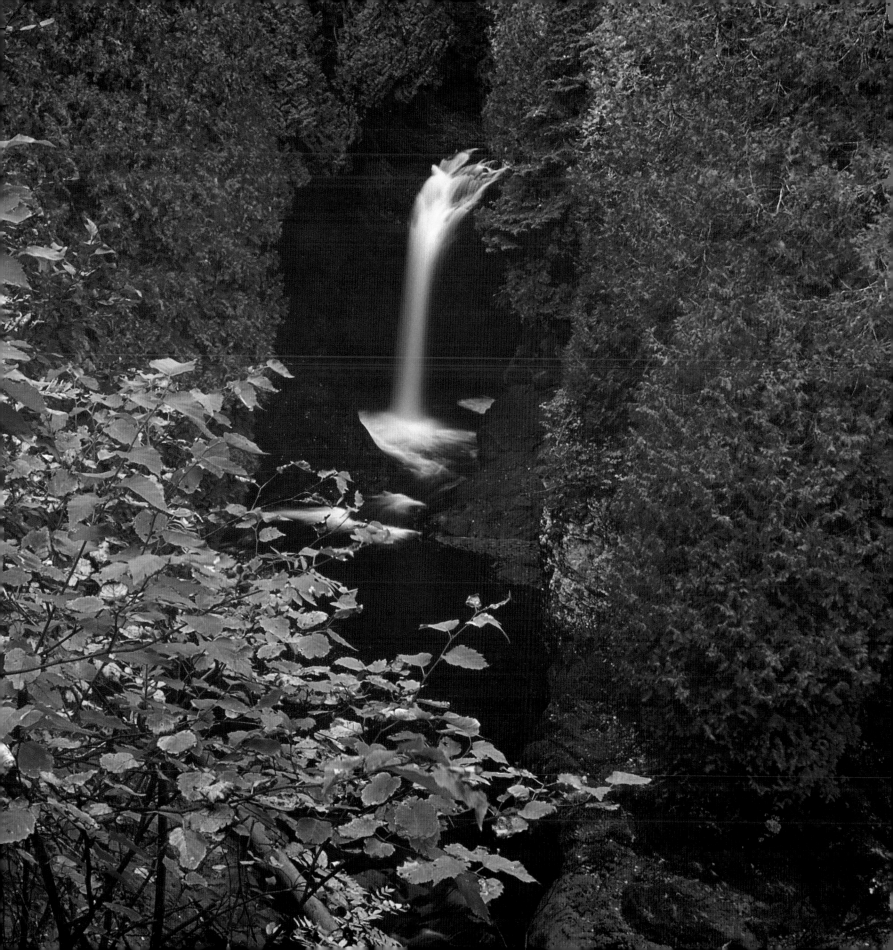

Cascade

Plunging into the granite channels and ancient rock formations of the Iron Range, the water continues on its way to Lake Superior.

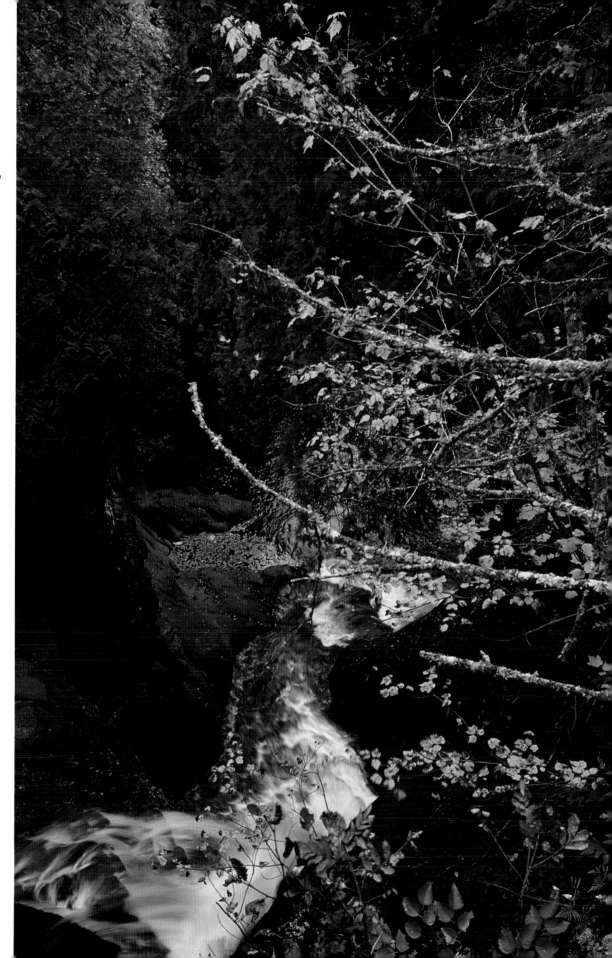

Dynamics of Water

Several things happen when water is recorded on film. Depending upon the available lighting, aperture setting, and shutter speed, the silky smooth water collected on film plays against the rough texture of the rock formations which are stationary. Using a long shutter speed and small aperture, the eddies and white water blur while the landscape remains in focus throughout the image. The blurring of the water conveys not only the direction of motion but speed and energy as well.

Downstream the water slows into eddies and collecting pools only to rapidly accelerate again. The sound of the waterfalls consumes my thoughts.

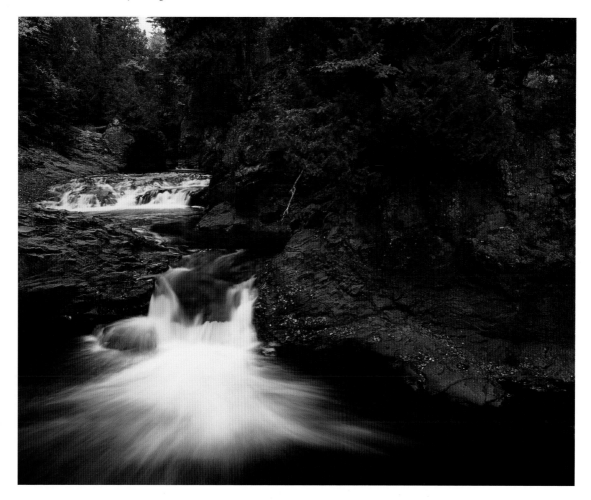

Nikon N90s camera
with 17-35 mm
f/2.8 Nikkor lens

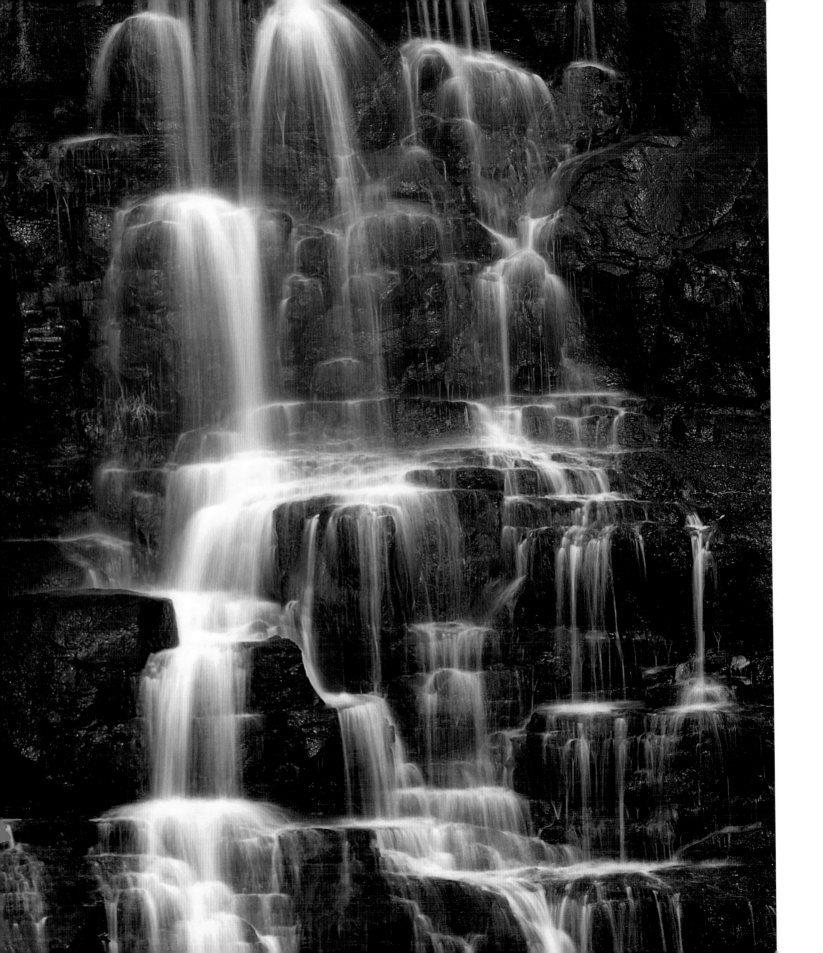

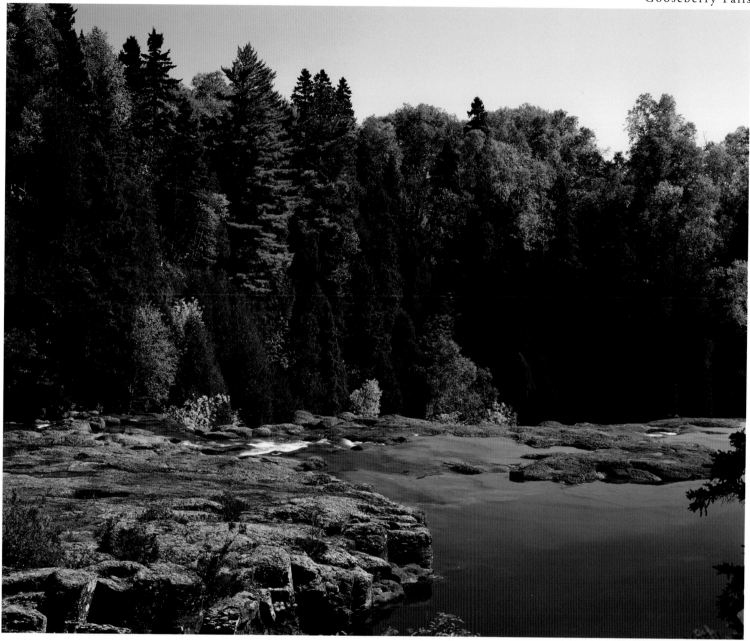

At the top of Gooseberry Falls State Park, quiescent water spills over the granite on a warm autumn day.

Mamiya RZ67 Pro II camera with 140 mm f/4.5 lens

Mamiya RZ67 Pro II camera with 65 mm f/4 lens

Left: Veiled in water, Gooseberry Falls is a unique and refreshing sight.

Split Rock Lighthouse

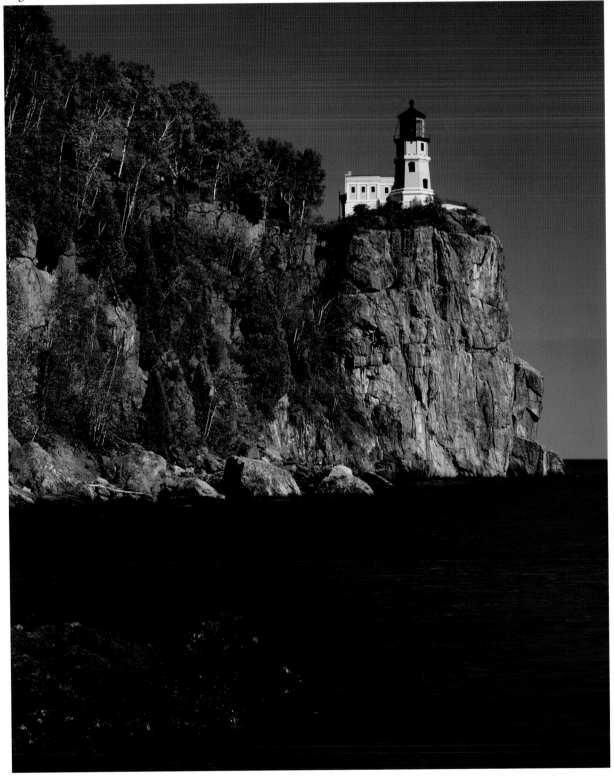

Mamiya RZ67 Pro II
camera with 65 mm f/4
lens

Left: Once the lifeline for ships on Lake Superior, Split Rock Lighthouse stands on vigilant watch.

Blending Nature

It is very rare I ever include man-made subjects in my images. In some ways it defeats what I am trying to accomplish. Occasionally however, there are objects that transcend the impact of man on the environment resulting in strong colors and form.

Nikon N90s camera
with 17-35 mm
f/2.8 Nikkor lens

Right: Inside the Split Rock Lighthouse, metal and glass spiral into the sky.

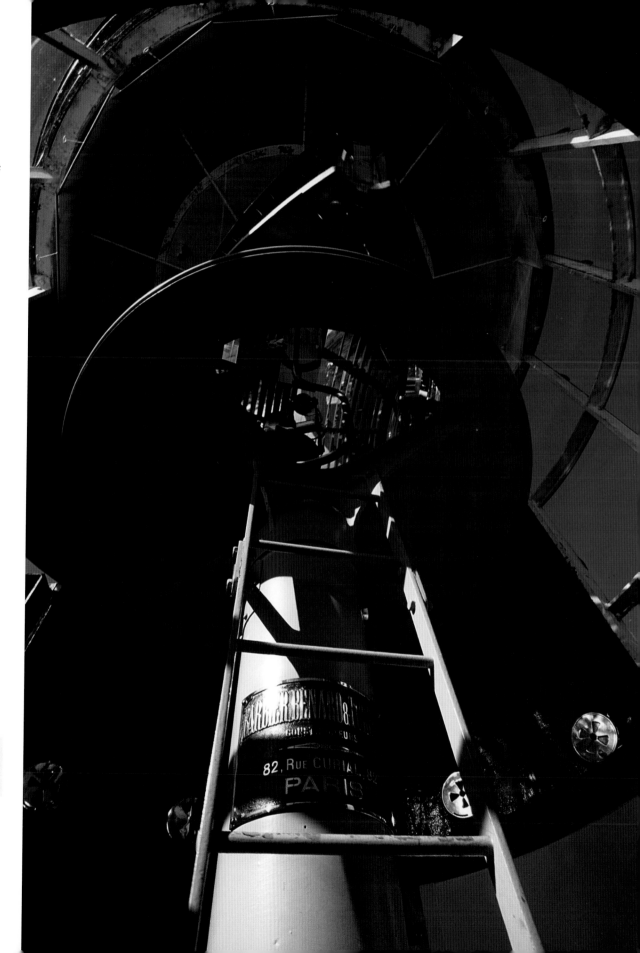

Gunflint Trial

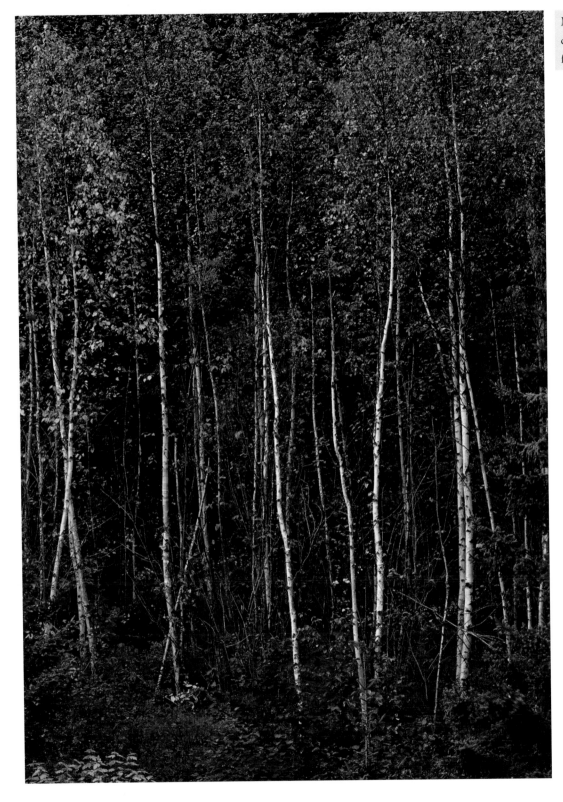

Mamiya RZ67 Pro II
camera with 500 mm
f/6 lens

Nikon N90s camera
with 17-35 mm
f/2.8 Nikkor lens

Throughout the Boundary Waters Canoe Area, ferns and deciduous forests have turned to vibrant colors.

Left: Heading inland, I picked up the Gunflint Trail approaching the Canadian border.

Shapes, Patterns and Textures

Lines form shapes. Shapes repeat into patterns and textures are lines within shapes. Amongst all the stunning color, I typically will use various camera and lens combinations to maximize these design elements. The more elements, often the more visually appealing photograph. Adding asymmetric balancing elements, such as the boulder, pulls the viewer into an image of patterns and texture from northern Minnesota.

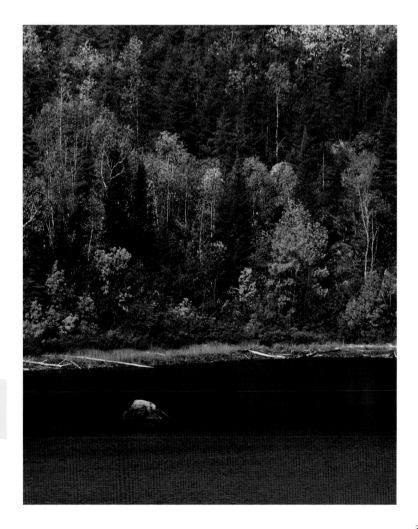

Mamiya RZ67 Pro II
65 mm f/4
Fujichrome Provia

At the end of the Gunflint, a Common Loon takes up residence near a large boulder on one of many lakes comprising the Boundary Waters Canoe Area.

Nikon N90s camera
with 17-35 mm
f/2.8 Nikkor lens

On the Water

Photographing from a moving platform runs the risk of blurred images or reduced depth of field. Using a "fast" lens, with a maximum aperture of f/2.8, and going wide - out to an incredible 17mm, these effects can be minimized. With the sunlight dancing on the water, the vastness of the Boundary Waters Canoe Area comes to life.

There are thousands of acres of unspoiled land, islands, streams, and lakes in the Boundary Waters Canoe Area of northern Minnesota. On these vast interconnected lakes, light and landscape come alive with color. Just as it might have looked hundreds of years ago, the landscape is void of development.

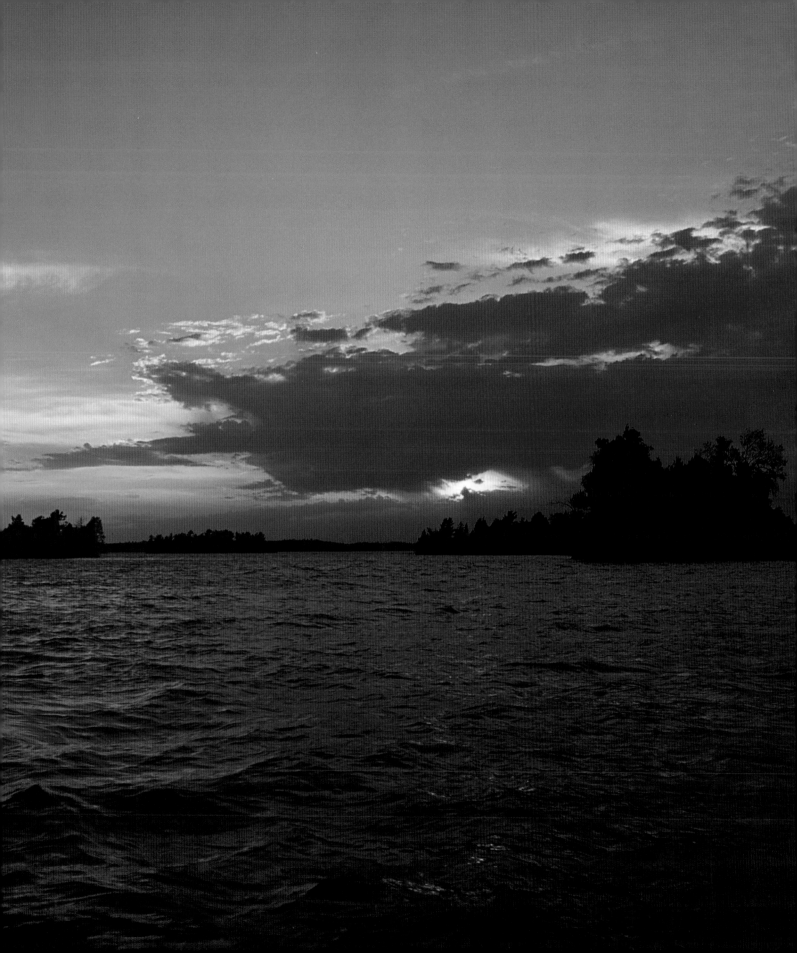

National Wildlife
Refuges

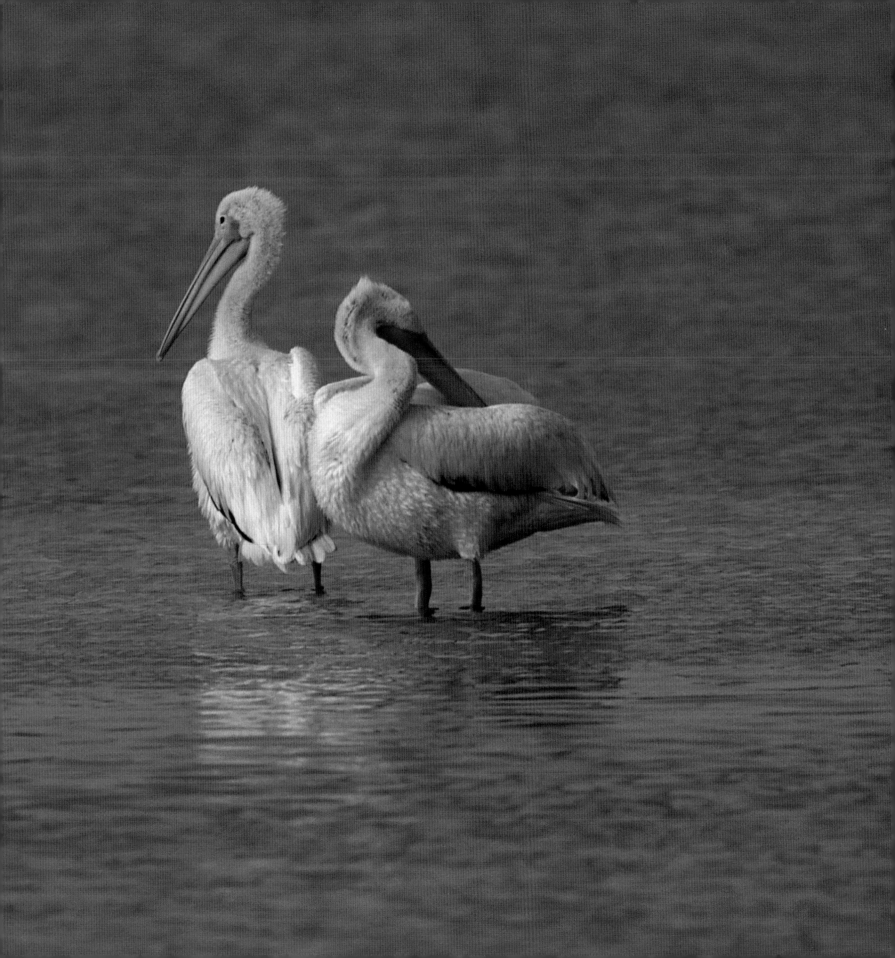

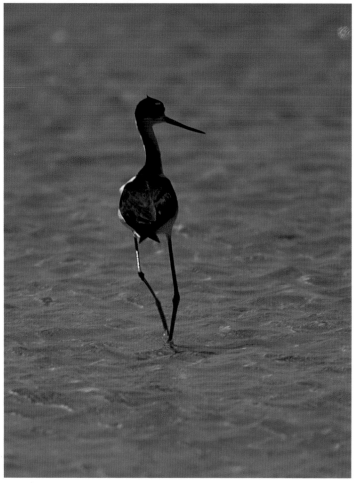

Below: With jet black plumage, a Double-crested Cormorant warms in the sun.

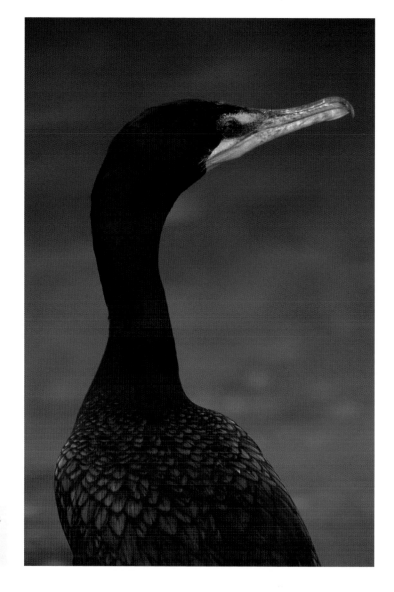

Above: Migrating from Central America, a Black-necked Stilt scours the tidal estuaries. Protection of the environment knows no boundaries.

Wildlife Up-Close

I routinely shoot with a 1.4x or 2x teleconverter and a 500mm lens. At an effective 750mm or 1000mm, suddenly wildlife once out of range can be photographed without disturbance. A sturdy tripod and plenty of patience are essential. To resolve the fine details and incredible colors of birds and waterfowl, Fujichrome Provia 100F or Velvia 100F are exceptional films.

Nikon N90s camera
with 500mm f/4
Nikkor lens

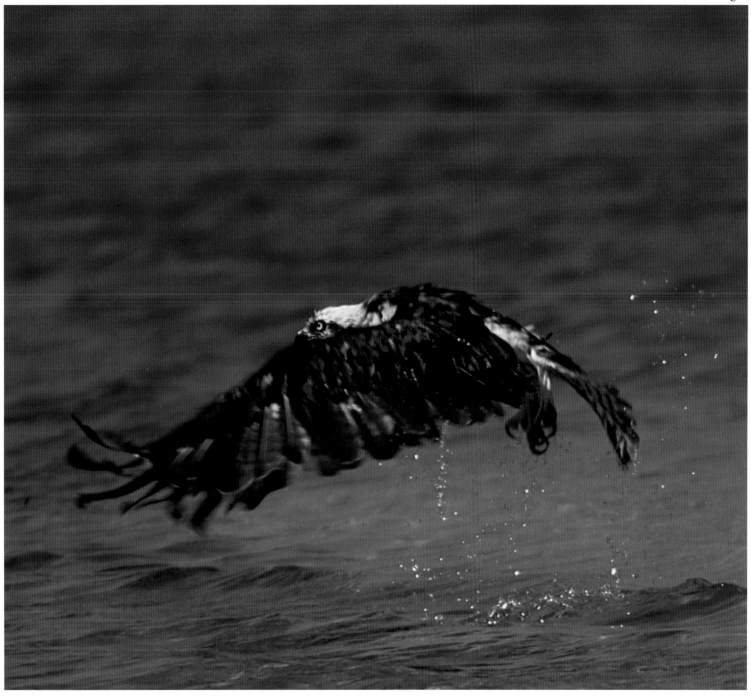

Moving fast and low across the estuary, an Osprey moves in for the kill. Presence of the Osprey is an environmental indicator of water quality and sufficient habitat. Thankfully, the Osprey is thriving in southern Florida with many nesting in and outside of protected areas.

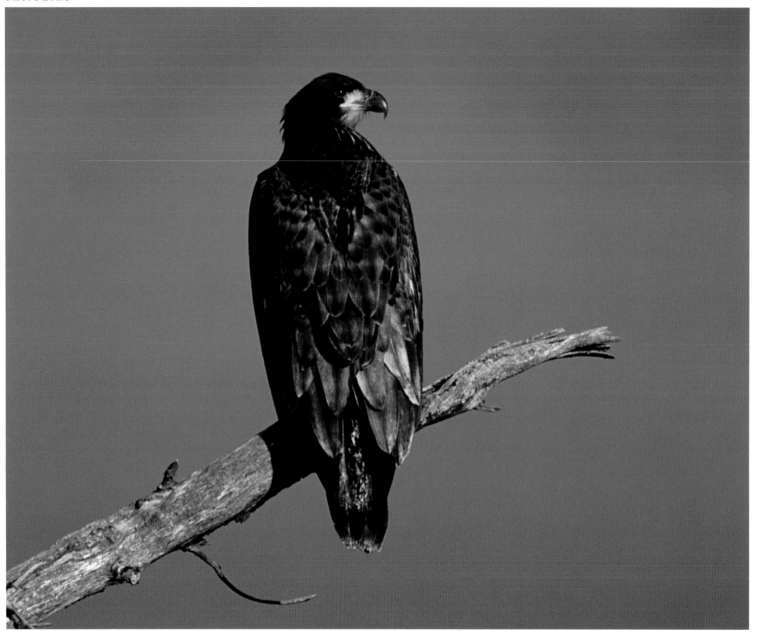

With summer arriving at the Sherburne National Wildlife Refuge in Minnesota, nesting Bald Eagles have a chance to raise hatchlings sustaining the chain of life. The refuge on average hosts 1-2 nesting pairs during the summer months. This immature Bald Eagle scans the wetlands of the refuge patiently waiting for the right moment.

Warming Up

Raptors often perch in the early morning, warming to the bright sunlight of the new day. Unlike the fast action flight throughout the day, these birds wait it out allowing me to photograph from many perspectives, change lenses, reload film, almost oblivious to my presence.

Opportunistic

I often leave for the refuge or park with a plan. I check what the local sunrise time is, lighting directions, trails, access, weather, and what type of wildlife might be in the area for a particular time of the year. With that said, it's important to modify and adapt quickly to changing situations and opportunities as they arise. Sometimes the best opportunities are those not in the plan.

Nikon N90s camera
with 500mm f/4
Nikkor lens

Young River Otters take a risky adventure out in the open.

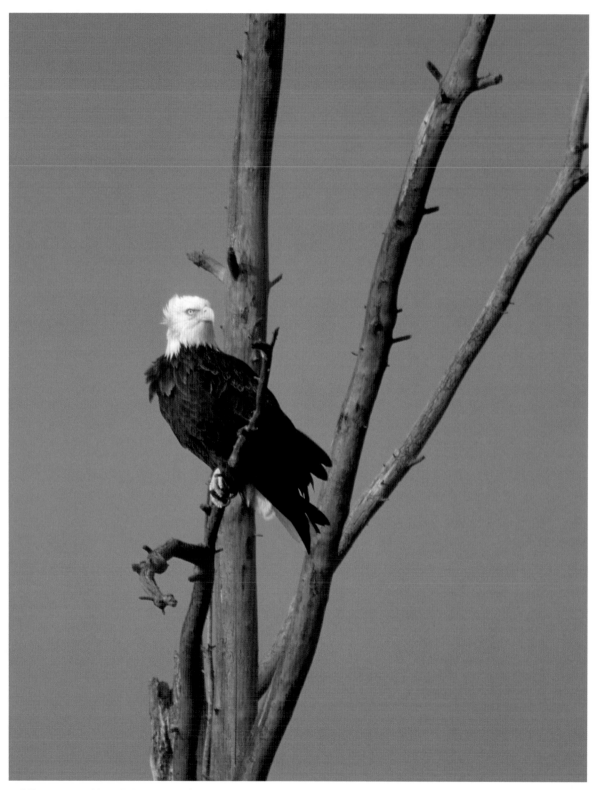

A fully mature Bald Eagle keeps a careful eye on the nest. Our National symbol, strong, powerful, and vigilant is thriving in Minnesota due in part to necessary habitat and significant improvements in environmental quality.

Two hatchlings sit atop a Bald Eagle nest. This nest is used year after year. Typically not far away, an adult Bald Eagle quietly observes while the mate hunts for food.

Cycles of Life

It is rare that I go to a location and never return again. Usually on my first visit I am studying the wildlife interactions, cycles of life, lighting, and logistics.

Returning over the weeks, months, and years, suddenly the cycles of life start to play out on film. New hatchlings, rhythms of migration, and life on the refuge becomes apparent. Over the years I have found it critical to return often.

Nikon N90s camera
with 500mm f/4
Nikkor lens

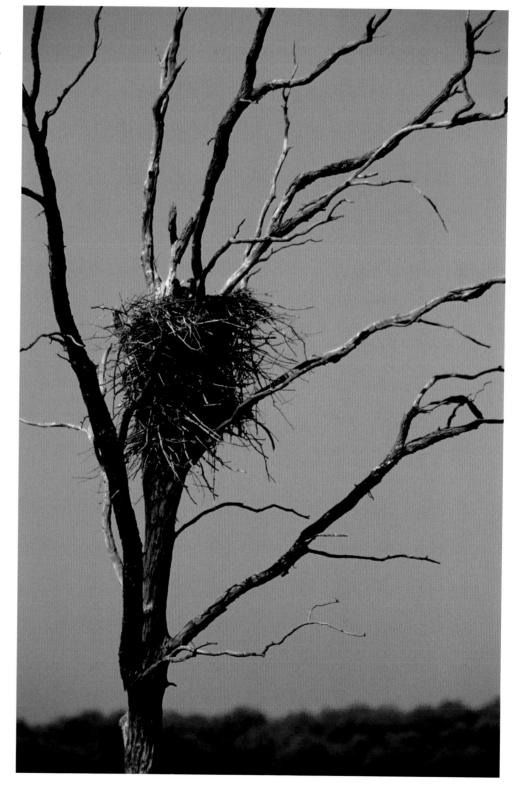

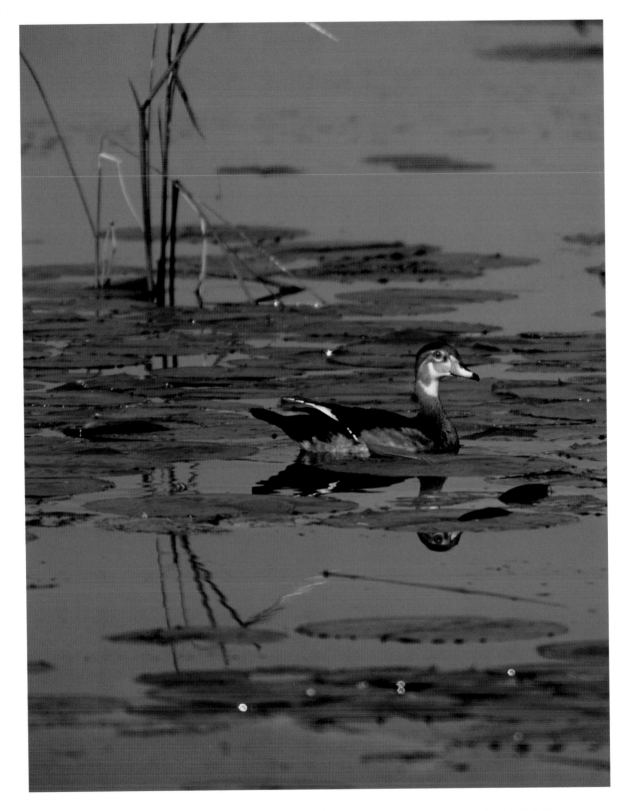

Often fearful of humans, a male Wood Duck quietly explores the wetlands of Sherburne National Wildlife Refuge.

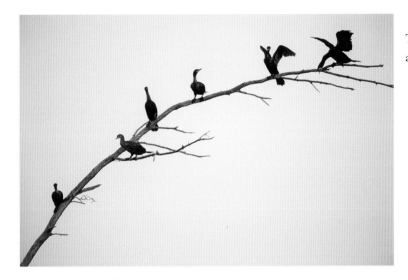

Typically creating a commotion on the refuge, Double-crested Cormorants amass over the marsh waters.

Nikon F100 camera
with 500mm f/4
Nikkor lens

Below: Intrigued by the reflection, a Double-crested Cormorant has found a friend.

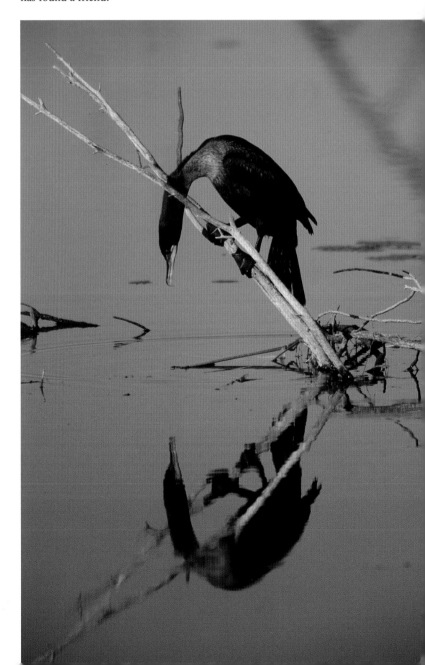

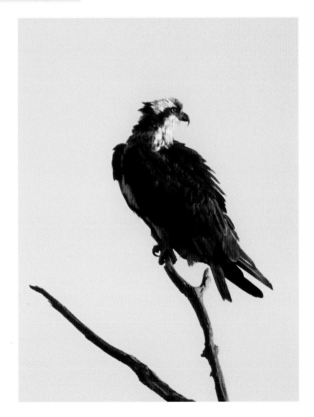

A rare sight at Sherburne National Wildlife Refuge, an Osprey has stopped in for a rest in late September.

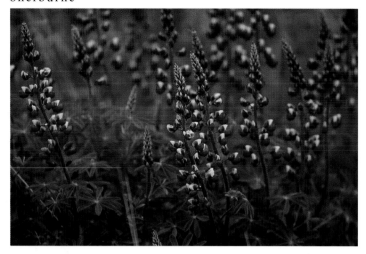

Like many refuges and parks throughout the upper Midwest, Sherburne hosts an array of wildflowers, including Wild Lupine, throughout the spring and summer.

Nikon N90s camera with 500mm f/4 Nikkor lens

Wildflowers and Plants

Wildflowers and plants are great compositional items to use in leading the viewer through a photograph. Using a large depth of field and wide angle, plants in the foreground can create a three-dimensional perspective. The colors and patterns offer a huge toolkit of opportunities. Likewise, when photographed with wide apertures and limited depth of field, the intricate details and construction jump out of the page.

Boneset blooms across the rolling topography.

Every few years controlled burns are managed in the spring to remove old growth and minimize fire hazards in the summer. Several weeks after the burn, vivid green vegetation reappears along with Prairie Sunflowers.

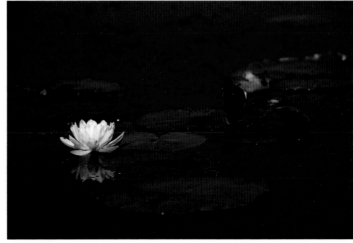

In the late spring, Fragrant Water Lilies bloom on the lakes and ponds of the refuge.

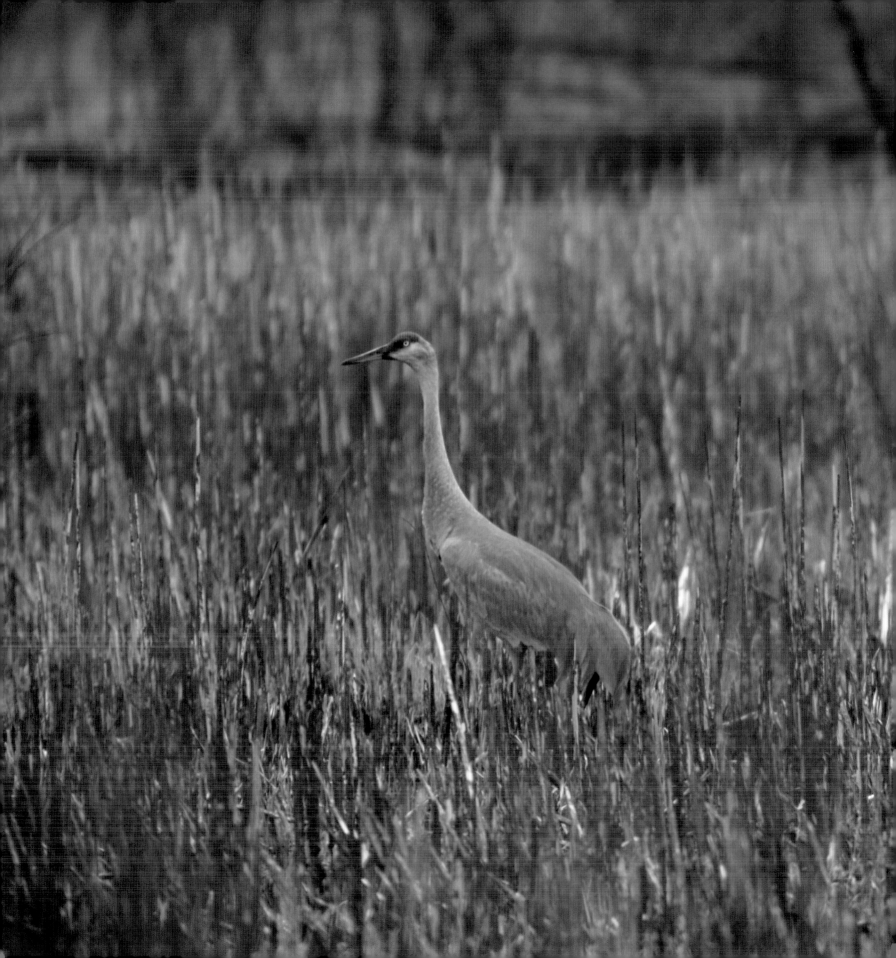

Interacting with the Environment

Knowing the refuge, seasonal changes, and species behavior, it is possible to unravel the interaction of wildlife with their surrounding environment. Blending amongst the charred reeds, the rust colored Sandhill Cranes take turn on surveillance as the other feeds on the marsh bottom. Rarely will both feed at the same time.

Soon, birds photographed last week appear again and again over the summer months. Their patterns of movement, easily distinguishable, their movements in groups and tolerance to intrusion, almost predictable.

Nikon F100 camera
with 500mm f/4
Nikkor lens

Sandhill Cranes feed in the marsh weeks after a prescribed burn on the refuge.

55

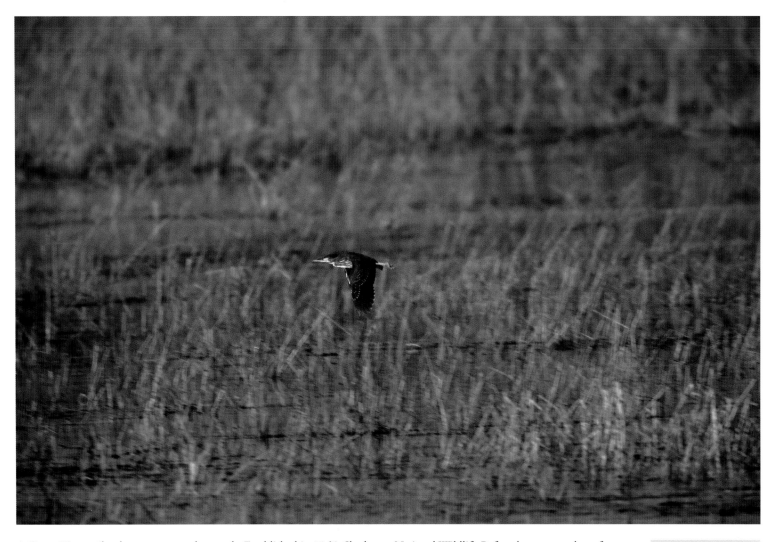

A Green Heron silently traces across the marsh. Established in 1965, Sherburne National Wildlife Refuge hosts a number of waterfowl, raptors, beaver and river otters on 30,665 acres of wetlands.

Nikon N90s camera with 500mm f/4 Nikkor lens

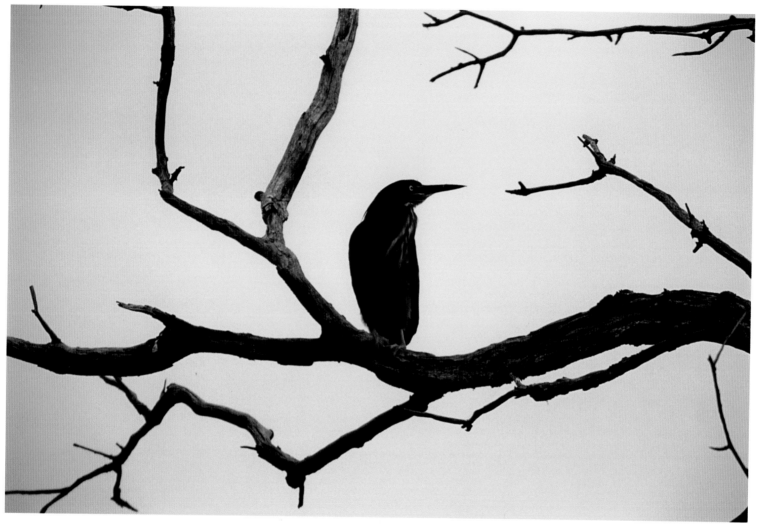

Roosting through the night, a Green Heron awakes on a branch overhanging a refuge access road.

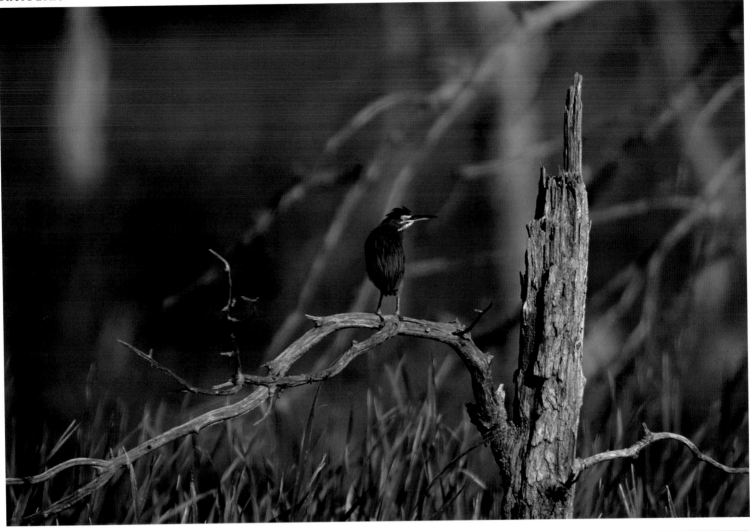

In the early morning, Green Herons scan the refuge and waterways for fish, periodically taking a break on one of the many dead trees throughout the marsh. As the sun climbs in the morning, they quickly blend into the low-lying reeds and marsh waters.

Nikon N90s camera with 500mm f/4 Nikkor lens

Daily Life

Just like humans, wildlife have distinct patterns throughout the day. The best time to photograph birds is early morning. Perching through the night, they occasionally turn up near the road. Using the car as a bird blind, it is possible to get quite close without creating a disturbance. This mobility and concealment allows the rhythms of daily life to be discovered without impacting the wildlife. Getting out of the car with your 500mm lens in hand however, game over.

Right: Gotcha. A Common Loon dives repeatedly for a mid-morning snack of crayfish.

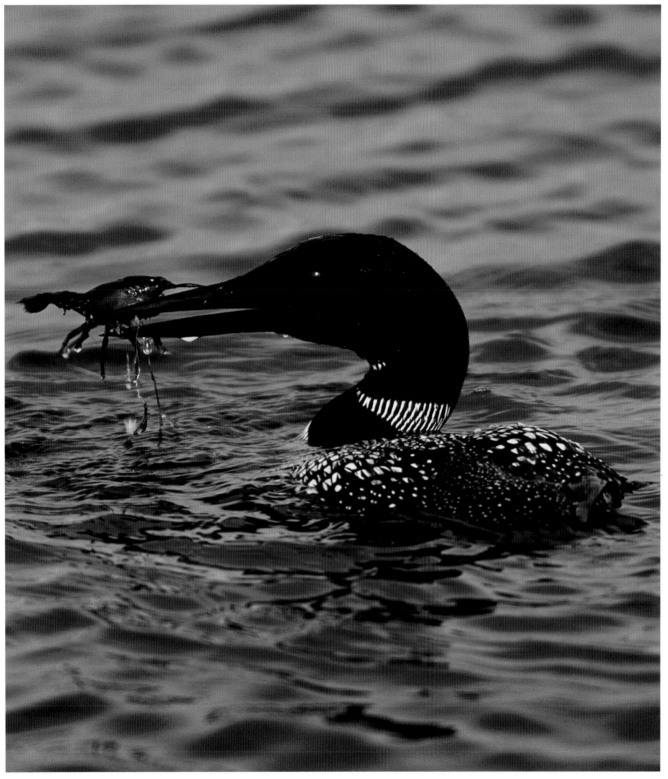

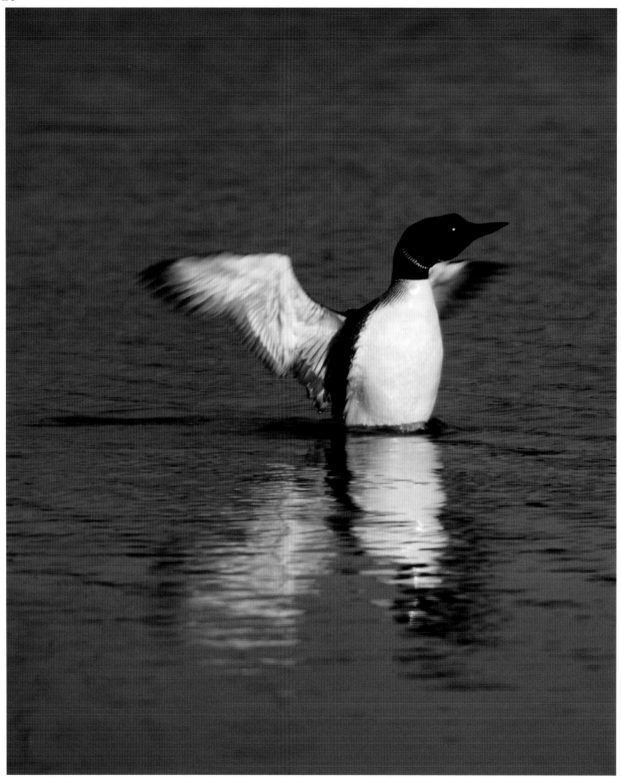

A Common Loon warms up for diving at the Sherburne National Wildlife Refuge.

Nikon F100 camera
with 500mm f/4
Nikkor lens

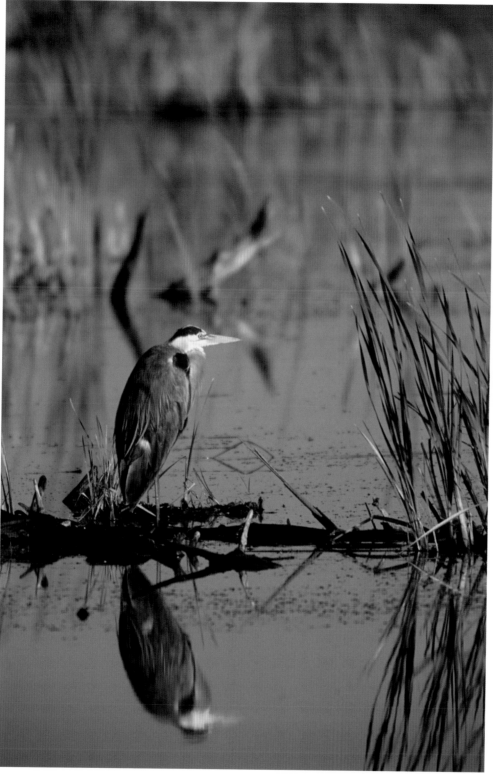

Easily spooked, this Great Blue Heron is at ease on a warm summer morning at the Sherburne
National Wildlife Refuge.

Rare Trumpeter Swans take to flight on the refuge.
During the early summer months, several mating pairs
are a common sight.

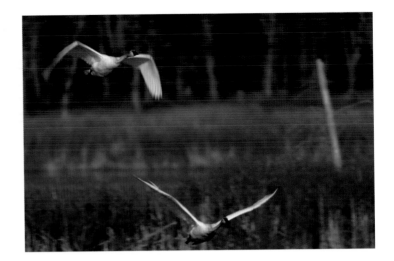

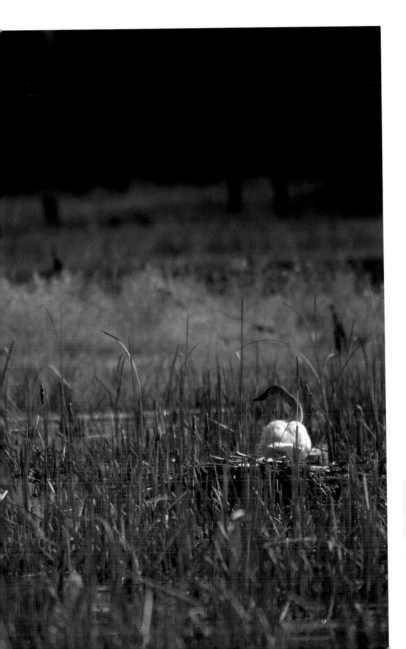

Nikon F100 camera
with 500mm f/4
Nikkor lens

On the nest, this Trumpeter Swan finds the habitat necessary to sustain the species.

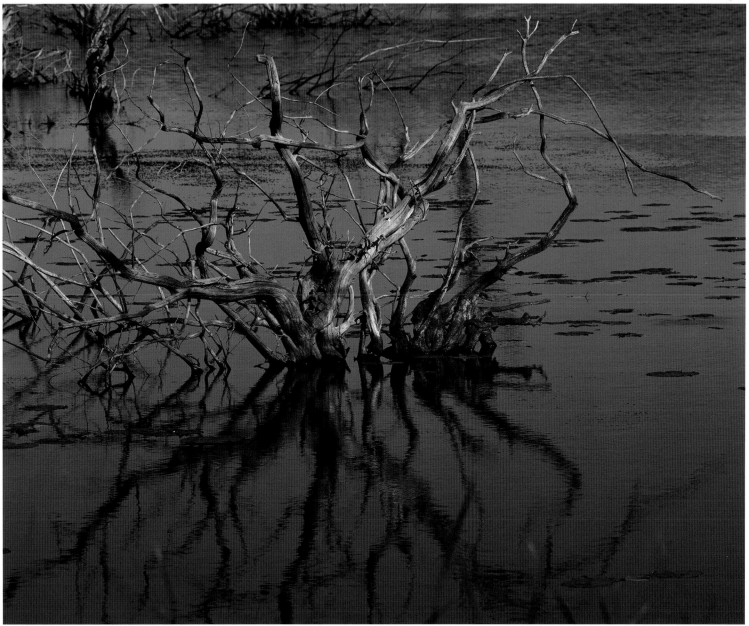

Throughout the Sherburne National Wildlife Refuge, trees yield to the presence of water. The refuge sits within a transitional zone of two major eco-systems - deciduous hardwood forests and tallgrass prairies. This is an ideal habitat for waterfowl such as Wood Ducks.

Mamiya RZ67 Pro II camera with 500 mm f/6 lens

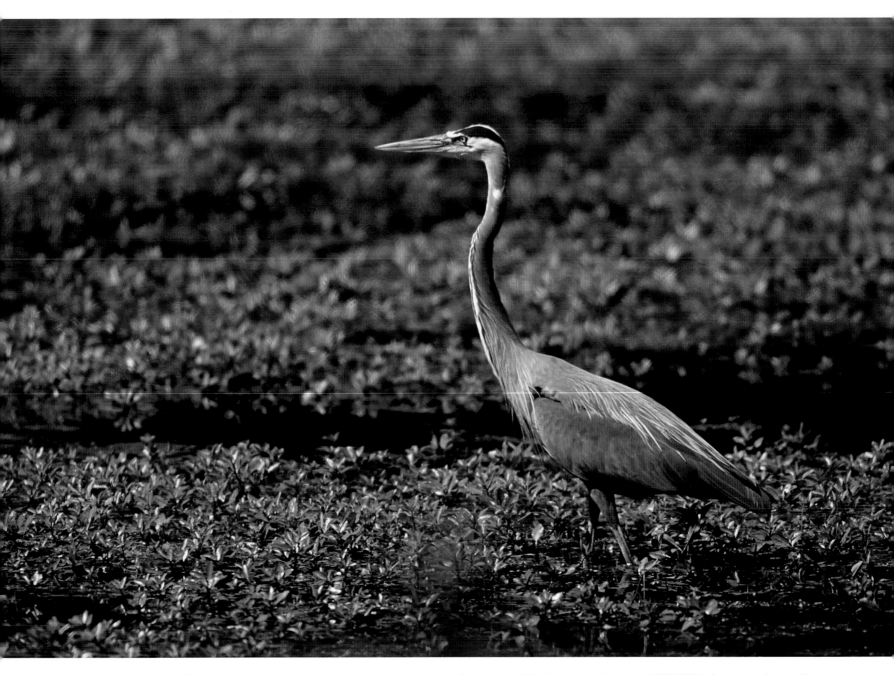

With summer in full swing, a Great Blue Heron slowly moves through the shallow waters of the Muscatatuck National Wildlife Refuge in southern Indiana.

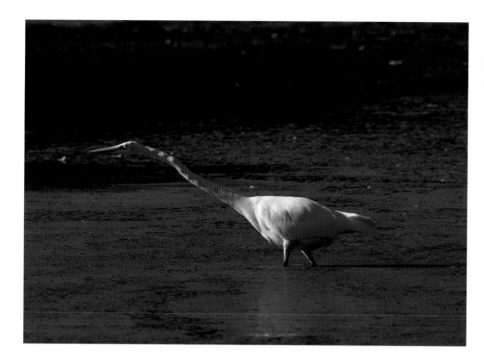

In the summer, a number of Egrets find the large nesting ponds ideal for fishing at the refuge.

Nikon N90s camera with 500mm f/4 Nikkor lens

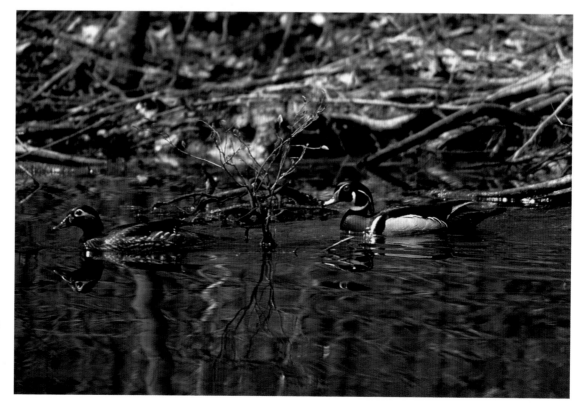

Muscatatuck, because of its heavily wooded and marsh areas, offers sanctuary to a large number of Wood Ducks. This female and male pair work their way down a narrow stream connecting the hardwood forest and marshlands.

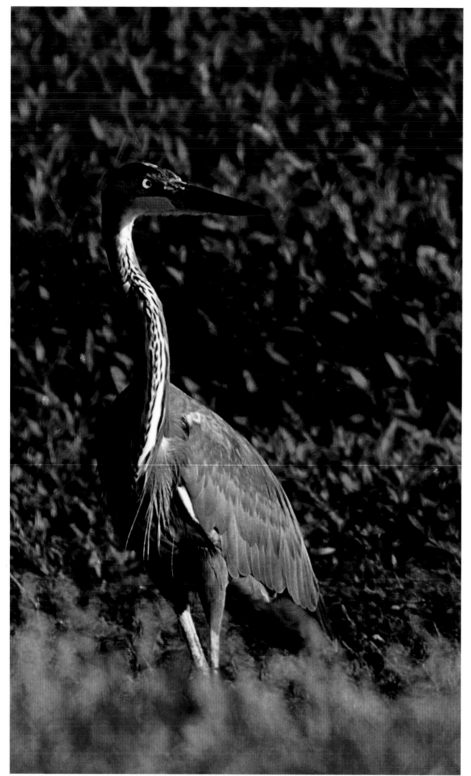

Always on alert, Great Blue Herons carefully monitor their surroundings while hunting. Their eyesight is so exceptional that they are easily spooked from several hundred meters away.

Nikon N90s camera with 500mm f/4 Nikkor lens

A Red-tailed Hawk dives for prey at Muscatatuck National Wildlife Refuge. Large, open fields sustain a number of hawks, Great Horned Owls, and an occasional Bald Eagle throughout the summer.

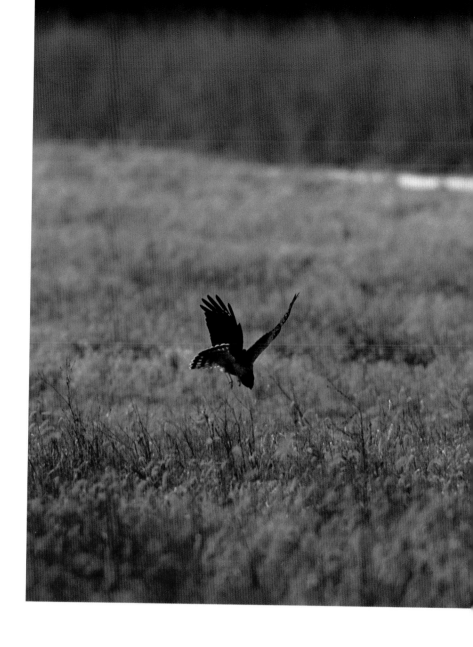

Fast Action Flight

Fast action flight is probably one of the toughest things to accomplish in bird photography. Although lightening fast autofocus and film advance mechanisms at 8 frames per second can be a real benefit, it can be difficult due to low light conditions and the lack of high shutter speeds. For these situations, I often will expose Fujichrome Provia 100F at ISO 200 and push process one stop when developing. This allows for a doubling of the shutter speed and freezing of the birds in flight.

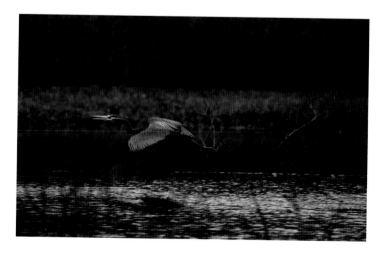

Alerted to an intruder, a Great Blue Heron squawks a loud call and then takes to flight across the nesting ponds of the refuge.

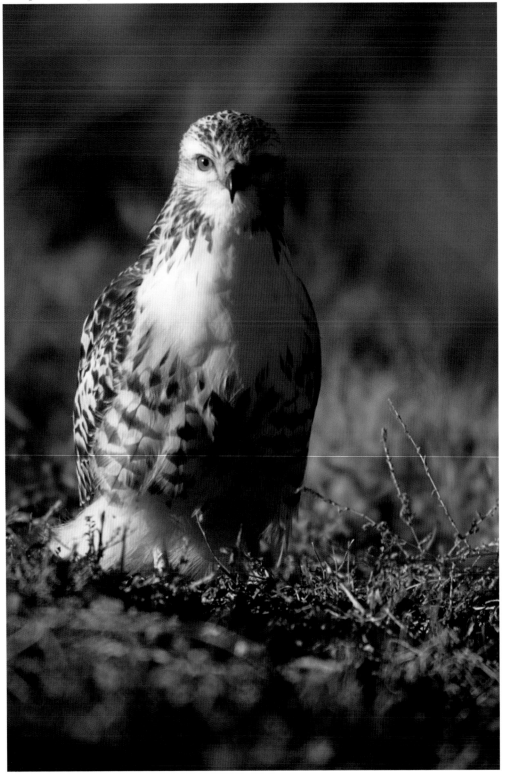

Wintering in the waterways and wetlands of the Bosque del Apache National Wildlife Refuge, hawks, eagles, Sandhill Cranes and Snow Geese find ample sanctuary along the waters of the Rio Grande. In early December, Snow Geese populations can quickly approach 30,000.

Numerous raptors such as this Juvenile Red-tailed Hawk also find wintering habitat.

Nikon N90s camera
with 500mm f/4
Nikkor lens

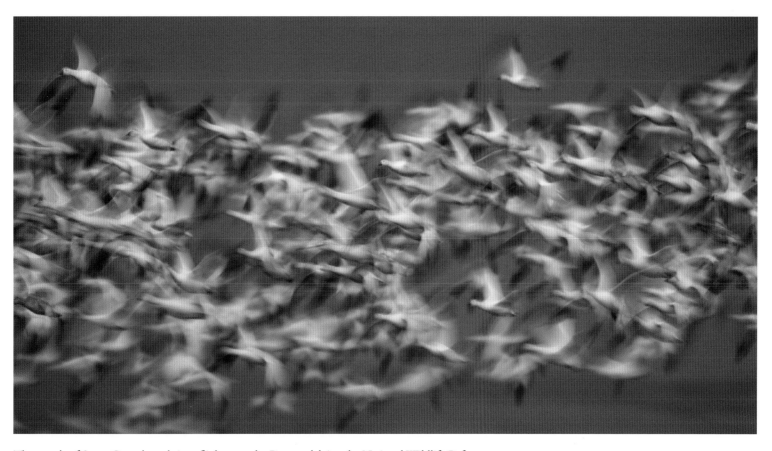

Thousands of Snow Geese launch into flight over the Bosque del Apache National Wildlife Refuge.

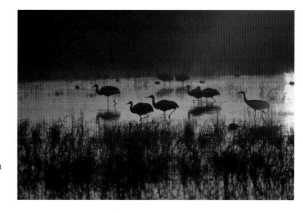

Sandhill Cranes move as silhouettes against a vivid New Mexico sunrise.

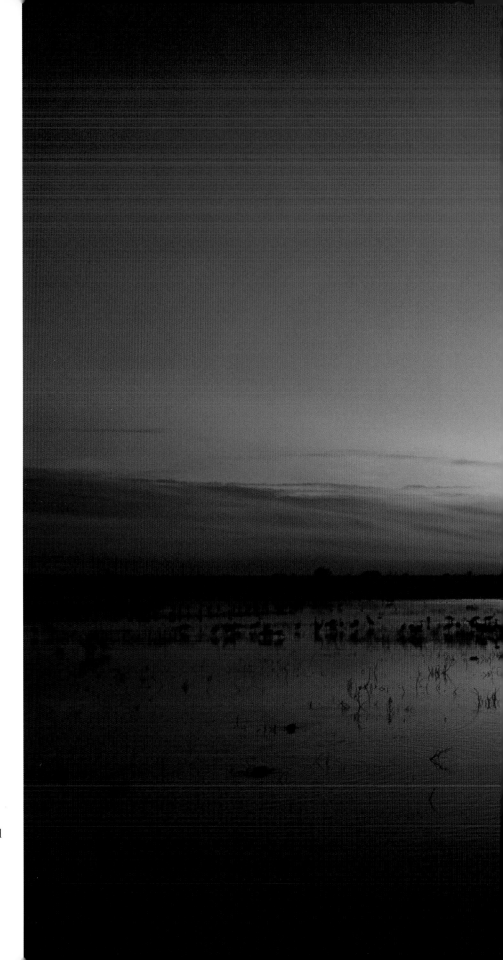

Into the Night

As dusk quickly sets in, time to go wide angle and take in all the color. In my photo backpack, I typically carry a 500mm f/4 Nikkor and 17-35mm f/2.8 Nikkor lens. With the available light quickly diminishing, switching to a "faster" lens picks up several stops of exposure and depth of field. As the moon climbs into the night sky, the Sandhill Cranes slowly fad into silently moving silhouettes.

Nikon N90s camera
with 17-35 mm
f/2.8 Nikkor lens

As evening quickly settles in on the Bosque del Apache National Wildlife Refuge, the sky explodes in color. Off in the distance, Sandhill Cranes have found a quiet resting spot for the night.

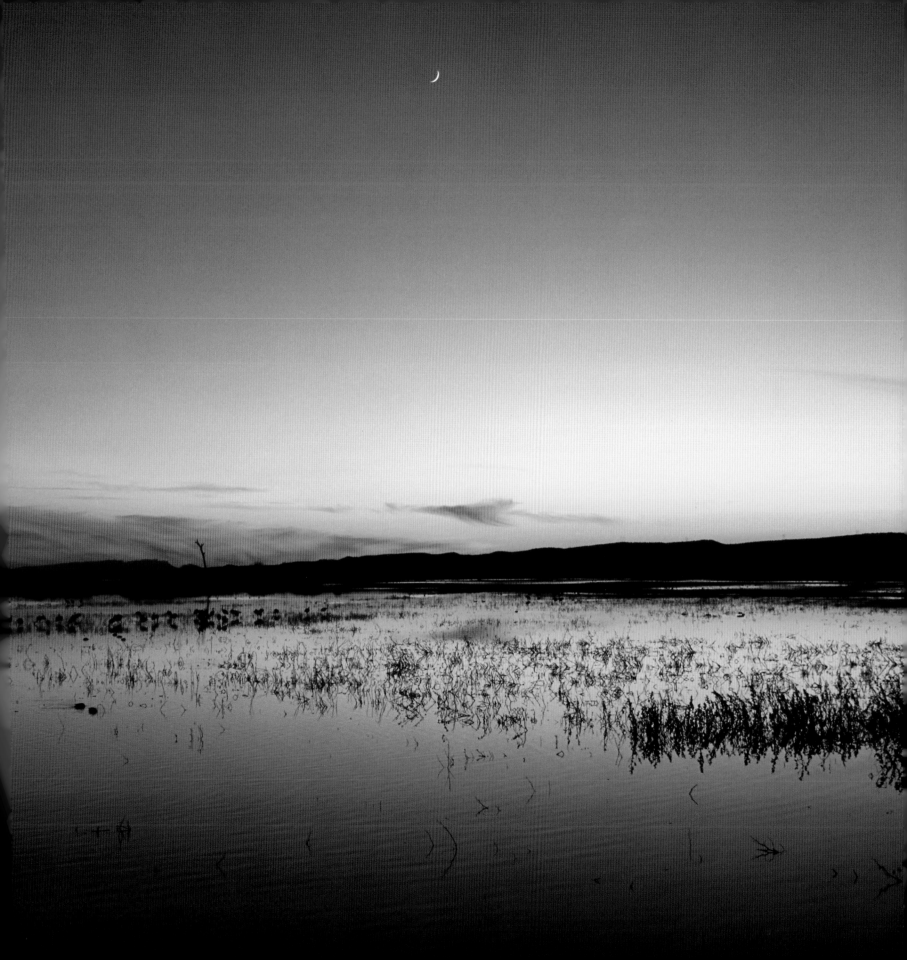

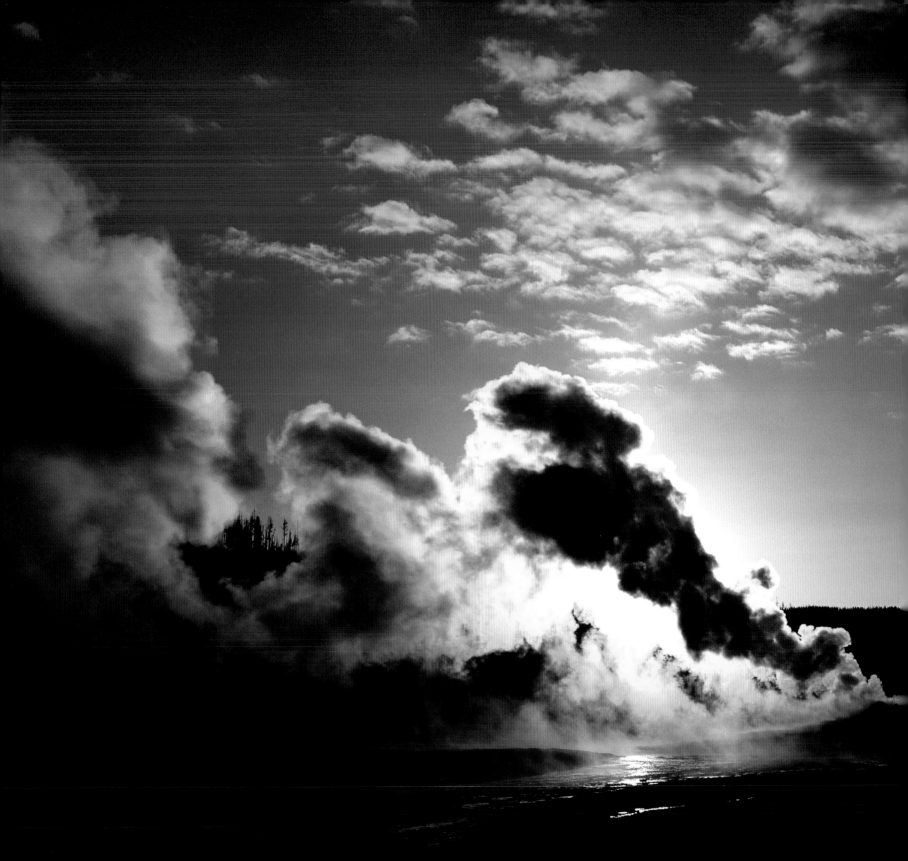

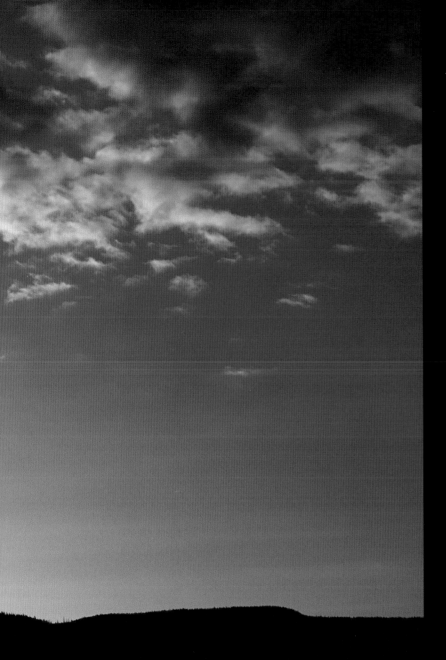

National Parks and Monuments

Mamiya 7 camera
with 80mm f/4
lens

Preceding Page: Old Faithful, Yellowstone National Park

Chasing the Color

To capture the color of a sunrise or sunset, it's essential to use a Graduated Neutral Density filter. In the early morning light, often five or more stops separate the dark areas from the light regions of the sky. Transparency film typically can only accommodate three stops of separation. That means some areas can go completely black or be washed out, void of color.

Although our eyes have a huge dynamic range, beyond twelve stops, film is significantly more limited. By holding back the intensity of the bright areas, such as the sky, it is possible to compress the true dynamic range into what can be recorded on film. With a three stop split Graduated Neutral Density filter, detail in the ground can be recorded and the sky held back a full three stops revealing the natural colors.

I routinely use a Singh-Ray Hard Split GND filter. Placing the split where the horizon meets the sky results in a natural looking image capturing the vivid colors on film. The trick of course is how to handle horizons that are not straight.

Mamiya RZ67 Pro II
camera with 65 mm f/4
lens

Appearing as it might have thousands of years ago, the sun rises on the Badlands National Park in South Dakota.
Following pages: As nightfall approaches, the sky is energized with thin strands of lightning.

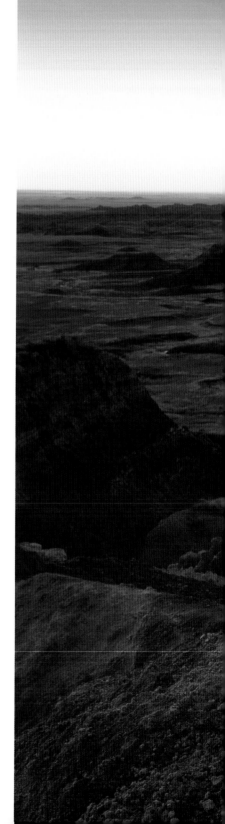

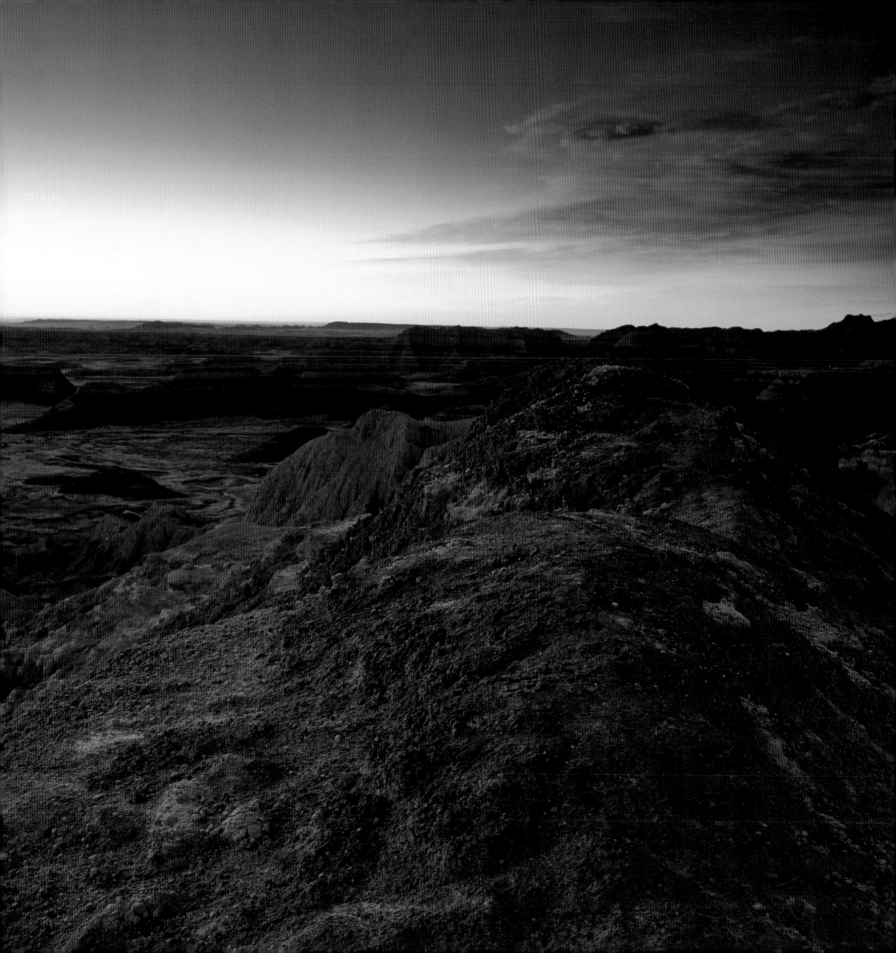

Badlands

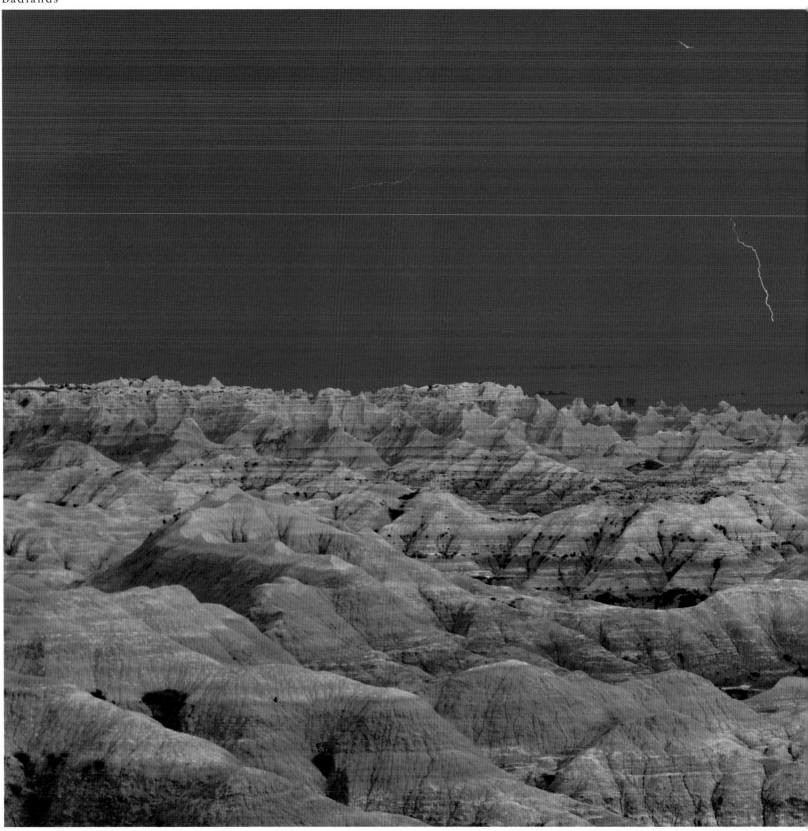

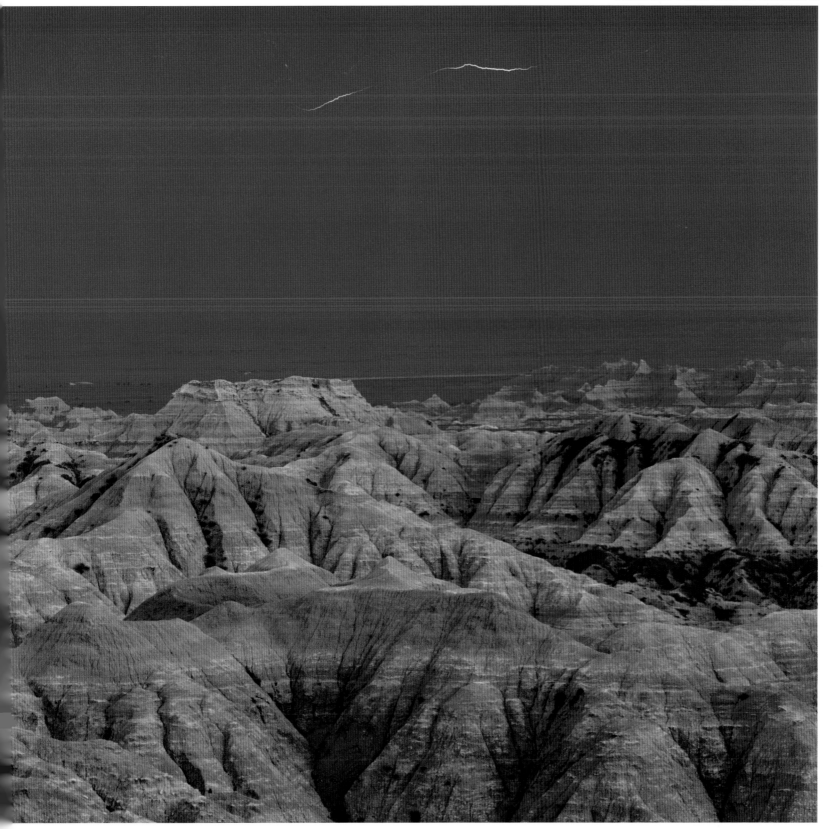

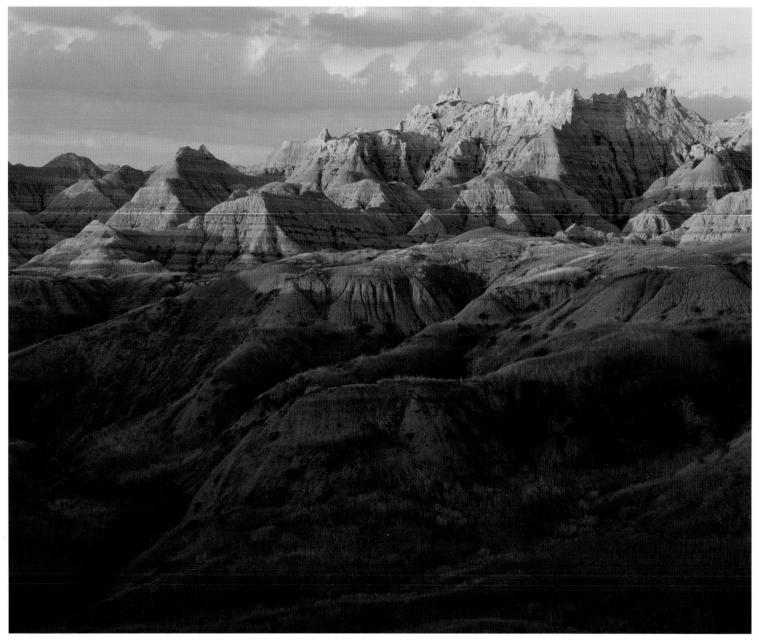

Once the site of an ancient seabed, the Badlands National Park in South Dakota is a landscape in continual change over millenniums and throughout the day. As sunrise approaches, the barren landscape explodes with color.

Mamiya RZ67 Pro II camera with 140 mm f/4.5 lens

Vivid Colors at Sunrise

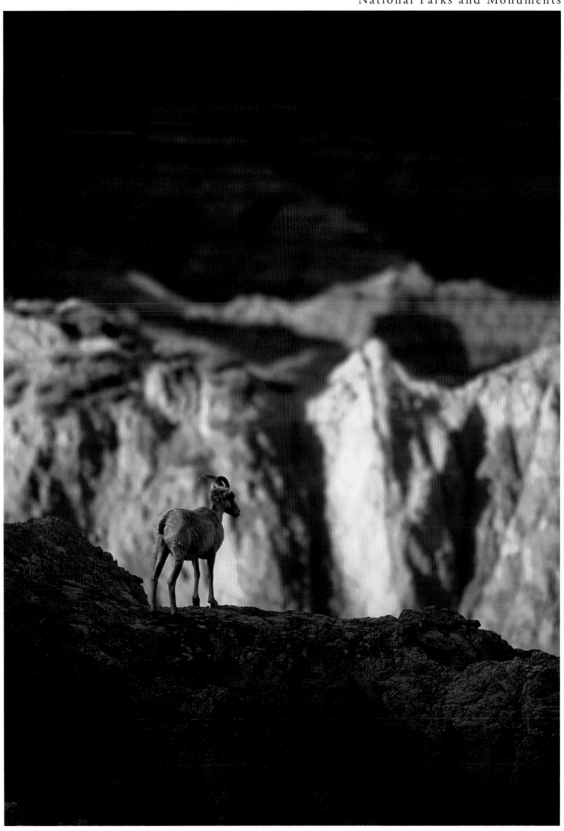

Nikon N90s camera
with 500mm f/4
Nikkor lens

Taking in the intensity of the new
day, a Mountain Goat quietly
observes the illuminated canyon
below.

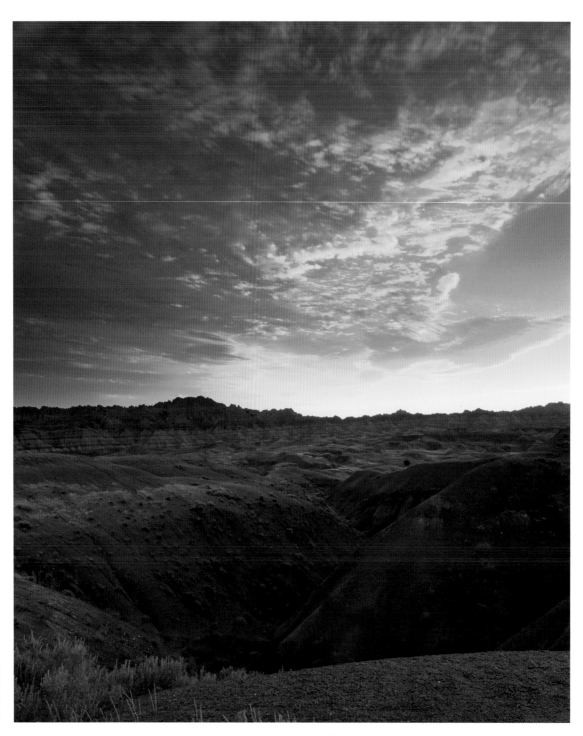

Mamiya RZ67 Pro II camera with 65 mm f/4 lens

Vivid, colorful and open skies are in stark contrast with the moon-like landscape of Badlands National Park.

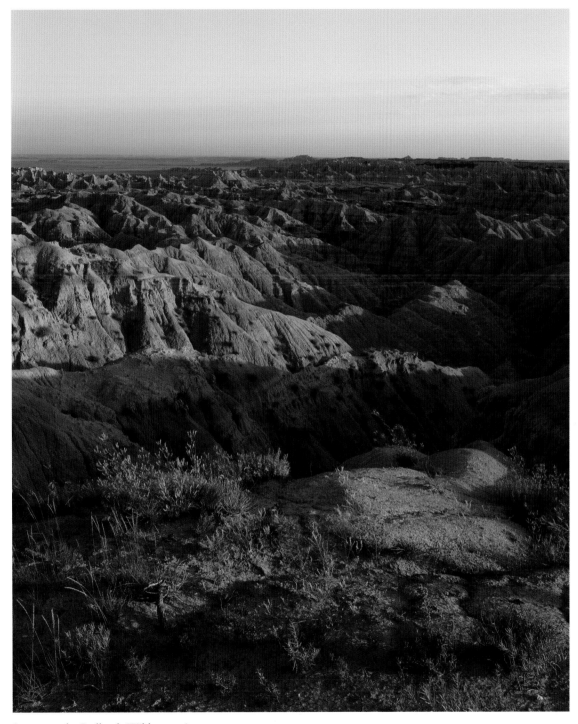

Sunset on the Badlands Wilderness Area.

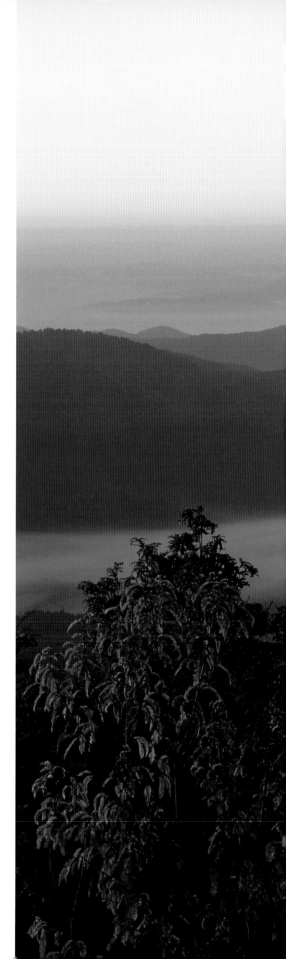

Mamiya 7 camera
with 80mm f/4
lens

Harmonious Light

Subtle pastel colors form a sweet light in the early morning. Before the sun breaks the horizon, the ground is illuminated with the reflected light from the sky. This extremely soft lighting condition is excellent for films such as Fujichrome Velvia 50. So smooth and almost without grain, the blues and greens take off in amazing color.

View of Mt. Pisgah. Riding the crest of the Blue Ridge Mountains in North Carolina, the Blue Ridge Parkway traverses 469 miles of scenic mountain views. Named after the biblical mountain from which Moses first viewed the promised land, Mt. Pisgah today forms the core of the Pisgah National Forest. In the early morning, temperature inversions are reminiscent of ancient lands.

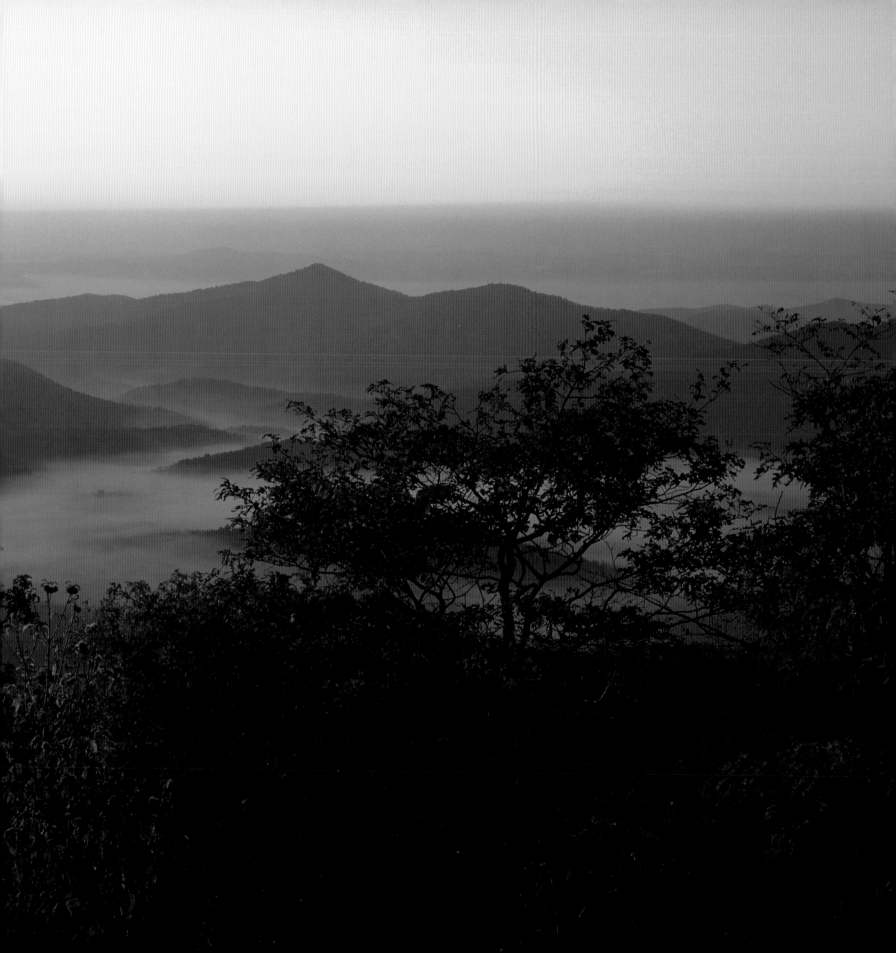

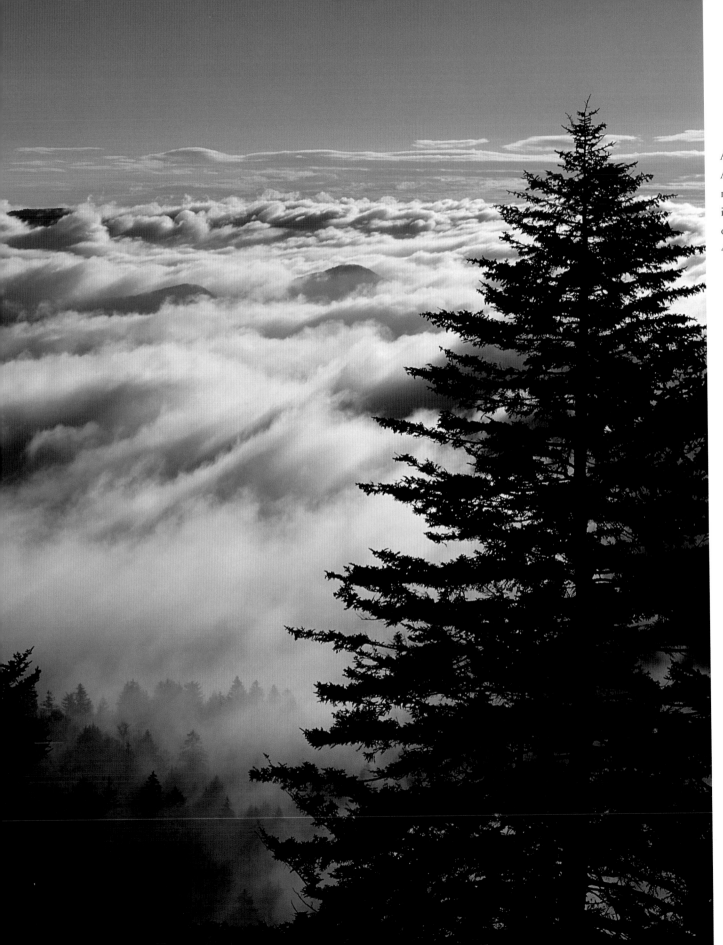

Above the smoke. At 6,047 feet, early morning temperature inversions create a sea of clouds. Milepost 430.

Mamiya RZ67 Pro II camera with 65 mm f/4 lens

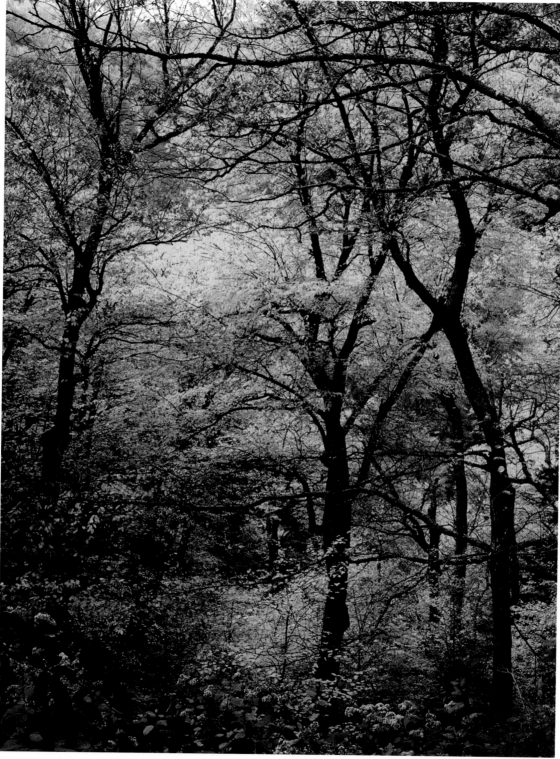

When autumn arrives on the Blue Ridge, so do the crowds to witness the forest erupt in vibrant fall colors.

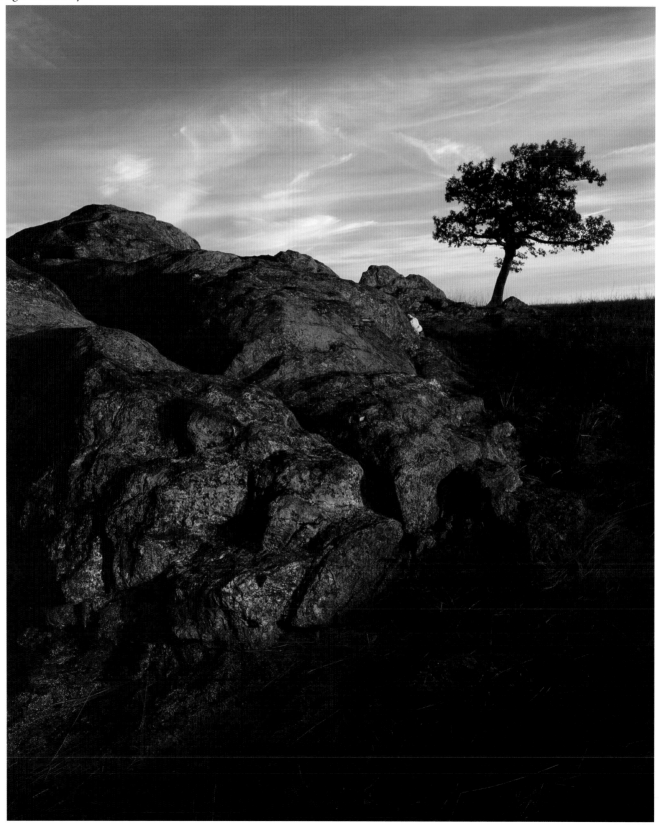

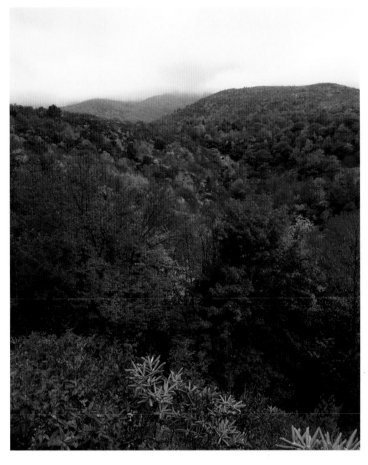

Once the site of a significant blow-down and forest fire years ago, trees today turn fire red against a foreground of Catawba Rhododendron at the Graveyard Fields, milepost 418.

Oriented in unison, Turk's Cap Lilies seemed to be trying to say something.

Nikon N90s camera with 80-200 mm f/2.8 Nikkor lens

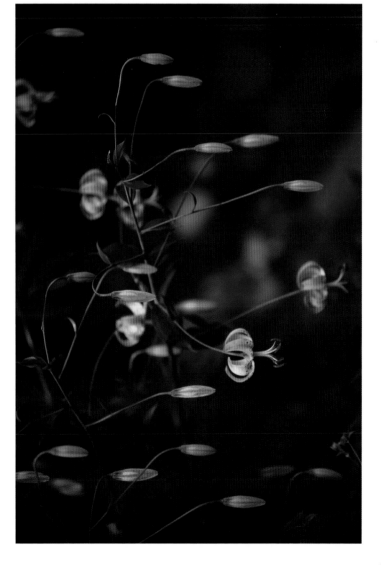

Fall Foliage and Low Light

Overcast, rainy conditions filter the harsh mid-day light drawing out the highly saturated fall foliage. To maximize the saturation, the best time to shoot is during or just after a rain. The challenge however is preventing wash-out of the sky, a great opportunity for a split GND filter.

Mamiya RZ67 Pro II camera with 65 mm f/4 lens

Left: Near the quaint diner and Bluff's Lodge just off the Parkway, an outcropping of boulders top Bluff Mountain at Doughton Park, Milepost 240.

Sunset on the Nantahala National Forest, Milepost 430.

Mamiya RZ67 Pro II
camera with 65 mm f/4
lens

Right and Following Page: Dusk on the Blue
Ridge Parkway, Doughton Park.

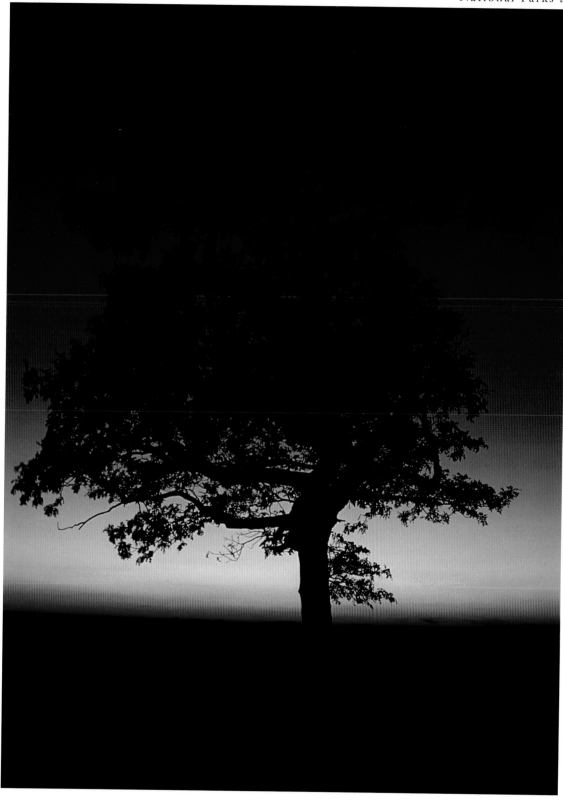

Nikon N90s camera
with 28 mm f/2.8
Nikkor lens

From the deep reds at the horizon to the indigo blues high above the land, the Nantahala National Forest quickly recedes into the darkness of the night.

Nikon N90s camera
with 80-200 mm
f/2.8 Nikkor lens

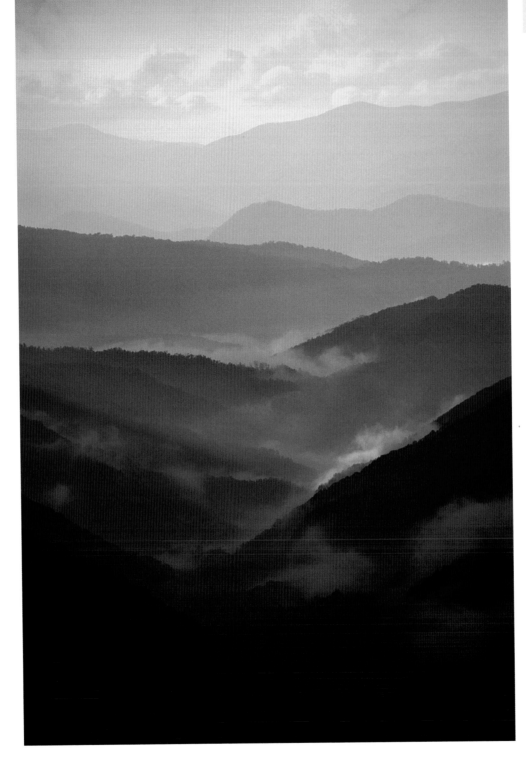

In the morning
along the road to
Clingmans Dome
in the Great Smoky
Mountains National
Park, fog slowly rises
from the valley. Just
minutes after this
photograph was
taken, clouds spilled
over the ridge line
blocking my view.

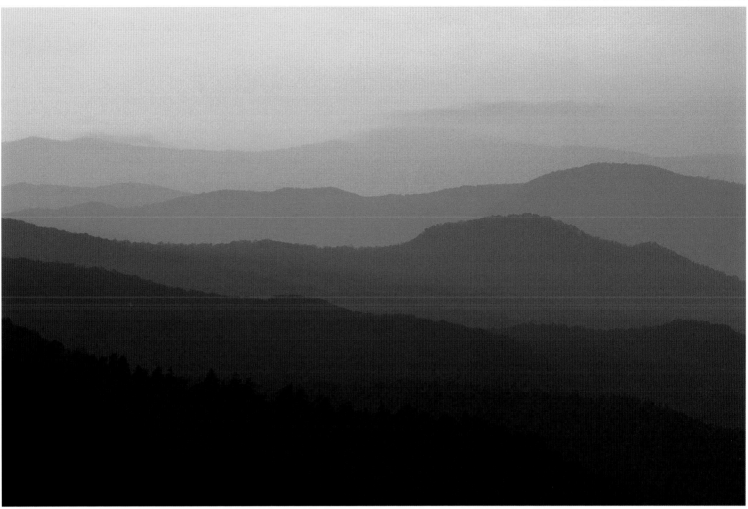

Meanwhile, standing atop the Newfound Gap along the crest of the Great Smoky Mountains National Park, I sat and watched as the sun continued to rise. The repeating patterns of the mountains and the range of colors only lasted a few minutes but were captured for a lifetime.

Rhythms of the Land

Just like in music, a repeated pattern is a rhythm. In the early morning, sunlight and atmospheric conditions combine to create a two-dimensional image based on the lowering intensity of the mountains at a distance.

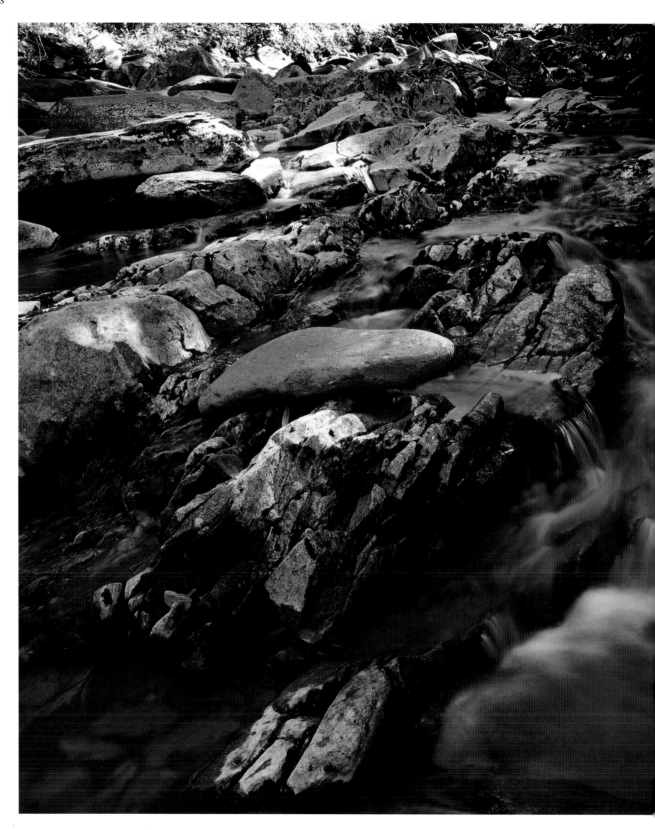

Across the Great Smoky
Mountains National Park
there are numerous quiet
streams and waterfalls.

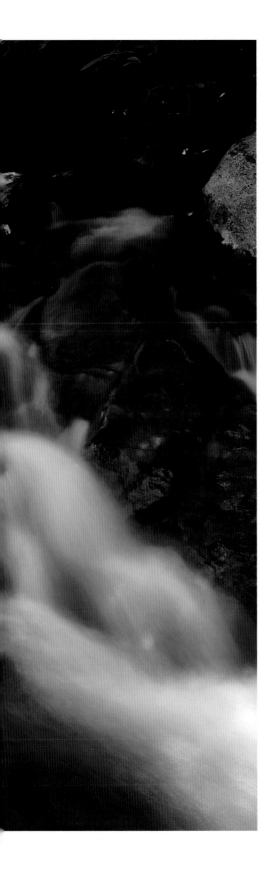

Mamiya RZ67 Pro II
camera with 65 mm f/4
lens

Quiet Streams

The dynamics of water, texture, lines and shapes come together when photographing quiet streams. Photographing from inside the stream, it is possible to accentuate the depth of field and motion pulling the viewer right into the water.

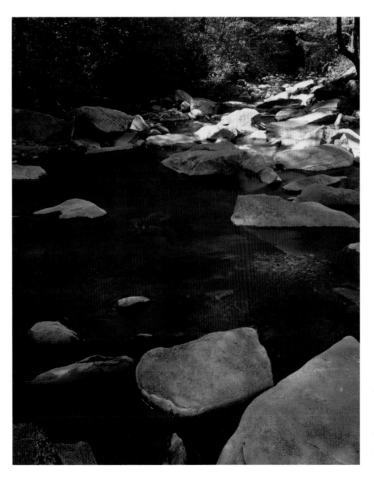

When the spring thaw and heavy rains subside, torrents of water give way to quiescent streams.

95

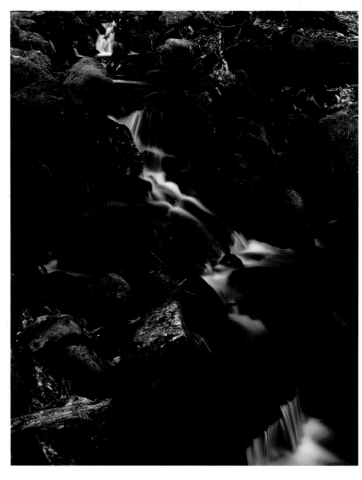

Nikon N90s camera
with 17-35 mm
f/2.8 Nikkor lens

Under the heavy cloak of the tree canopy and rugged mountains, secret
waterfalls abound in the park.

Across the Smoky and Blue Ridge Mountain ranges,
rhododendrons line the waterways and mountain
sides.

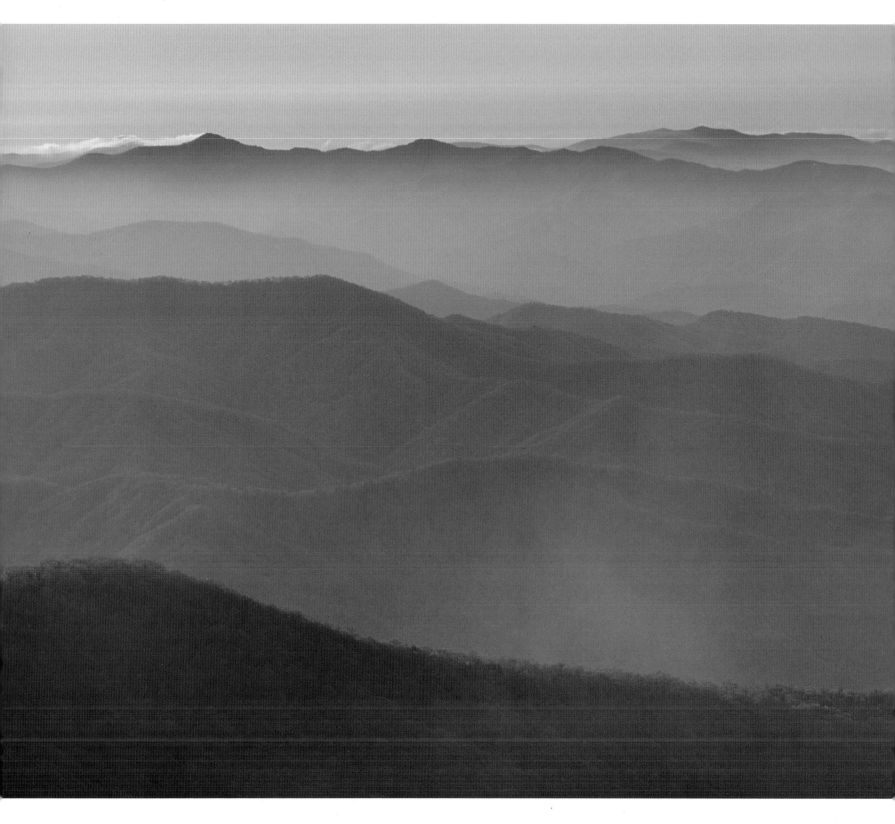

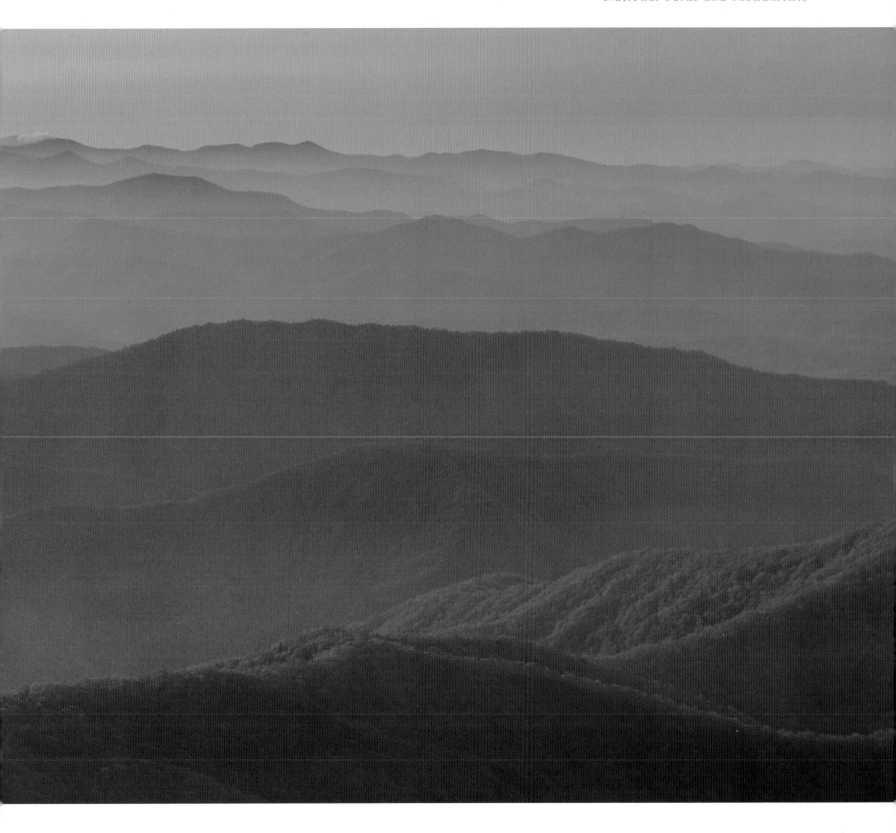

Great Smoky Mountains

Preceding Page: Miles of uninterrupted views from Clingmans Dome. At 6,643 feet, this is the highest location in the park.

A dramatic sunrise. Degraded air quality over the years has reduced the stunning views of the Blue Ridge Mountains. Air pollution combining with naturally occurring emissions from the forest produce a smoke-like haze blanketing the mountains. In recent years late summer views such as these are a thing of the past. With the shutter open for what seems like minutes, swift mountain breezes keep trees and plants in continual motion.

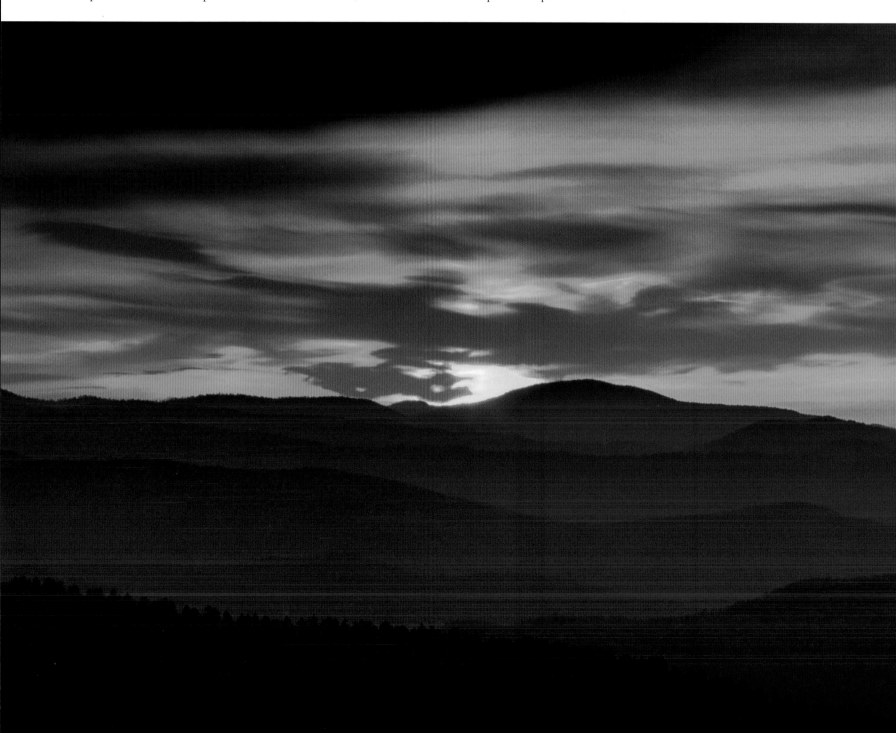

Where Mountains Meet Clouds

At higher altitudes the weather can change rapidly. In the Rockies in particular, it is not uncommon to see storms form right in front of you. These rapidly changing conditions offer a number of photographic opportunities as the environment can undergo significant changes in a matter of minutes.

Mamiya RZ67 Pro II camera with 140 mm f/4.5 lens

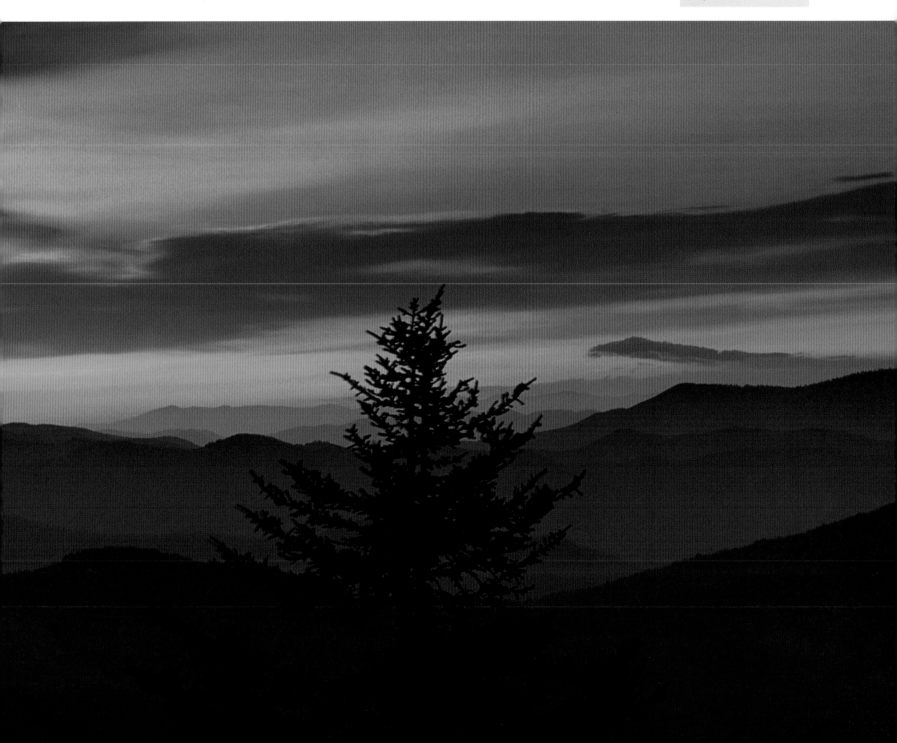

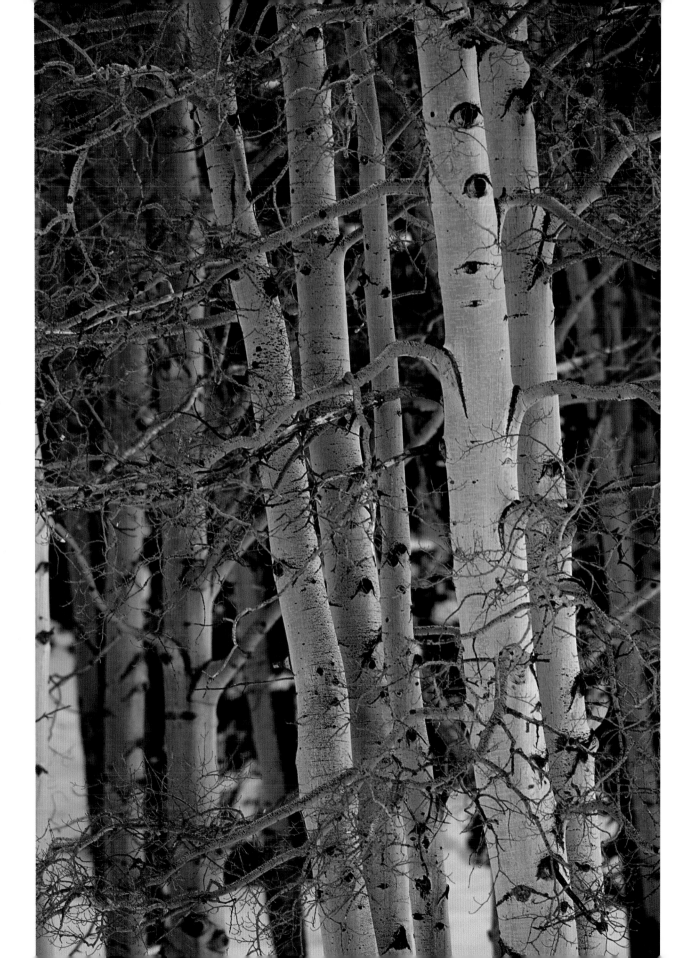

A trademark of the Rocky Mountain range, Aspens stand firm in the harsh mountain winter of Rocky Mountain National Park.

Nikon N90s camera
with 500mm f/4
Nikkor lens

Fog quickly rolls into the valley below. Off in the distance, the final rays of light bid a farewell to Long's Peak.

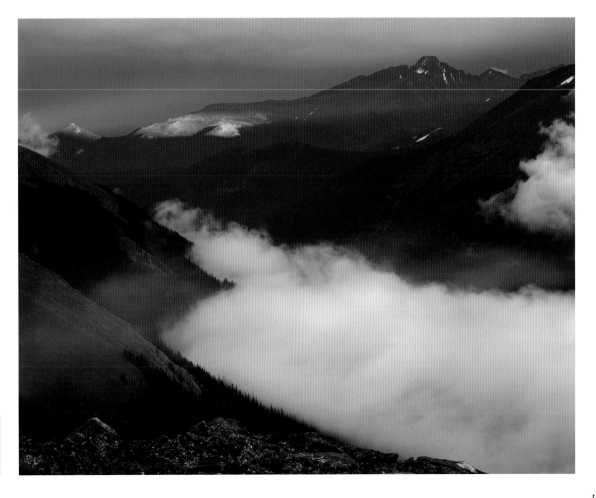

Mamiya RZ67 Pro II
camera with 140 mm
f/4.5 lens

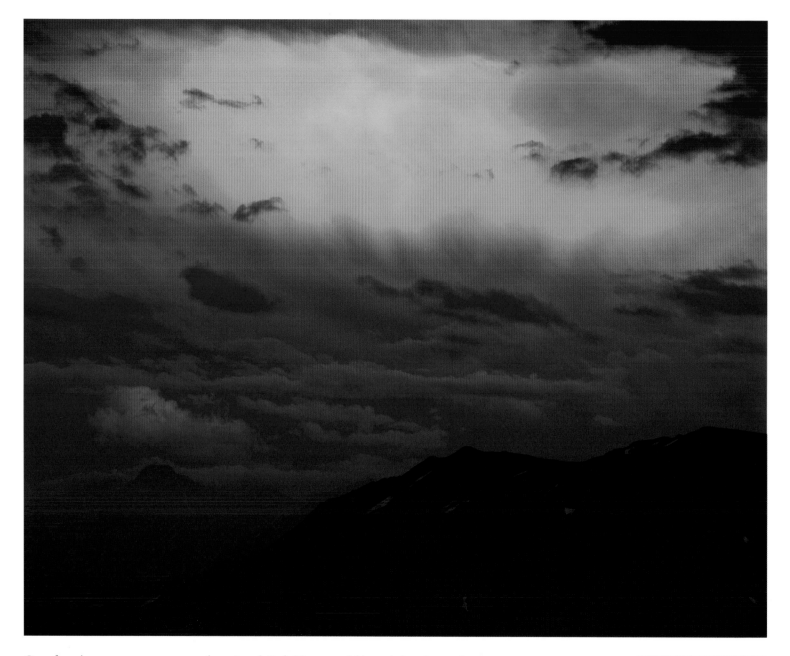

Out of nowhere, a summer storm envelopes Long's Peak. Time to quickly get below the tree line.

Mamiya RZ67 Pro II camera with 140 mm f/4.5 lens

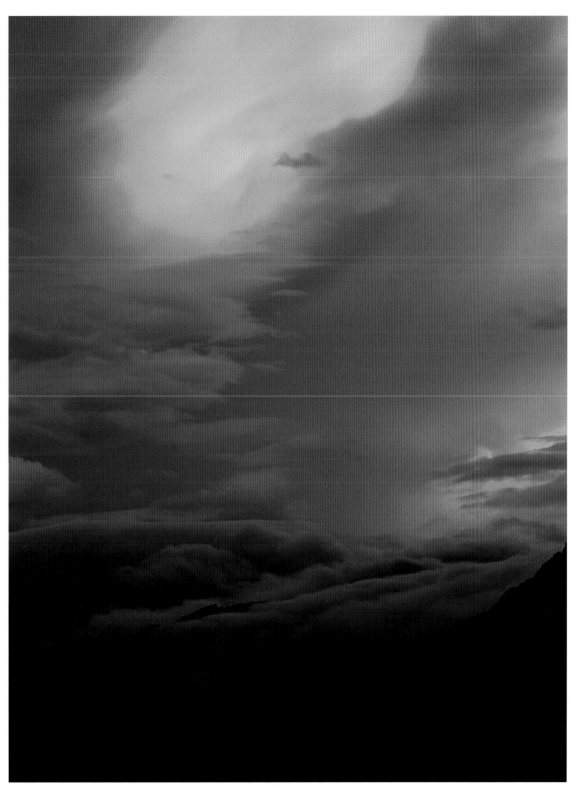

Mamiya RZ67 Pro II
camera with 140 mm
f/4.5 lens

Soon, strangely luminous clouds
conflict with a rapidly forming
storm.

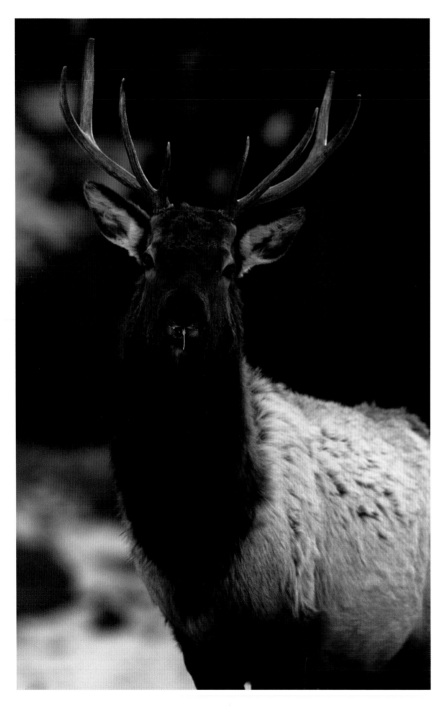

Nikon N90s camera
with 500mm f/4
Nikkor lens

Elk, numerous throughout the Rockies, winter at the lower elevations near the park entrance.

Connecting with the Land

Right: Visiting the park in mid-summer, I returned night after night to the Trail Ridge Road. Exploring just off the road each evening, I saw the greatness of our national parks and wilderness areas.

Mamiya RZ67 Pro II
camera with 140 mm
f/4.5 lens

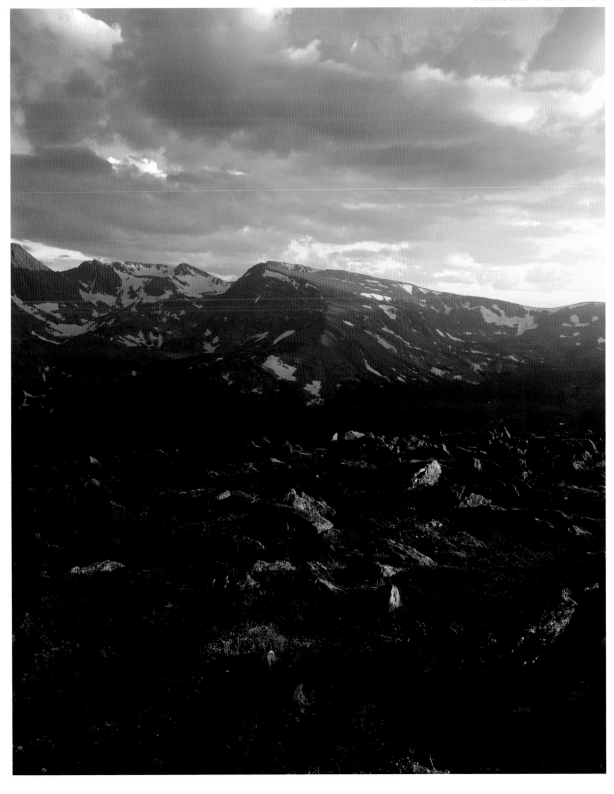

Sandstone bluffs and mesas overlook a vast lava field at the El Malpais National Monument in New Mexico. El Malpais means "The Badlands".

Perspective

Converging parallel lines create the effect of a three-dimensional object by adding depth. Here among the ancient rock formations of El Malpais, I used an extremely wide 17mm focal length to include many near and far elements. These sweeping perspectives pull the viewer into the image.

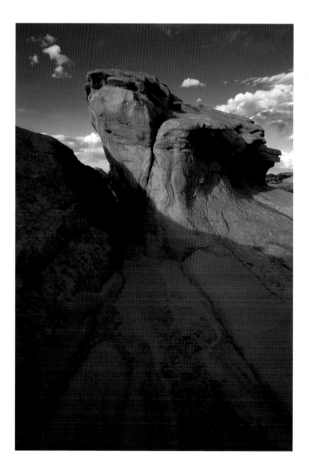

Nikon N90s camera with 17-35 mm f/2.8 Nikkor lens

Continuously reworked by the winds and water, the land is in constant change. Exploring with my camera, I quickly become lost in the magical landscape of the southwest.

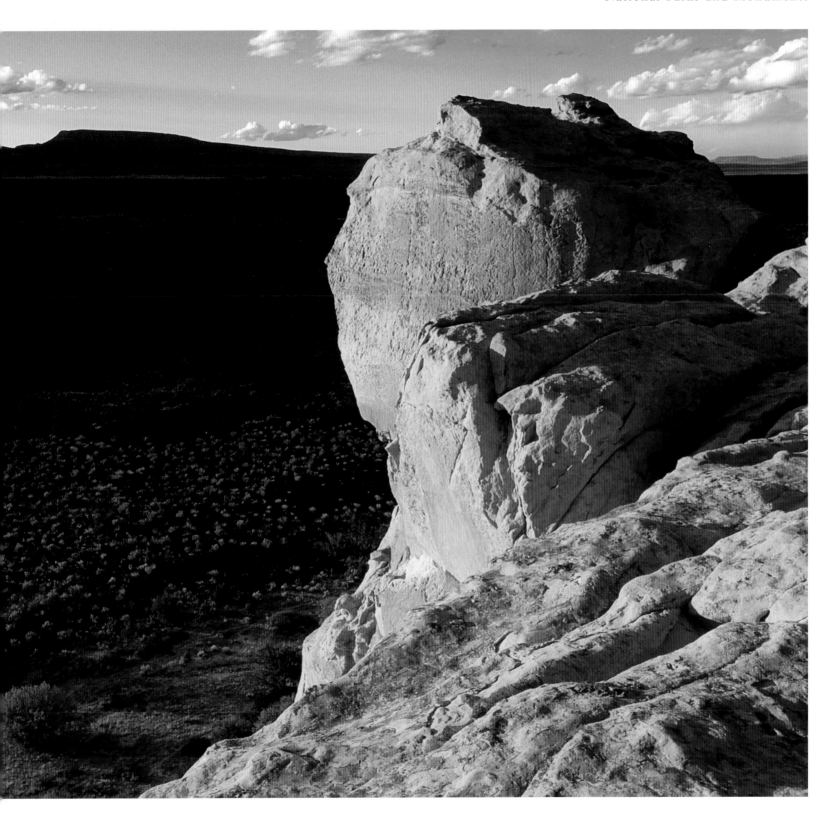

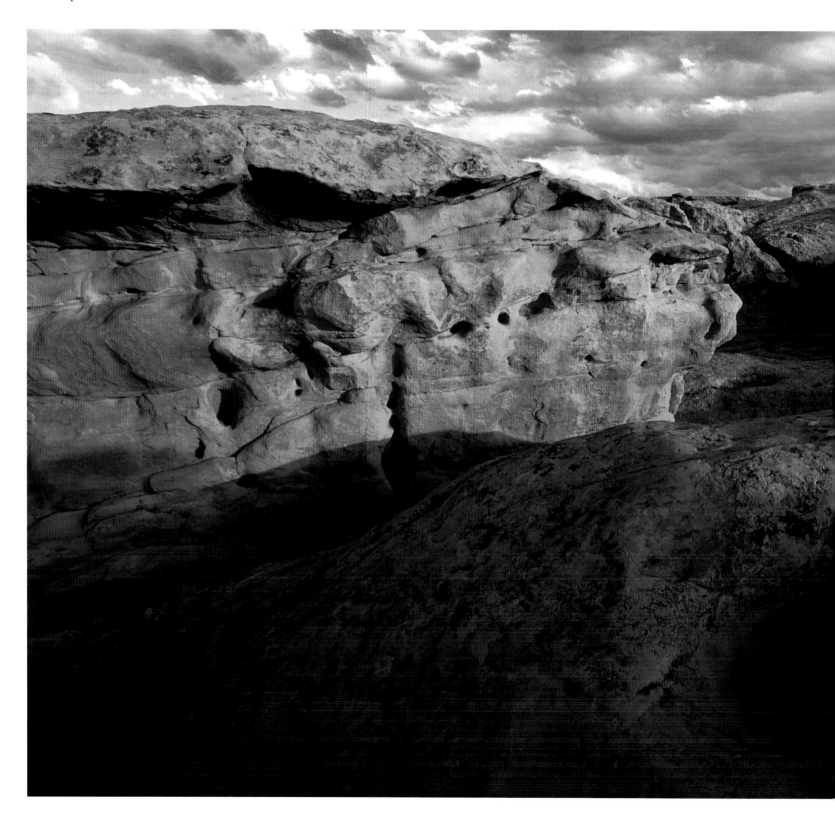

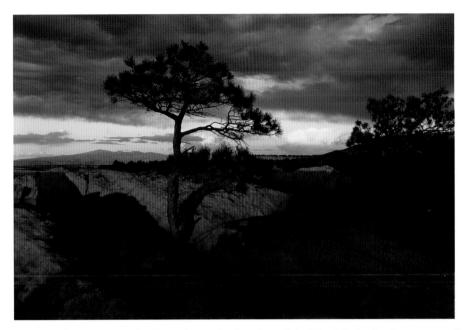

As a late afternoon storm builds to the north, the colors of the New Mexico landscape come alive.

Nikon N90s camera
with 17-35 mm
f/2.8 Nikkor lens

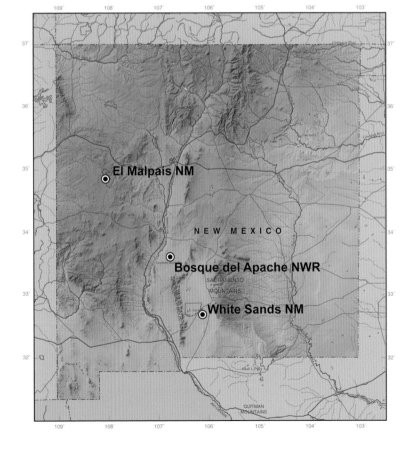

El Malpais is a rugged landscape that has been explored by mankind for more than 10,000 years. It hosts a number of significant geologic and cultural natural resources.

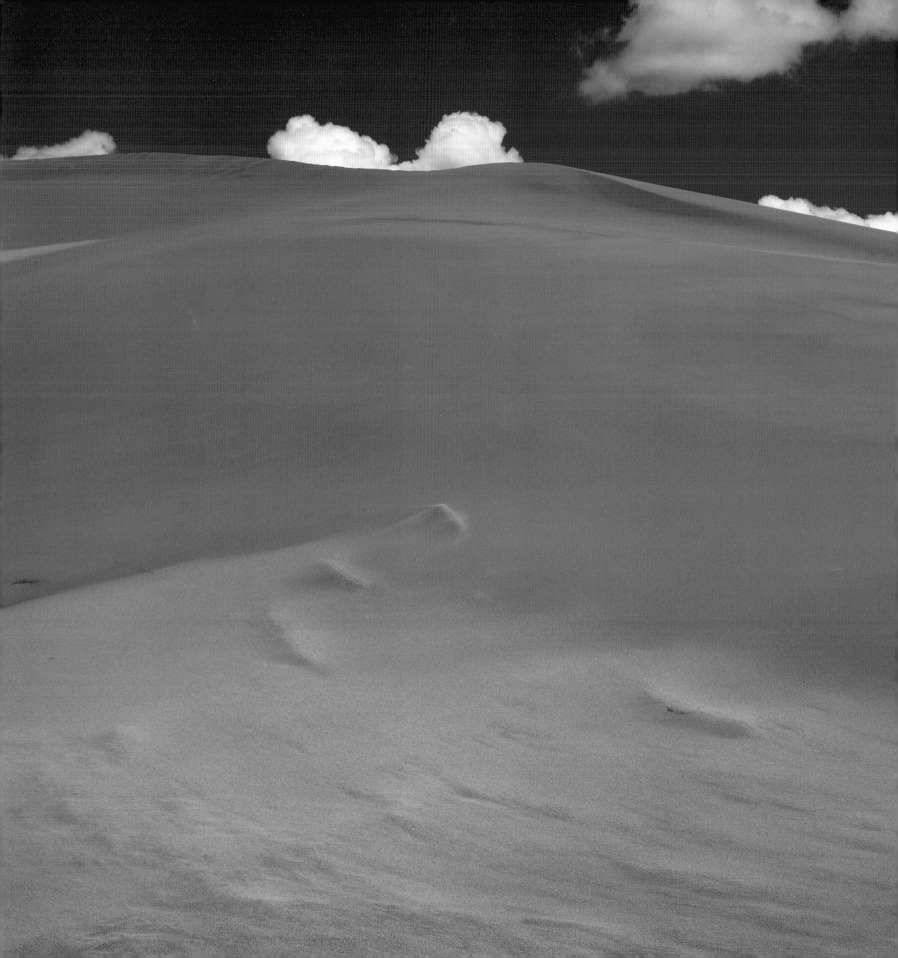

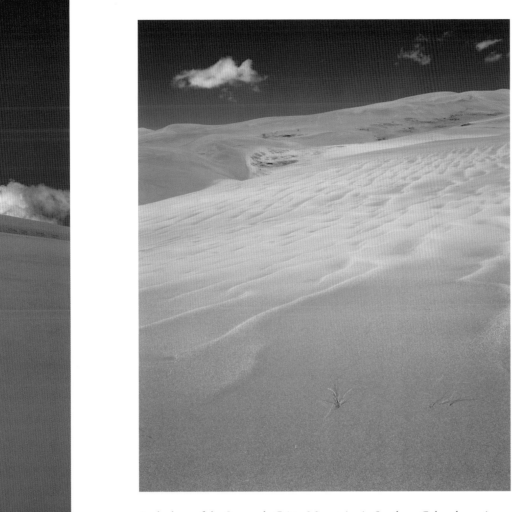

Mamiya RZ67 Pro II
camera with 65 mm f/4
lens

At the base of the Sangre de Cristo Mountains in Southern Colorado, grains
of sand continue to accumulate forming the largest sand dune in North
America known as the Great Sand Dunes National Monument.

Fluidity of the Land

Photographing sand dunes can be very difficult as it is easy to lose a sense of scale. Suddenly huge sand dunes can look very small. Logistically, it is necessary to plan your entry and exit carefully to avoid getting footprints in the image. Since I often use a manually focusing split image camera, finding an appropriate focal point further complicates the process. In terms of design elements however, the strong presence of lines, shapes and colors set up a huge number of possible combinations.

Vast, sweeping sand dunes stretch for miles in all directions. Easy to lose a sense of scale and perspective, hikers can quickly become
disoriented. As in the Rockies, a careful eye to quickly forming summer storms can be a lifesaver.

Living with Sand

Nothing can damage a camera or roll of film quicker than getting sand into sensitive mechanisms. The trick is to minimize exposure by changing film and lenses in protected areas and transporting your gear in a protective case. Using a photo backpack offers excellent protection allowing me to hike for hours in the most extreme conditions.

When it's time for the camera to come out or go back in, the chance of a catastrophic gust of wind dumping thousands of grains of sand into my bag goes way up. To minimize this, I'll look for an area shielded from the wind and limit contact of the bag with the sand surface.

Photographing in tough environmental conditions, such as blowing sand, forces me to concentrate more on visualizing the final image before picking up the camera.

For thousands of years, prevailing winds continue to carry sand from the west crossing the San Jaun Mountains and coming to rest in the San Luis Valley.

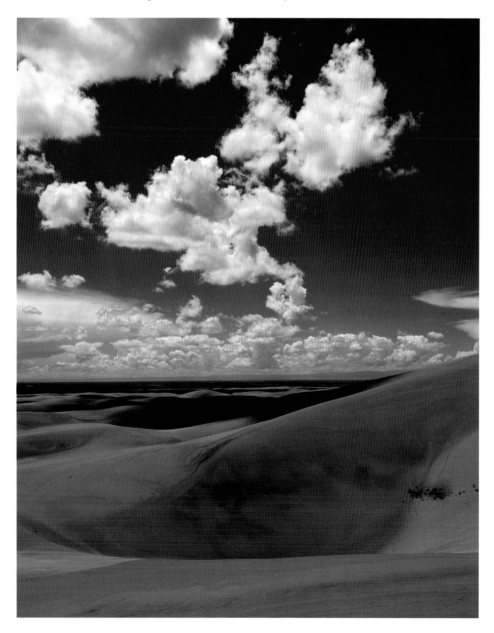

Mamiya RZ67 Pro II camera with 65 mm f/4 lens

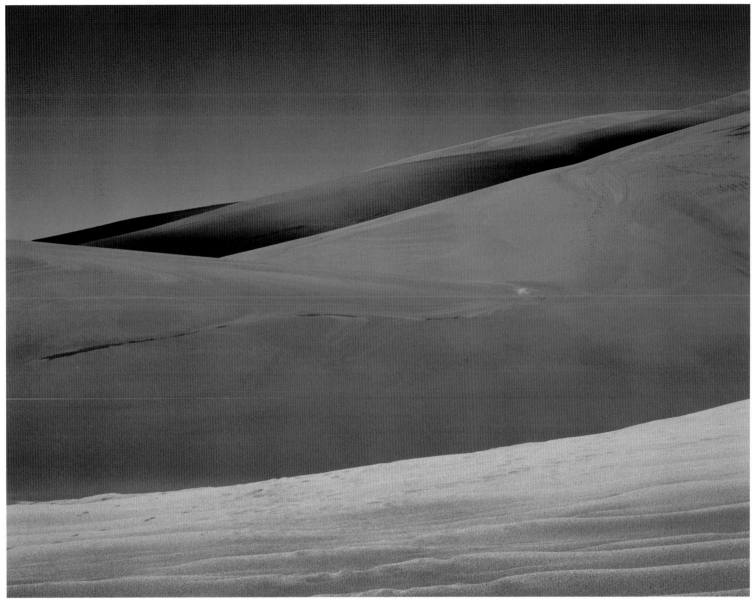

Photographing in the Great Sand Dunes National Monument can be a challenge as the loss of depth perception, heat, and physical exhaustion can take a toll. For those lucky to persevere, this can be a place of endless possibilities.

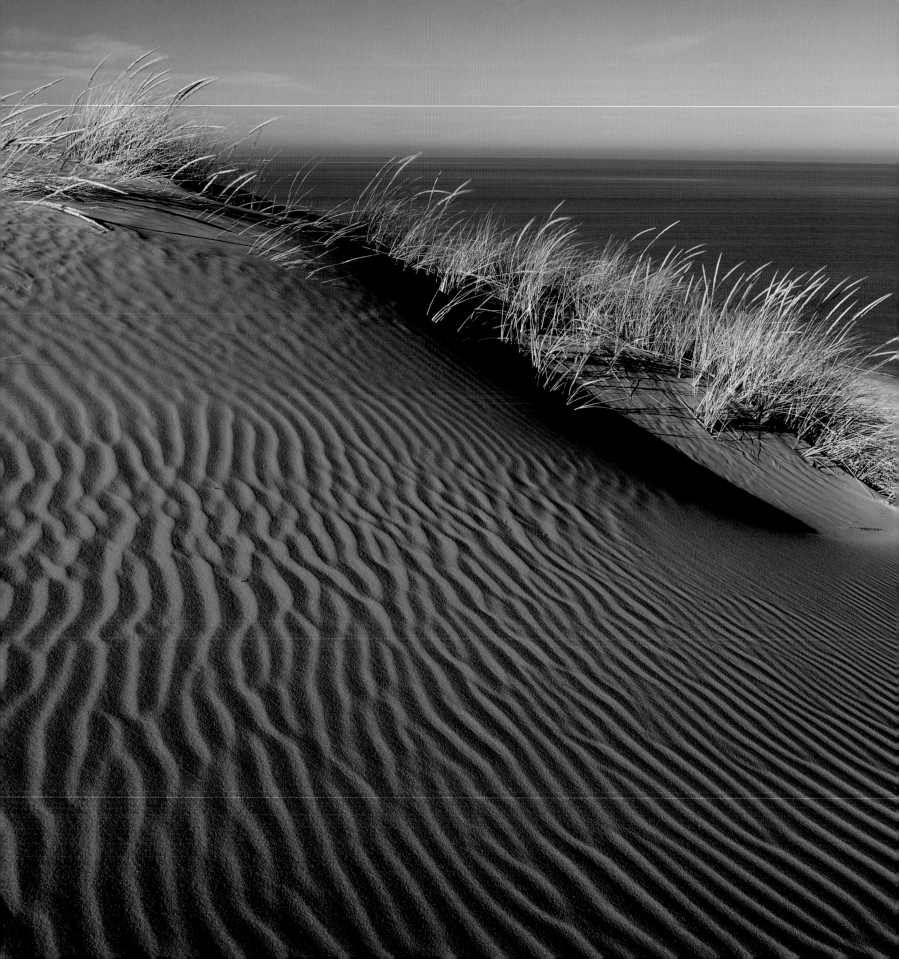

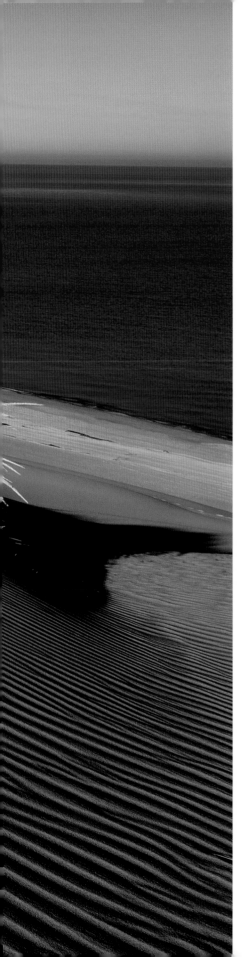

Growing up in northwest Indiana, I always dreamed of returning and capturing on film the sweeping dunes and constantly changing landscape. Here, bounded on all sides by heavy urban development, the Indiana Dunes National Lakeshore stands as the last vestige of untouched land meeting the shores of Lake Michigan.

The largest dune in Indiana, Mount Baldy rises 126 feet above Lake Michigan. Each year the dune advances four feet inland driven by the strong winds off the lake. Soon the dune will encroach upon the surrounding urban developments.

Nikon N90s camera with 17-35 mm f/2.8 Nikkor lens

Mamiya RZ67 Pro II camera with 65 mm f/4 lens

Nikon N90s camera
with 17-35 mm
f/2.8 Nikkor lens

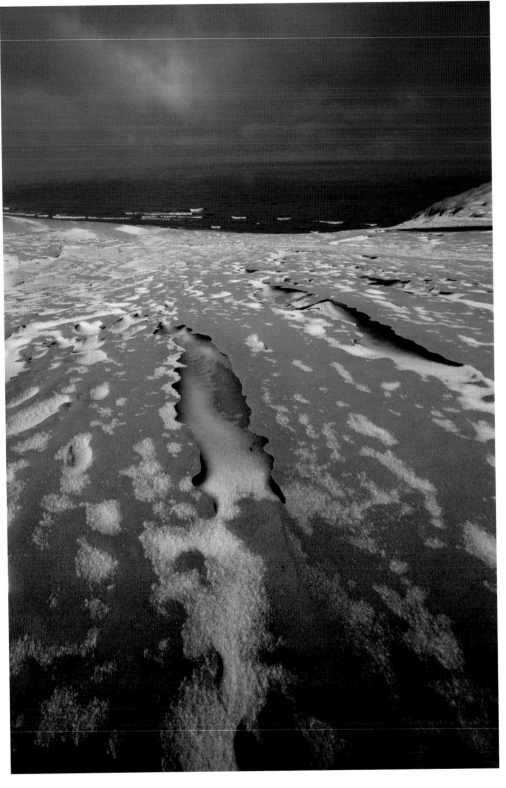

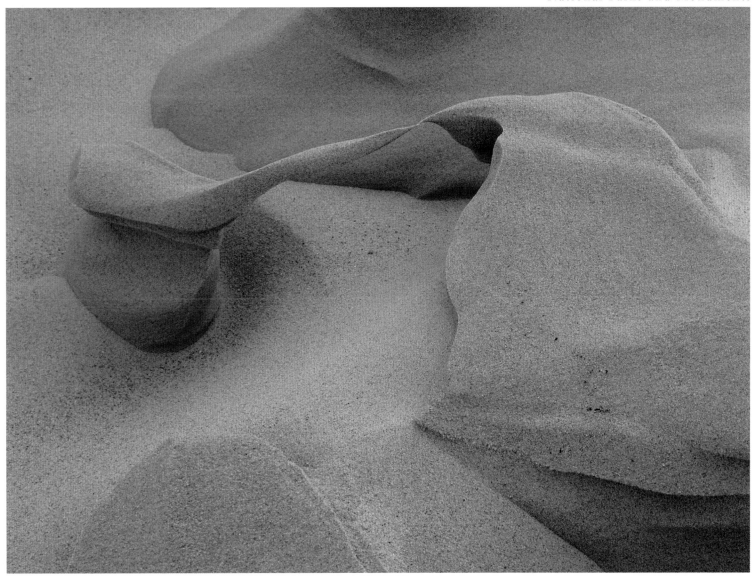

A fragile world. Tucked into small outcroppings at the top of Mount Baldy, extremely delicate sand structures form in the winter. Throughout the day water freezes and thaws while the sand is continuously shaped by the wind. So delicate, even the slightest touch would destroy this carving formed by the wind.

Mamiya RZ67 Pro II camera with 65 mm f/4 lens

Delicate Structures

Left: Winter weather along the shores of Lake Michigan and Mt. Baldy can be severe. Snow, freezing temperatures, and strong winds form extremely fragile sand structures. With bitter temperatures, blowing sand, and wind chill, keeping a camera operational becomes a grand challenge.

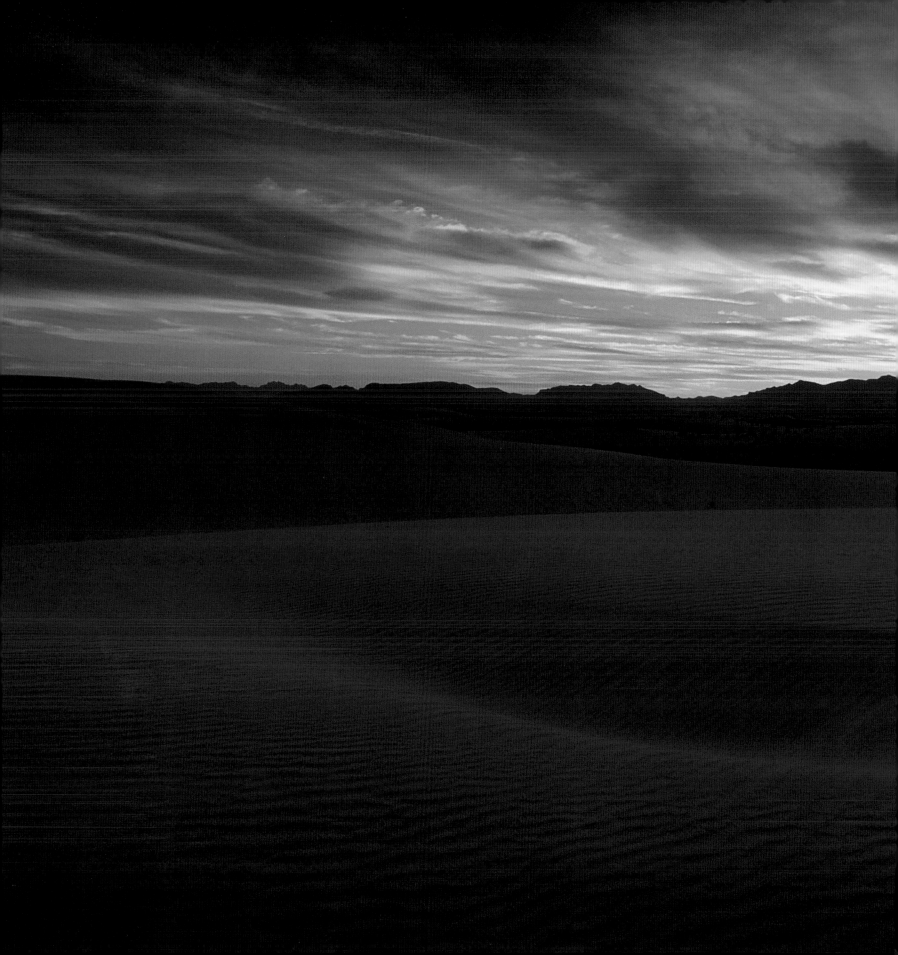

Grand Landscapes

There are few places I have photographed that have as wide a range of compositional elements, color, and sheer vastness than White Sands National Monument. During the day, the sweeping sand dunes flow across the landscape for miles. In the evening, the sky explodes with color.

To photograph these special landscapes, I routinely reach for a wide angle zoom such as the 17-35mm f/2.8. This incredible lens, particularly at 17mm allows the vastness and color to be captured on film. Lightweight, I can hike for miles with plenty of water, a little food, cell phone, a GPS, and still stay energized for sunset at the end of day.

Nikon N90s camera
with 17-35 mm
f/2.8 Nikkor lens

On July 16th, 1945, just sixty miles north of White Sands National Monument, the landscape was forever changed with the detonation of the world's first plutonium bomb at the Trinity test site. Today, a colorful New Mexico sun sets peacefully on the White Sands National Monument.

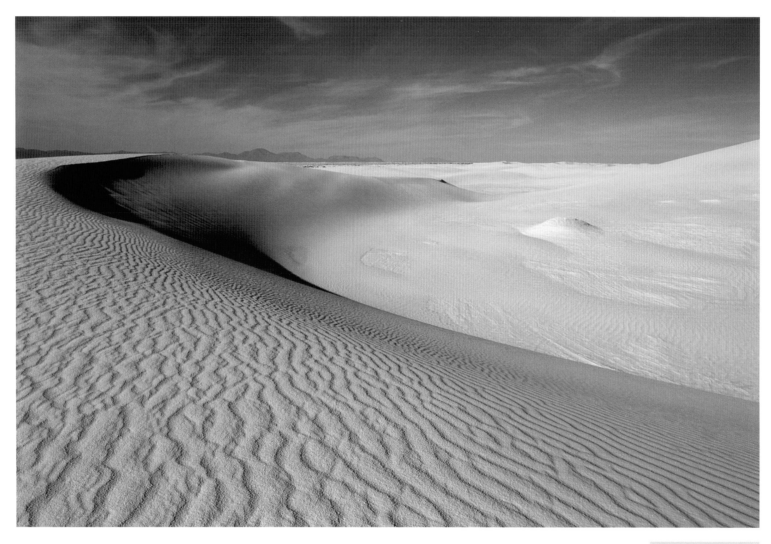

The sweeping gypsum barchan dunes of White Sands National Monument started their formation 250 million years ago as depositions in a shallow sea once covering this area. Some 70 million years ago, the same time the Rockies were being uplifted, these marine deposits also underwent uplifting, forming a giant dome. Sixty million years later this dome started to collapse into what is known today as the Tularosa Basin located between the San Andres and Sacramento mountain ranges. It is here that the White Sands National Monument shimmers under the clear skies of the southwest.

Nikon N90s camera with 17-35 mm f/2.8 Nikkor lens

Hiking through the barchan dune fields in the Alkali Flats, remnants of vegetation remain for years. Once the site of a Skunkbush Sumac, the vegetation has long since passed leaving a pedestal, reminiscent of an ancient sphinx, that is continually reworked by the elements.

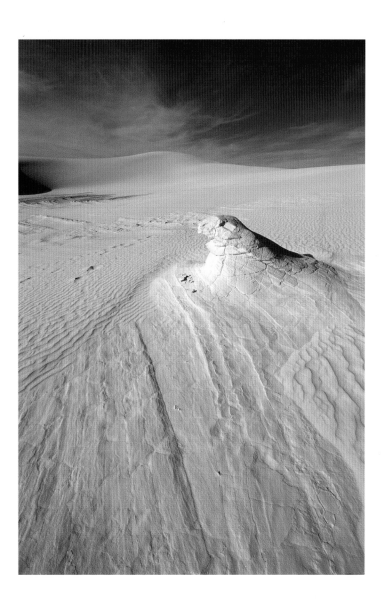

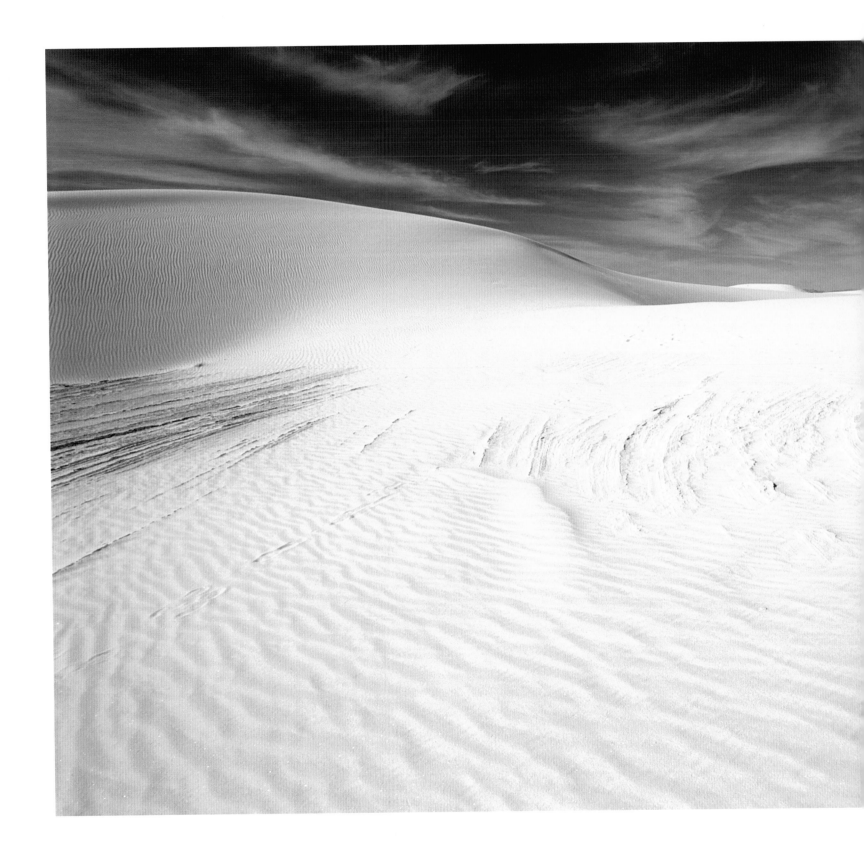

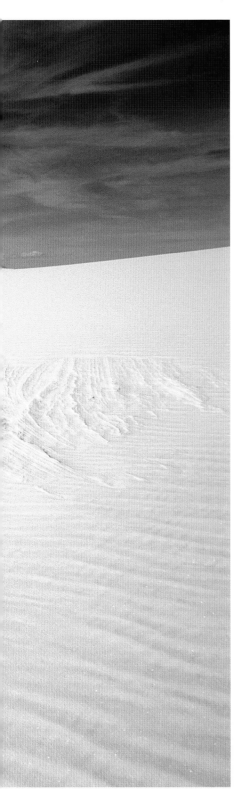

Hiking the dunes on a calm day, vast open areas continue on for miles and miles. Wildlife, people, nor anything of human origin can be seen. The only sound that can be heard is the beat of your heart.

Lost in a Sea of Sand

As sand supplies increase, barchan dunes join together forming larger dune structures known as transverse dunes.

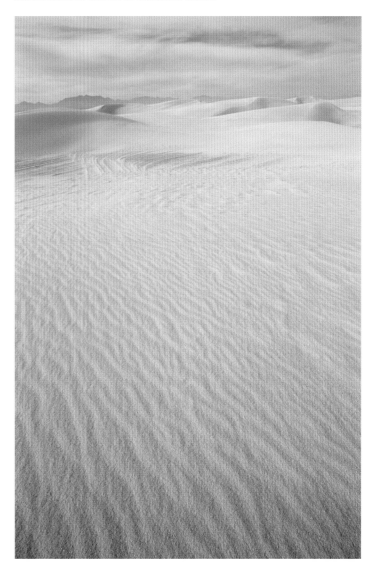

Nikon N90s camera with 17-35 mm f/2.8 Nikkor lens

Remnants of an ancient sea.

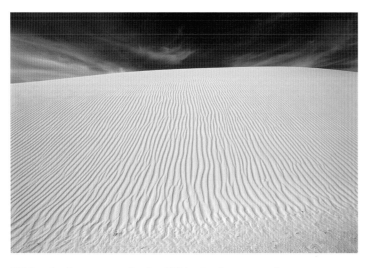

Hiking the dunes on a calm day, White Sands seems endless.

Nikon N90s camera
with 17-35 mm
f/2.8 Nikkor lens

Footprints in the gypsum can remain for some time due to the compaction properties of the sand. Unfortunately, this can disturb the natural appearance of the dunes.

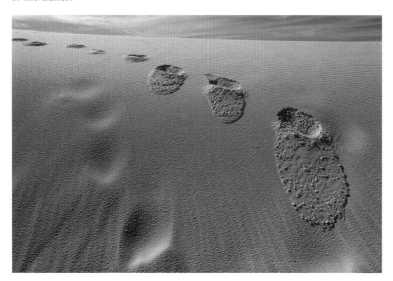

White Sands

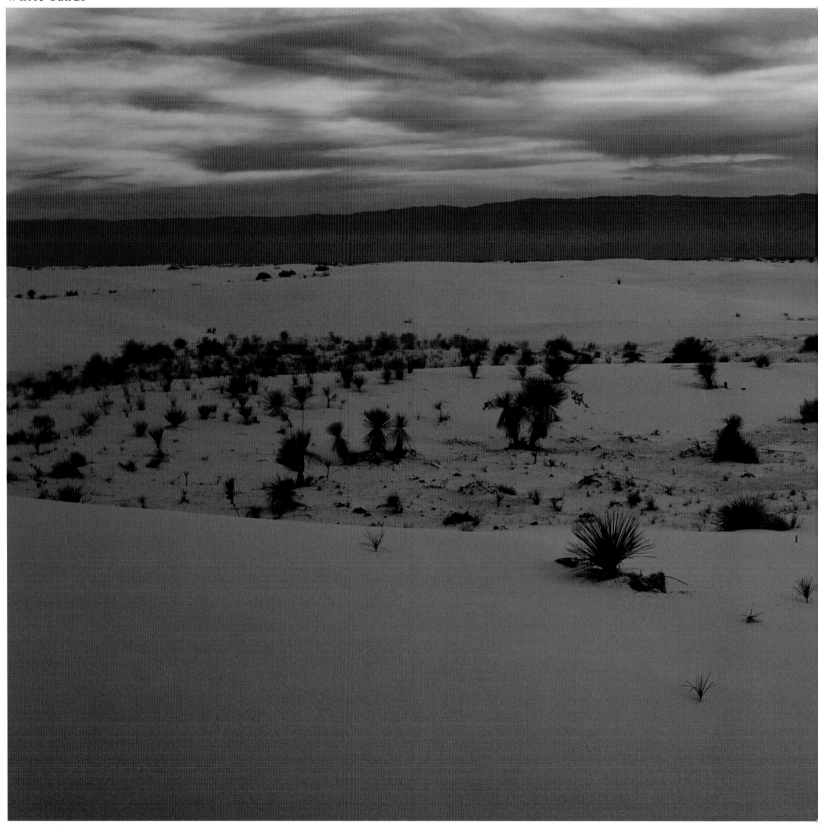

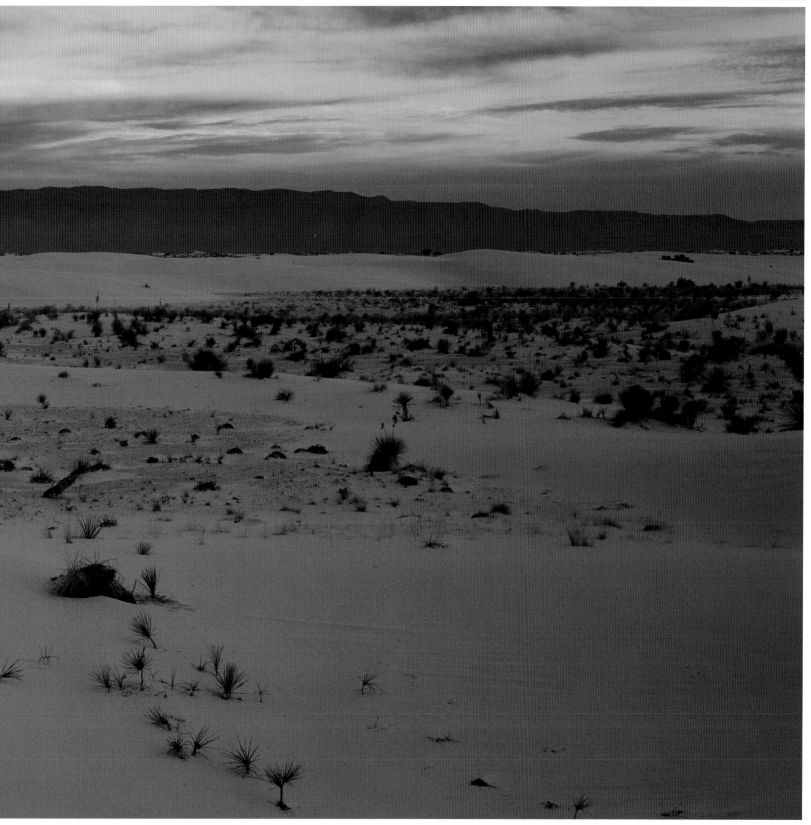

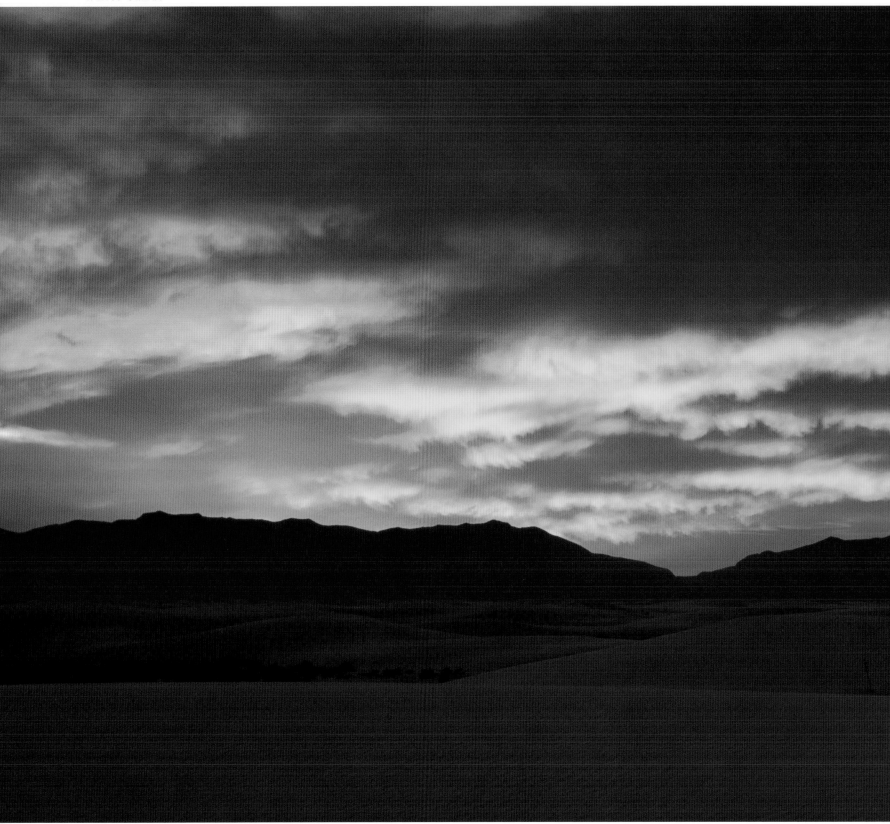

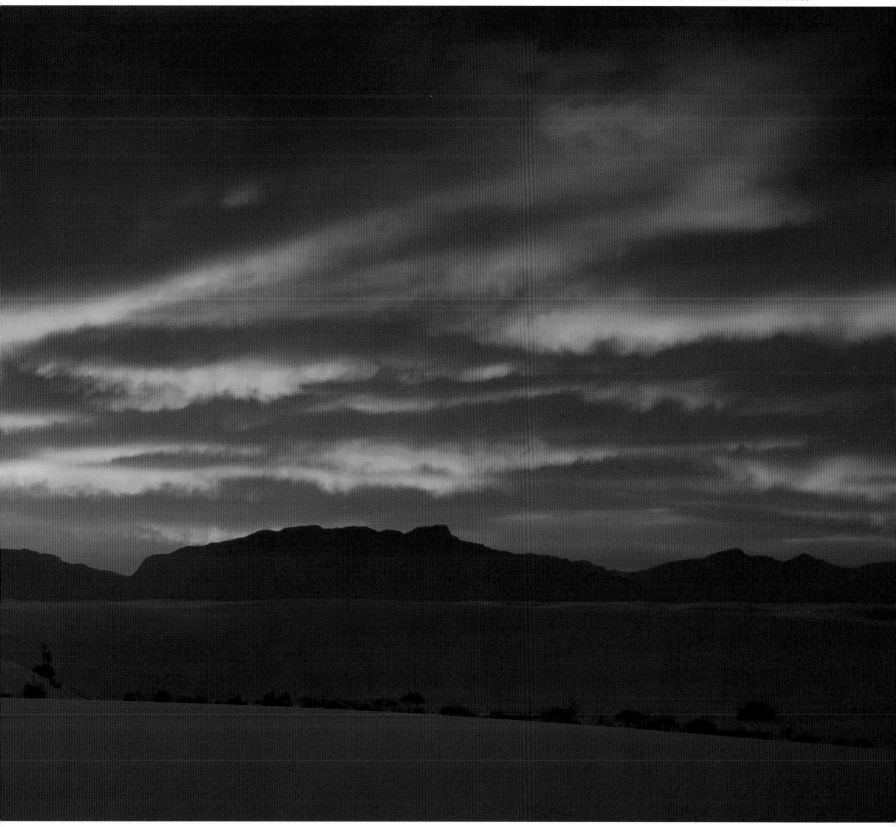

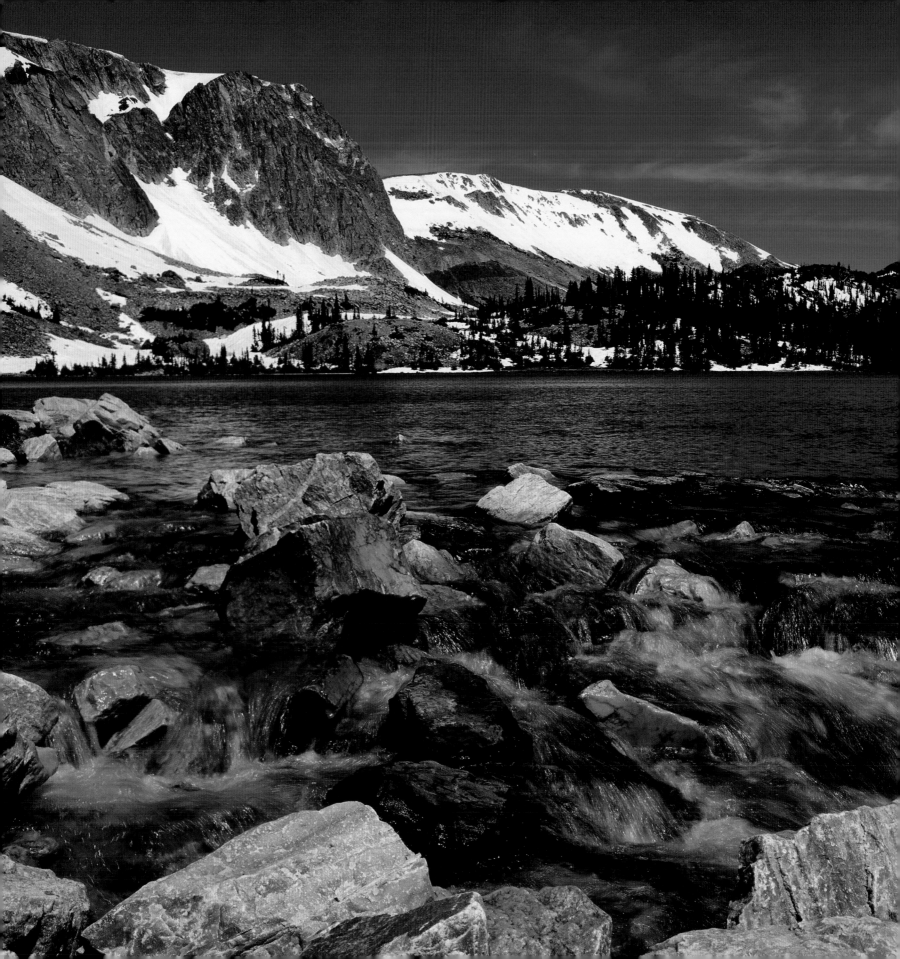

Mamiya RZ67 Pro II
camera with 140 mm
f/4.5 lens

Alpine Country

At an altitude above 5000 feet, I never know what to expect. I've been pelted with hail, freezing rain, and snow. At the same time, I have seen and photographed some amazing landscapes and wildlife.

Although it is important to know the environment and seasonal conditions, here it is more important to be prepared for just about anything. Years ago I was so taken by the photographing in the Rocky Mountain National Park, I wandered off the trail and was lost. Not prepared with food or water, and ten miles of alpine hiking behind me could have been a recipe for disaster.

I survived, first by remaining calm, getting hydrated with the alpine snow, and waiting until I saw others on the trail hundreds of meters away. Today, I always hike with a GPS, cell phone, plenty of water, and lots of film!

Rich in natural resources and American history, the Medicine Bow National Forest was first protected in 1902. Rising out of Laramie, Wyoming the Snowy Range Scenic Byway traverses 29 miles of spectacular mountain views. At the top of the byway, Lake Marie has thawed briefly for the summer.

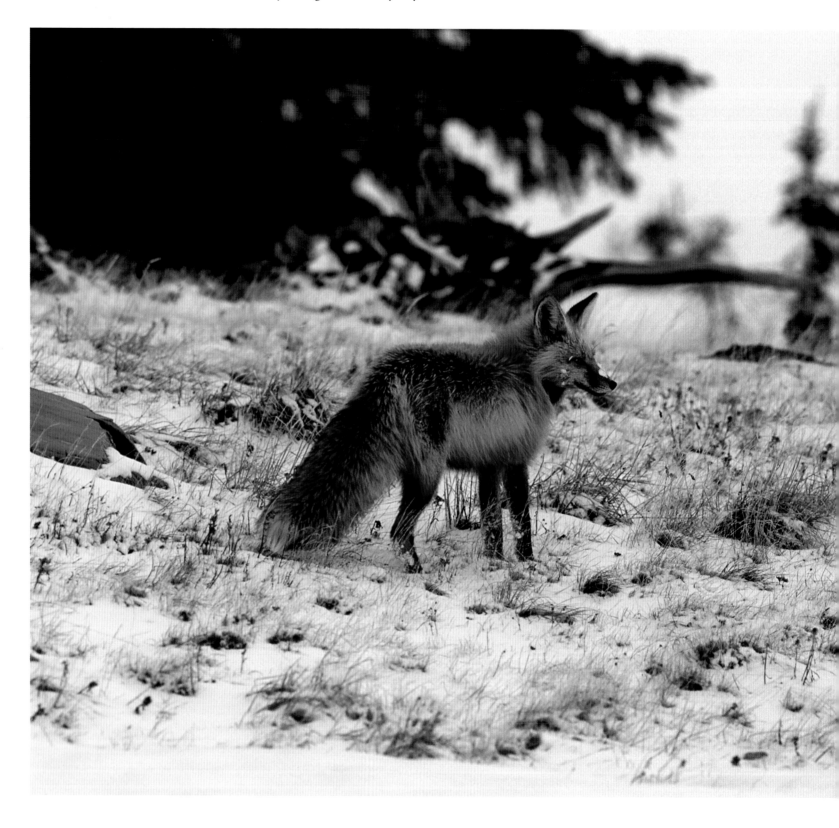

Nikon N90s camera with 500mm f/4 Nikkor lens

In the harsh winters of the Snowy Range, a Red Fox searches for food. Standing in a near white-out, by chance a late spring snow storm subsides as this fox crossed my path. Photography is often about being at the right place at the right time and having the ability to respond quickly.

As spring arrives, the risk of avalanches increases significantly. Perched high atop the Snowy Range, a precarious snow shelf has formed.

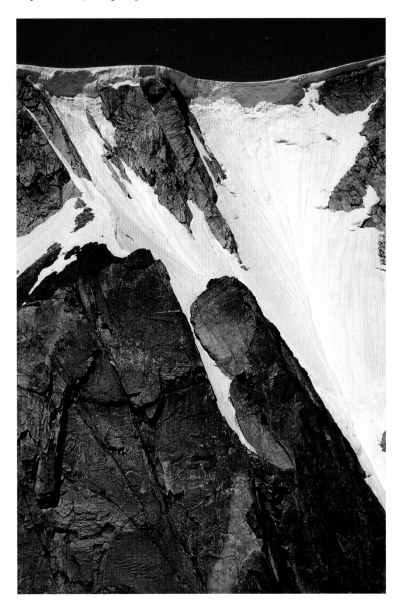

National Treasures

A certain level of responsibility comes when photographing in our national parks. On any given day there can be hundreds of photographers, both amateurs and professionals, thousands of visitors, and lots of traffic.

It's very easy to quickly become frustrated or be part of the problem. Just seeing a huge 500mm lens or tripod can quickly back up traffic causing the proverbial "bear jam".

I usually shoot in the early morning or evening when the light is soft and the crowds are limited. If I see a moose, elk, or other wildlife, I'll quickly take my photographs and keep moving. If I stop, I'll find a trail and will move out of view of the road so as to not attract more attention. As photographers, we have a responsibility to not become the problem, rather capture the incredible views and rhythms of our national treasures.

Mamiya 7 camera
with 80mm f/4
lens

On a cool spring morning, the Grand Teton National Park is bathed in majestic color.

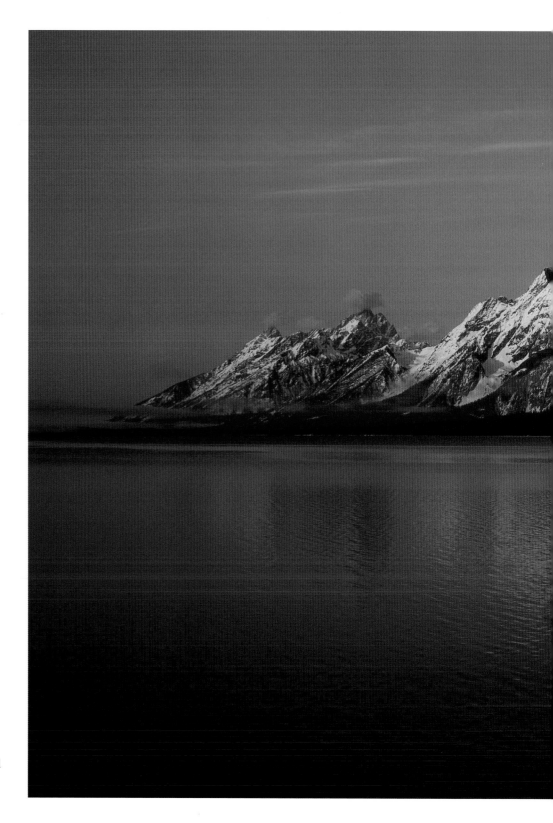

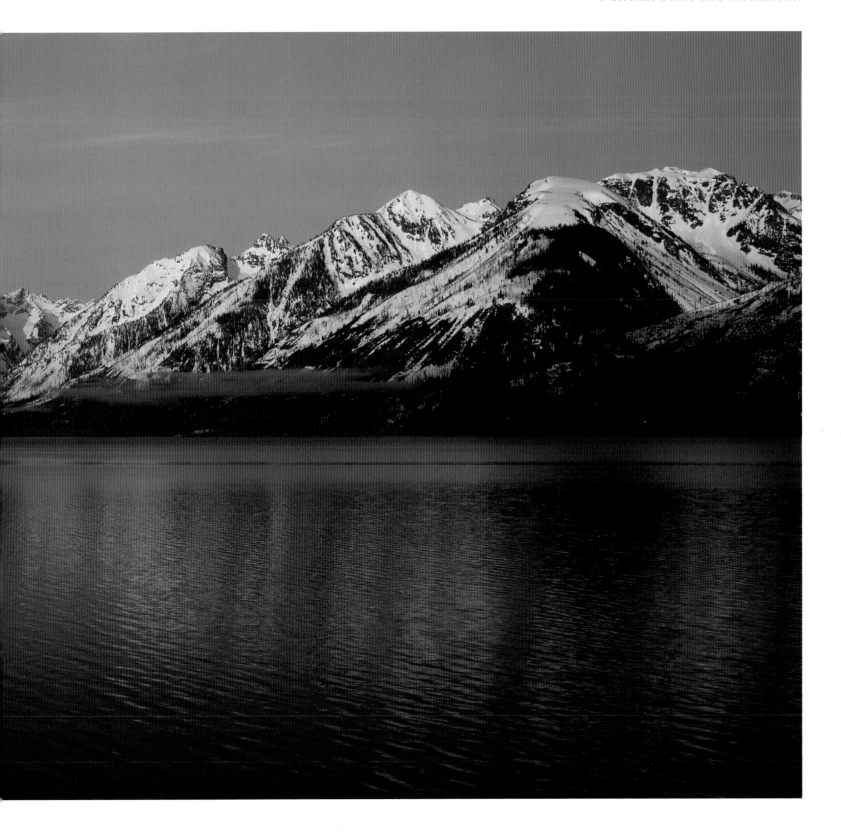

Nikon N90s camera
with 500mm f/4
Nikkor lens

In and around the Lake Jackson Lodge, moose are as frequent as the park visitors.

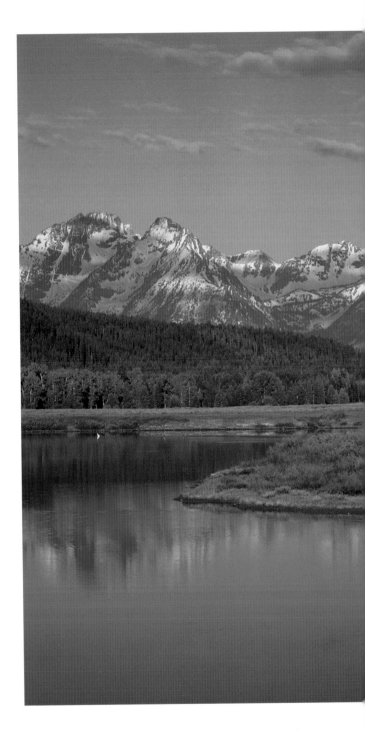

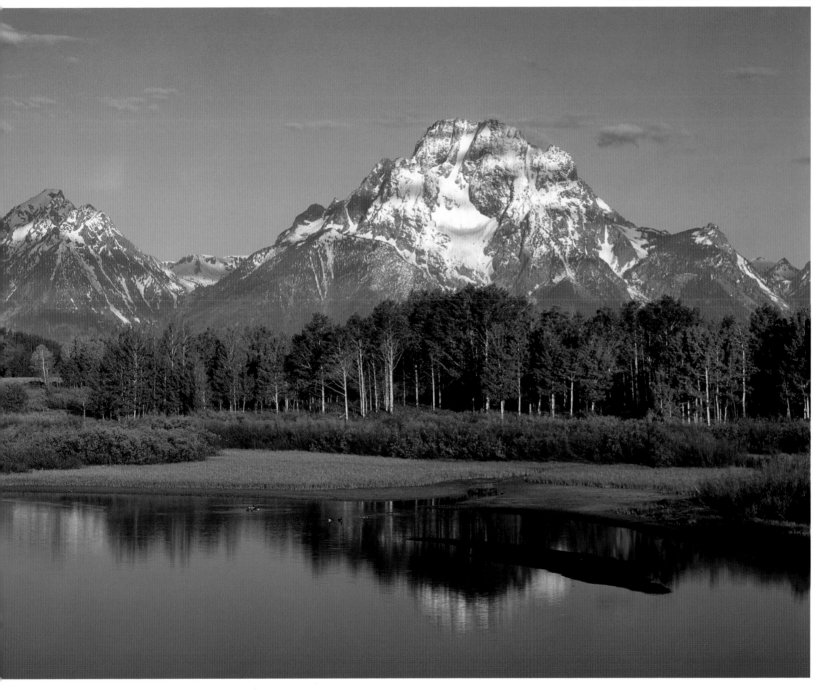

The magnificent Teton range and Mount Moran jet
above Oxbow Bend, a popular photographic site.

Mamiya RZ67 Pro II
camera with 140 mm
f/4.5 lens

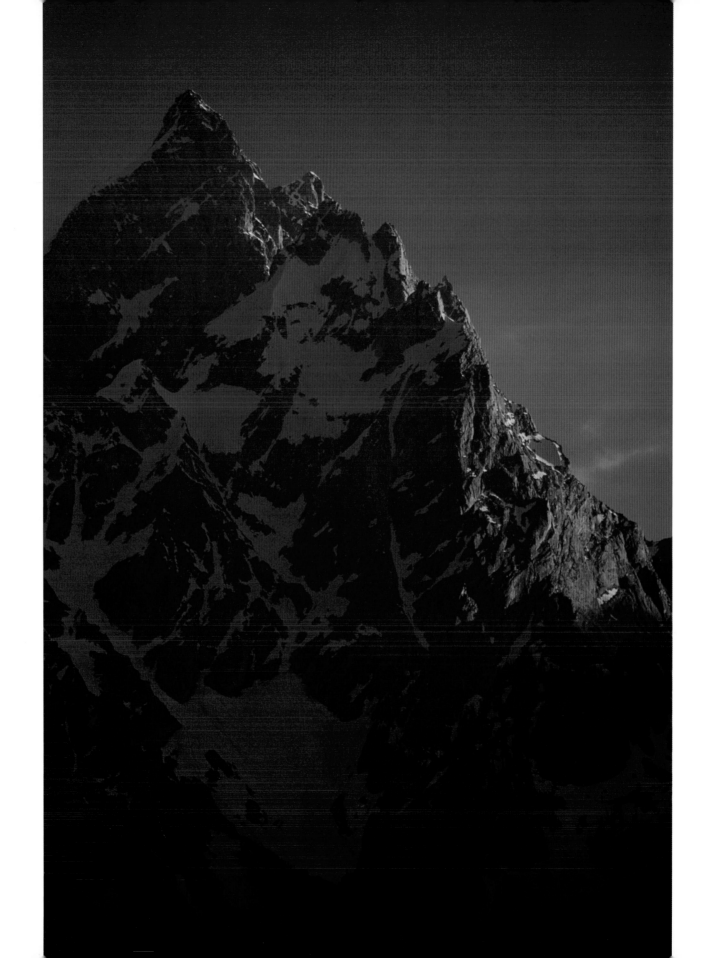

Nikon N90s camera
with 500mm f/4
Nikkor lens

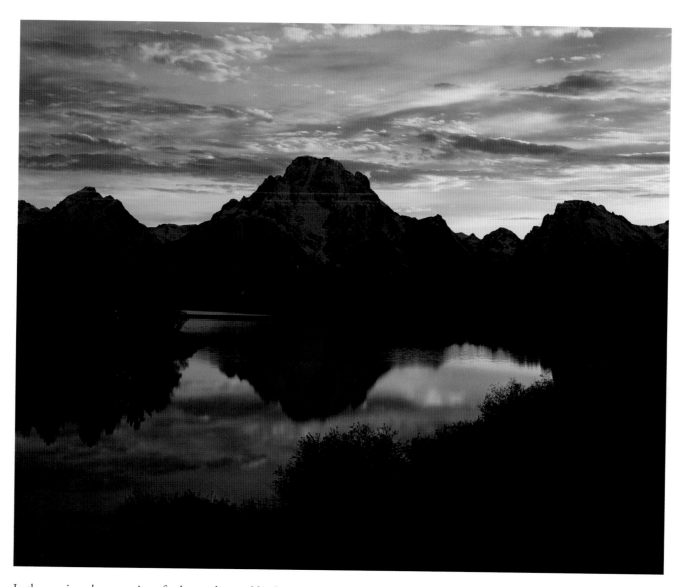

In the evening, the saturation of colors and rugged landscape provide for overwhelming views of the Grand Teton National Park.

Mamiya RZ67 Pro II
camera with 140 mm
f/4.5 lens

Left: Off in the distance, the final rays of light streak across the rugged mountain tops.

In and around the Lake Jackson Lodge, the magnificent Teton range is in constant view.

Nikon N90s camera
with 500mm f/4
Nikkor lens

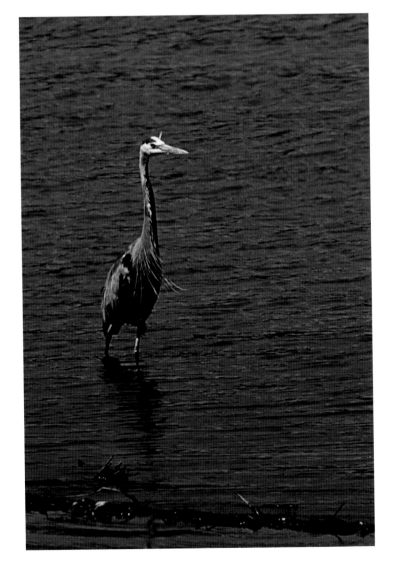

Wildlife in the Park

Great Blue Herons, moose, elk, and bears all thrive in the vast bio-diversity of the Teton-Yellowstone eco-system.

Back at the lodge, the guests and moose have found a cool, comfortable resting spot.

A national symbol, the Teton range exemplifies the vast, open ruggedness of the American West.

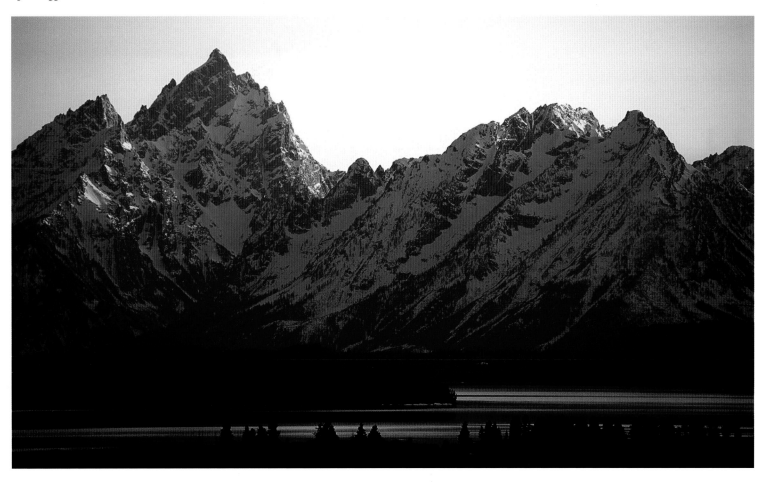

Sweeping Views

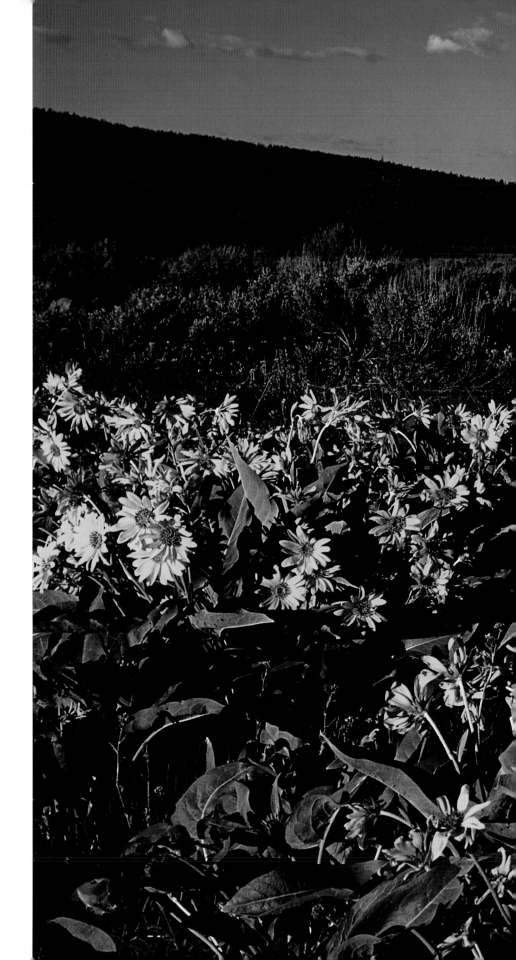

Nikon N90s camera
with 17-35 mm
f/2.8 Nikkor lens

Arrow-leaf Balsam Root explodes across the Teton landscape.

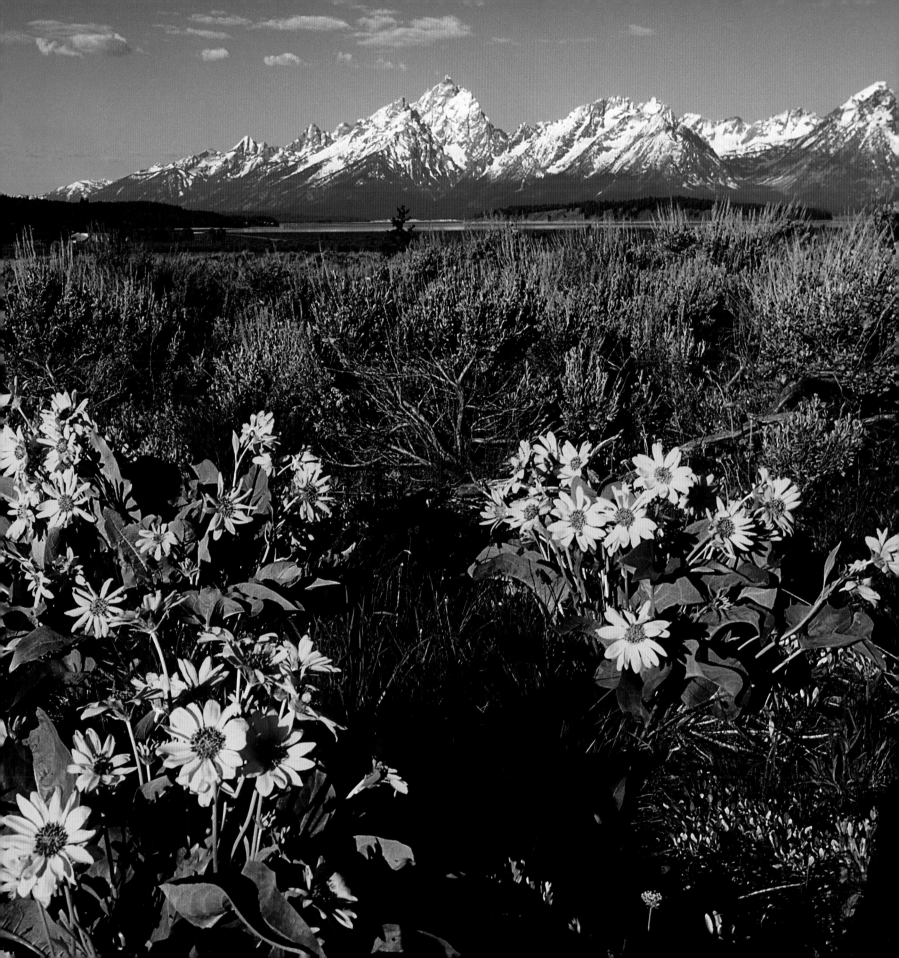

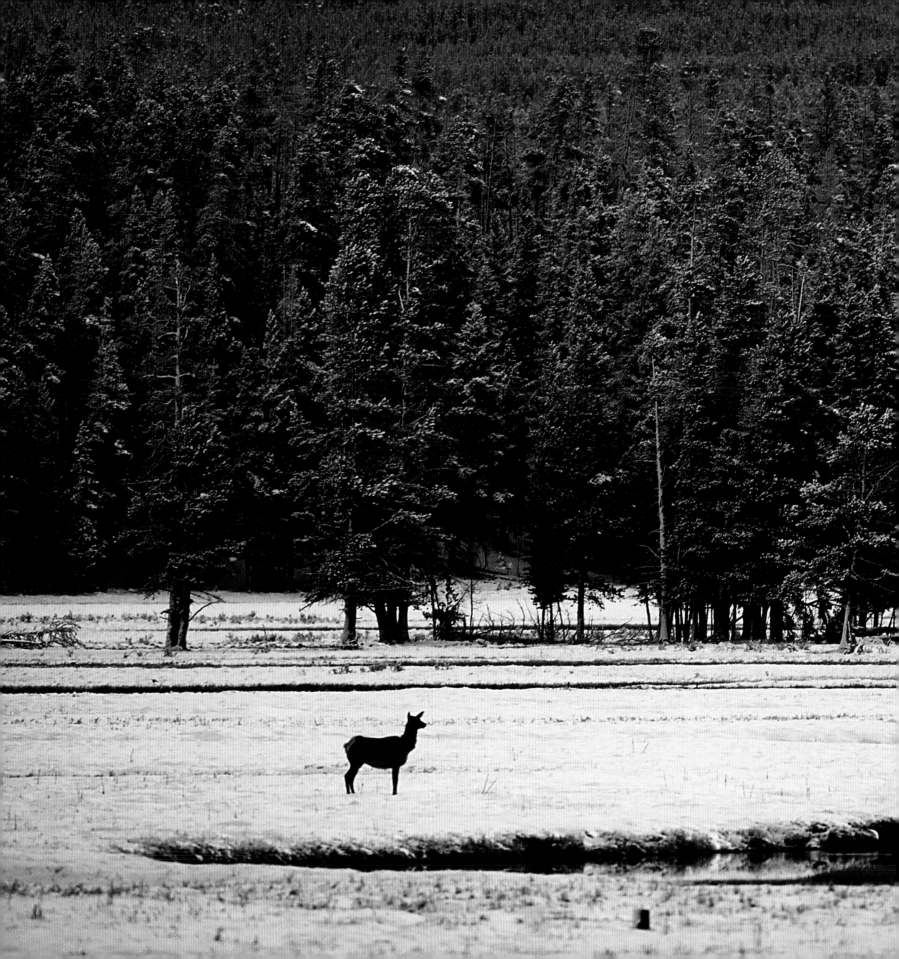

Nikon N90s camera
with 500mm f/4
Nikkor lens

Weather is No Barrier

It can snow anytime of the year in Yellowstone. In the early morning, this can reduce the available light to unacceptable levels. Switching to Fujichrome Provia 400F, or push processing, can increase shooting speeds by several stops while sacrificing image quality with higher film grain. Making that trade, I often will choose a fast, wide angle lens and stick with a slower, finer grained film such as Provia 100F or Velvia 100F.

With heavy, wet snow falling, I also will use a protective cover for the 500mm lens and camera, shielding the housing from collecting snow or rain. On the trail or shooting from the car, shooting in winter weather is no barrier.

A late spring snowstorm blankets Yellowstone National Park.

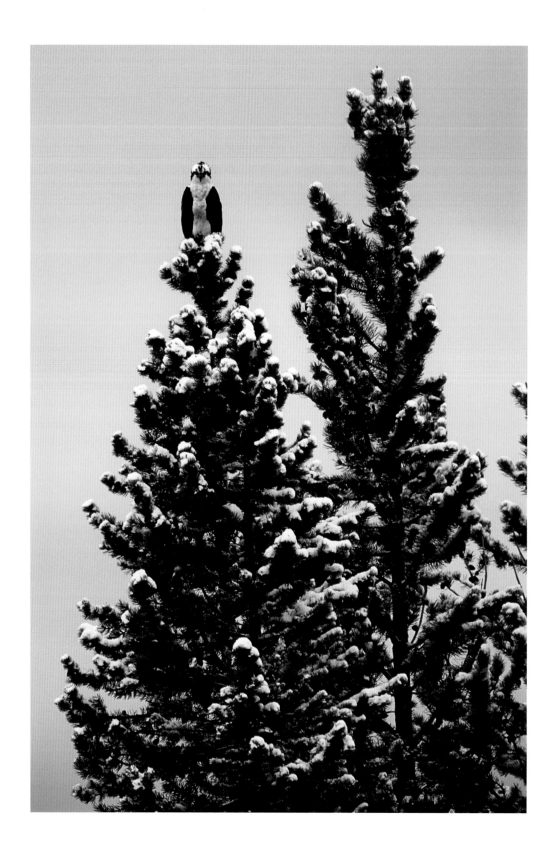

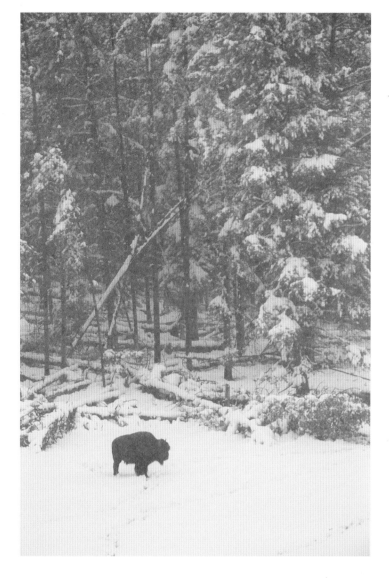

After a long, hard winter, a lone Bison searches for grass after eight inches of new snow blankets the park in late June.

Concealed in the blizzard, several wolves have taken down an Elk calf. The disturbed mother Elk nearby watches helplessly as the wolves devour the carcass.

Mother and cub explore the trails in Pelican Valley.

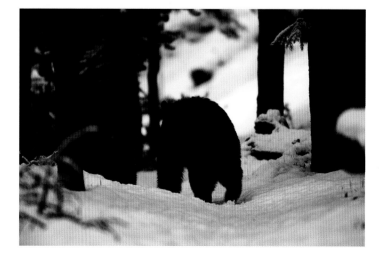

Nikon N90s camera
with 500mm f/4
Nikkor lens

Left: Ready for the holidays six months early, an Osprey tops a spruce tree along the Yellowstone River.

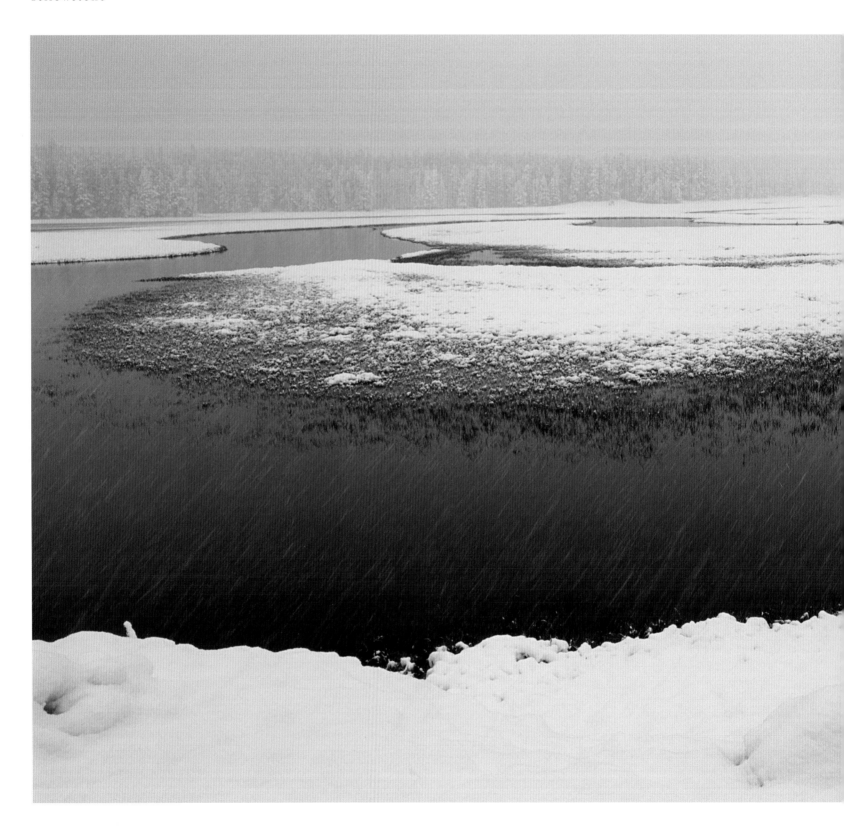

Mamiya RZ67 Pro II
camera with 65 mm f/4
lens

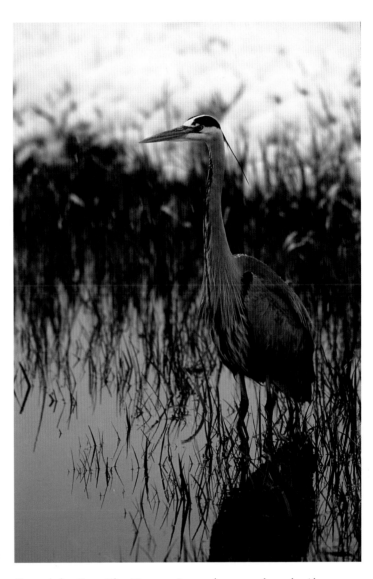

Nikon N90s camera
with 500mm f/4
Nikkor lens

Grounded, a Great Blue Heron waits out the storm along the Alum
Creek in Hayden Valley.

As the snowfall picks up, spring growth on Lake Yellowstone quickly vanishes as if to return to the
long months of winter.

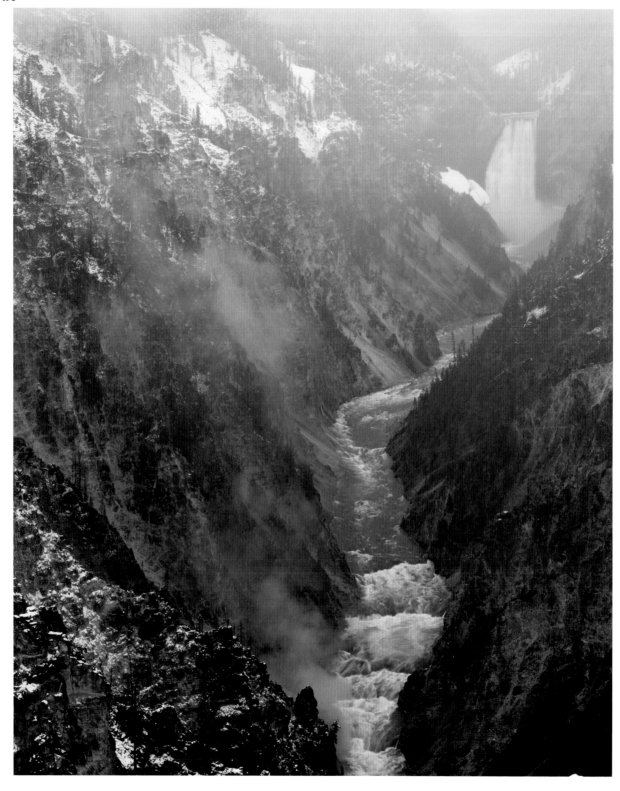

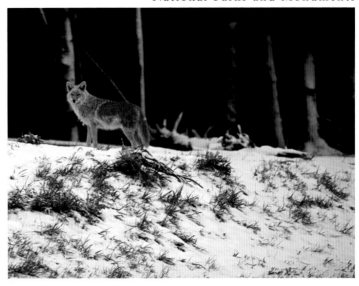

Left: Standing atop one of the most famous photographic sites in America, Artist Point is alive with steam, blowing winds, and a mixture of snow and rain.

Mamiya RZ67 Pro II camera with 140 mm f/4.5 lens

Nikon N90s camera with 500mm f/4 Nikkor lens

Not slowed by the weather, a coyote scans the Fishing Bridge area in the early morning.

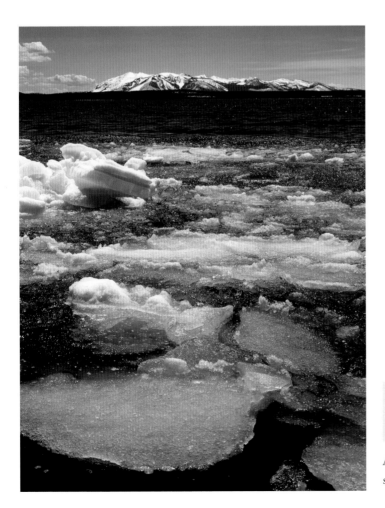

Mamiya 7 camera with 80mm f/4 lens

As spring gets into full swing, the final pieces of ice collect along the shores of Lake Yellowstone.

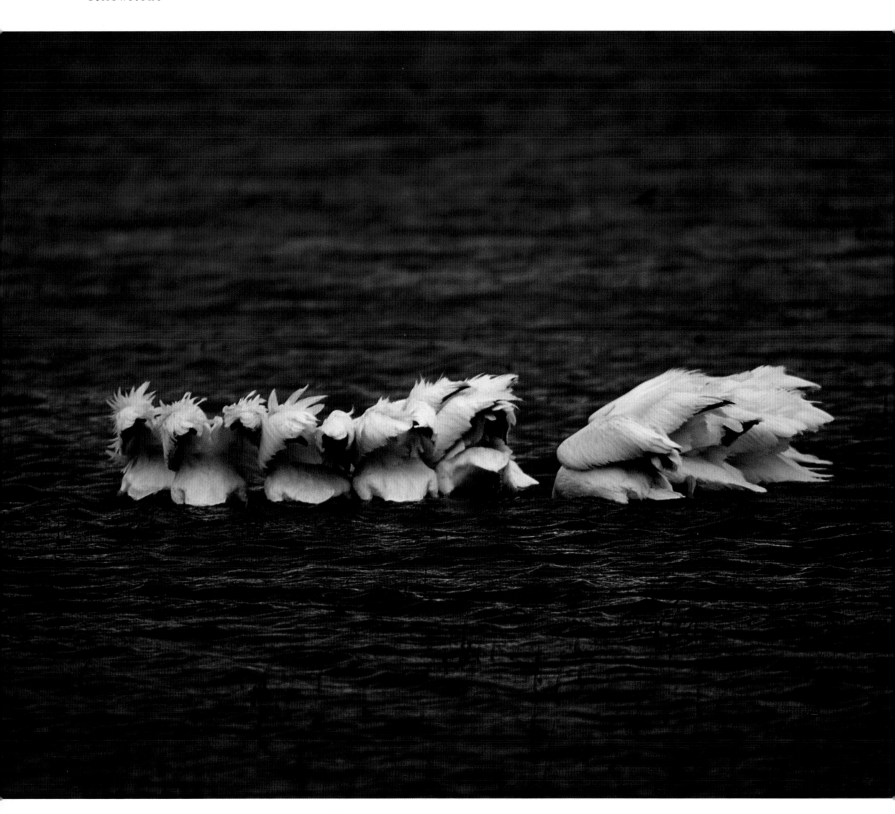

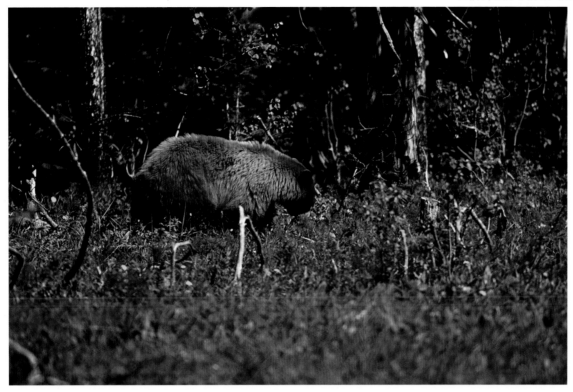

Above and below: Numerous bears frequent the park and are easily seen from the road. Although safe from a distance, the biggest hazard is the traffic jams that occur as they go on about their business of foraging for food.

Survival of the Species

Nikon N90s camera
with 500mm f/4
Nikkor lens

Left: White Pelicans work together to chase fish into a choke point.

Thriving with Millions of Visitors

Yellowstone is at the front of the line in terms of park visitors making it one of America's most sought out national parks. With all this attention, it can be easy to lose sight of the incredible bio-diversity in the Teton-Yellowstone eco-system. Finding "your Yellowstone" is incredibly important in achieving better photographs. Knowing where to return year after year, exploring new areas, and learning the predictive flow of visitors and wildlife can open up a much wider array of photographic opportunities.

Nikon N90s camera
with 500mm f/4
Nikkor lens

Yellowstone hosts a tremendous array of bio-diversity. A large number of coyotes frequent the park thriving off the elk and deer populations.

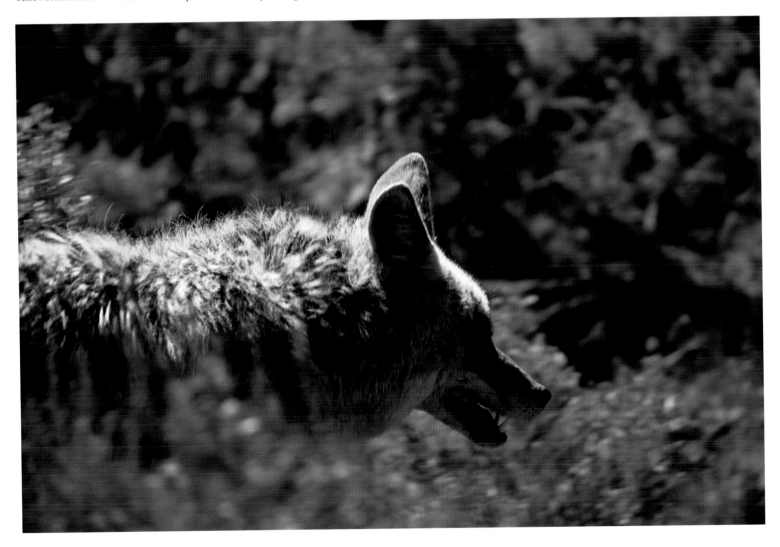

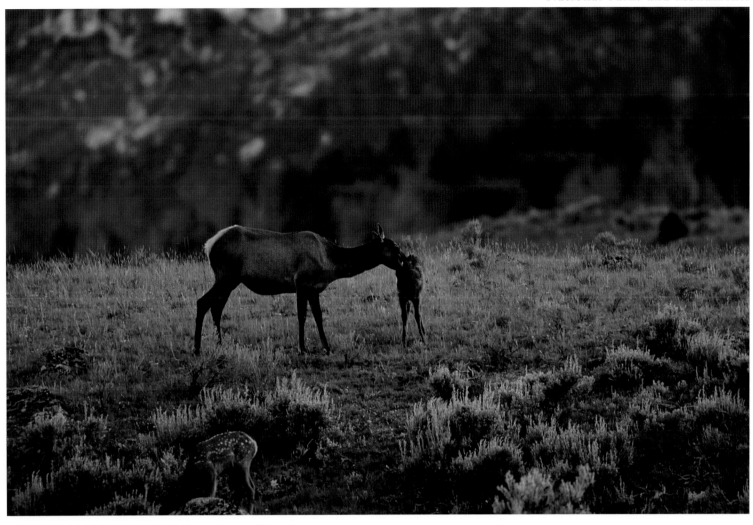

Newly minted Elk near Mammoth Hot Springs.

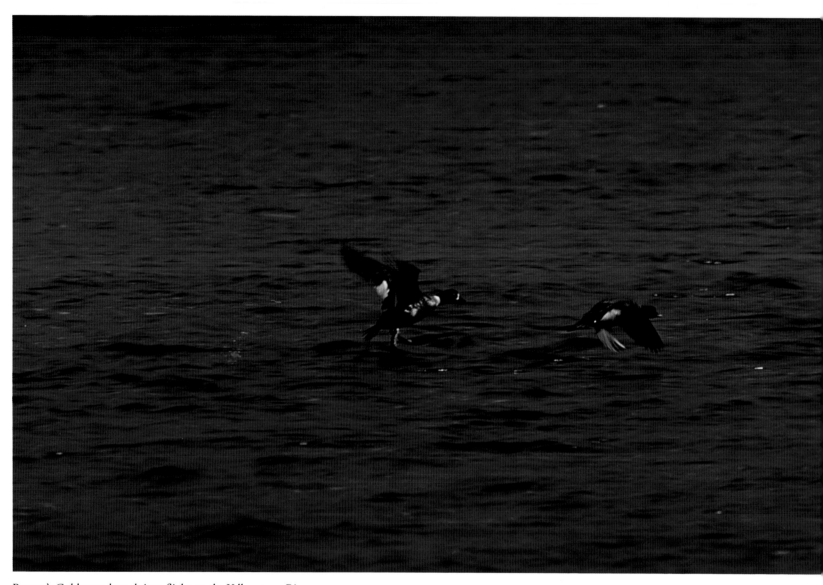

Barrow's Goldeneye launch into flight on the Yellowstone River.

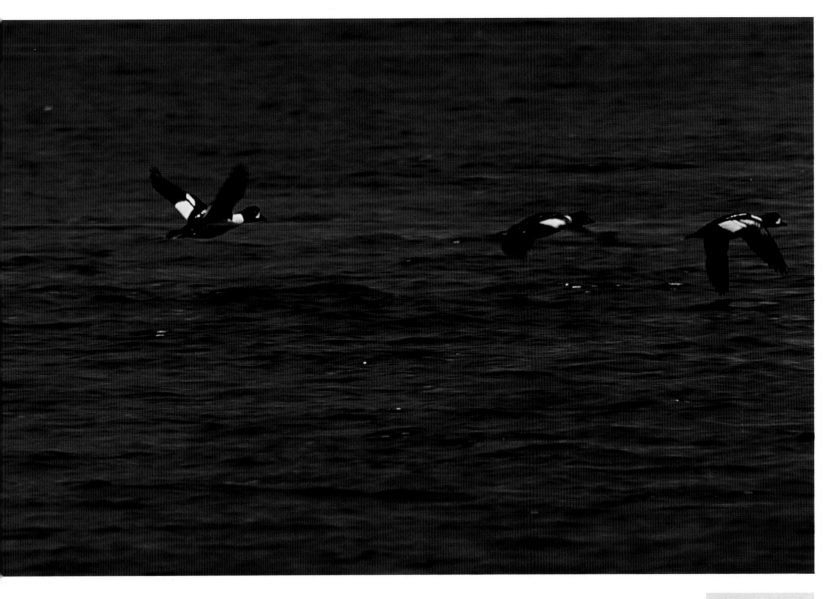

Nikon N90s camera
with 500mm f/4
Nikkor lens

Left: The power of Yellowstone lies deep within the caldera. Leading geologic theories point to a massive and sudden volcanic eruption millions of years ago. Evidence further indicates this mechanism is still in place and overdue for another event. At the Grand Prismatic Spring, steam shields a massive thermal pool, a leftover from the caldera.

Portions of the park continue to expand, indicating pressure increases underground. On the surface, outward signs of thermal features continue to draw visitors to the park at areas such as Firehole Lake Drive, oblivious to the potential for a sudden and violent eruption.

Mamiya RZ67 Pro II camera with 65 mm f/4 lens

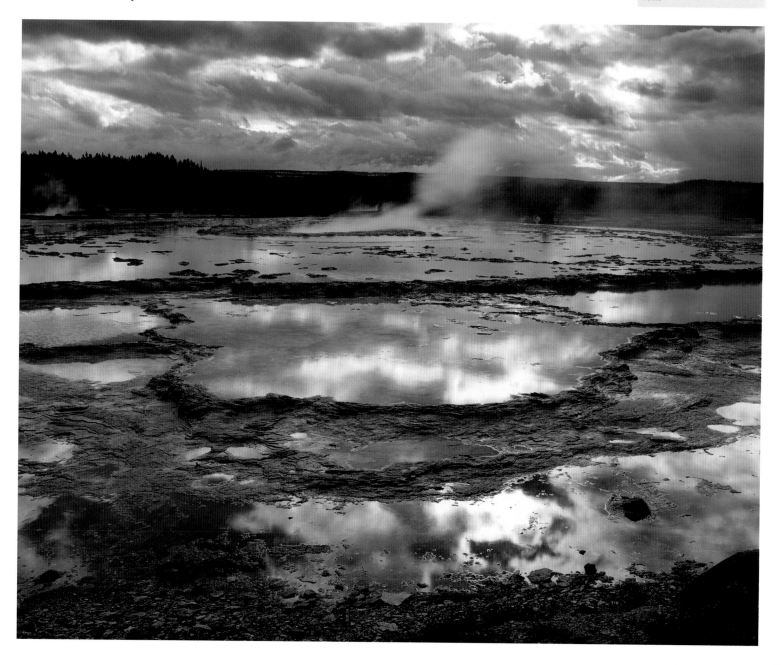

Mamiya 7 camera
with 80mm f/4
lens

Steam rises out of the ornate
travertine formations of Minerva
Terrace at Mammoth Hot
Springs.

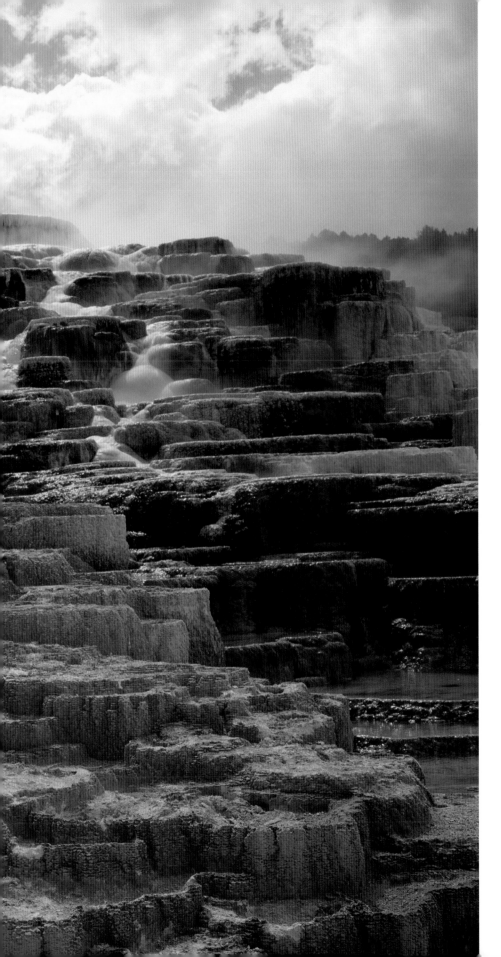

Inside the Caldera

Photographing from the many boardwalks of Mammoth Hot Springs or West Geyser Basin, expensive camera equipment can quickly be covered in a warm, damaging mist of sulfur.

Despite my attempts, I often am left with the chance encounter of which way the wind is blowing. With the wind at my face, I'm quickly coated with this witches brew. At my back, the stunning colors and indigo pools are revealed as the steam peels away from the Earth. Often sporadic, the winds shift about making for a challenging game of finding the compositional elements and color before being enveloped in steam.

Yellowstone

Appropriately named, Opal Pool sits calmly in the Midway Geyser Basin.

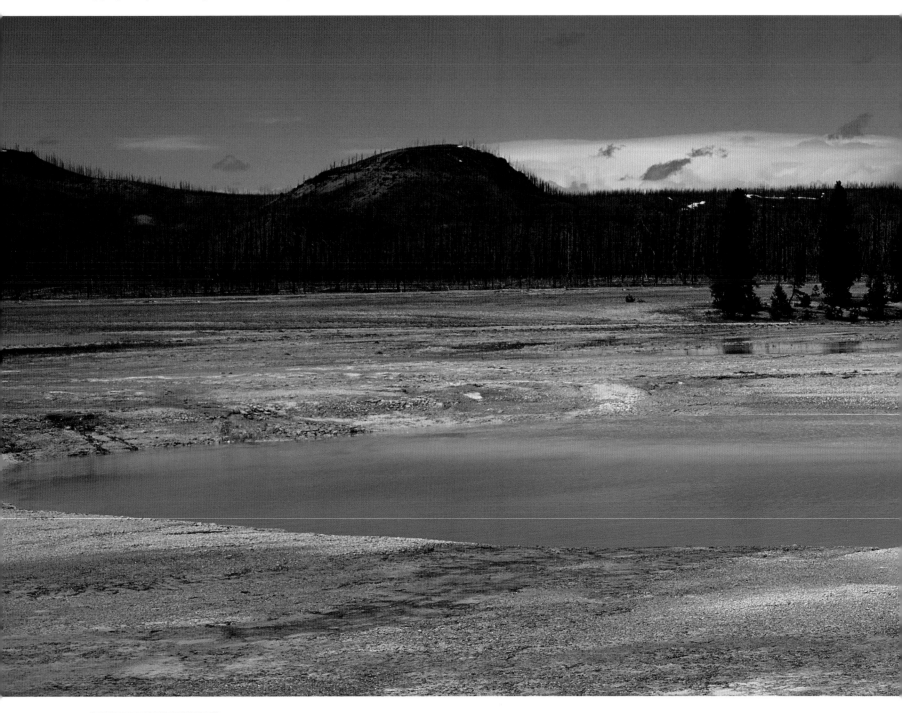

Mamiya RZ67 Pro II
camera with 65 mm f/4
lens

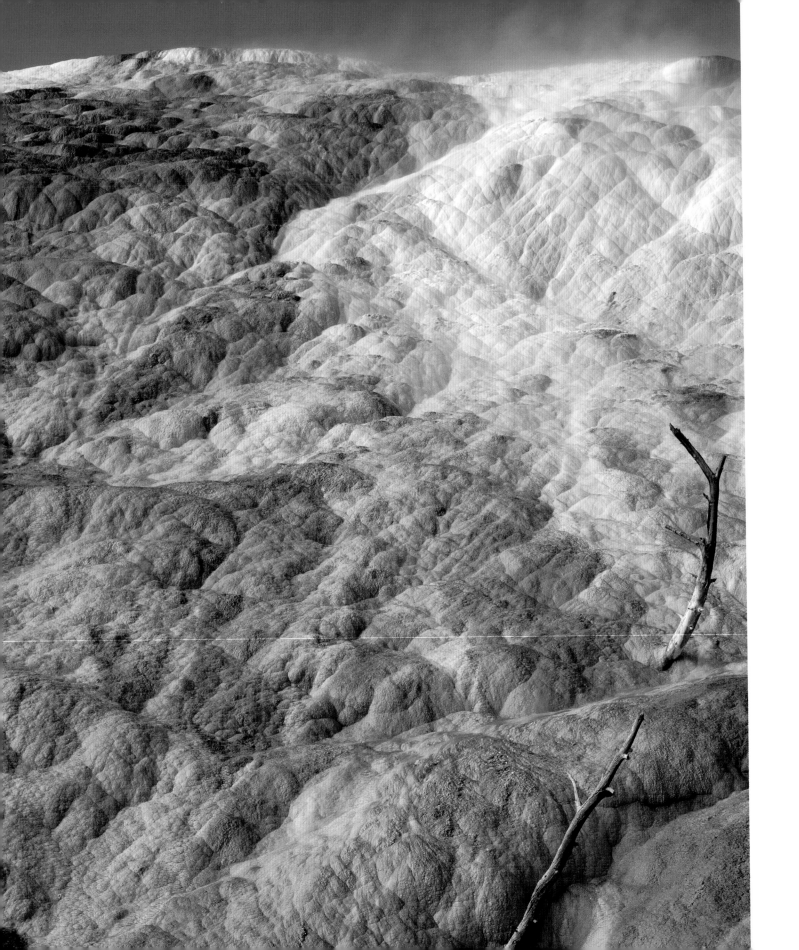

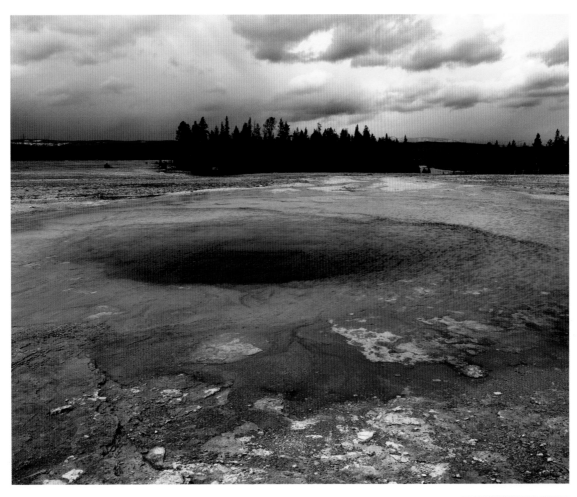

Yellowstone is a richly wonderful place. Its history is forever linked to the power and energy of the caldera. Wildlife and tourists seek this area for its bio-diversity. It's a place where life is renewed each year. Hundreds of species call this place home and many more rely on its bio-diversity for survival. In many ways it is a place that should exist in all corners of America.

Nikon N90s camera with 17-35 mm f/2.8 Nikkor lens

Mamiya RZ67 Pro II camera with 65 mm f/4 lens

The Living Earth

Left: Fed by water at the top, colorful bacteria give Palette Springs a well-suited name.

Zion

Mamiya 7 camera
with 80mm f/4
lens

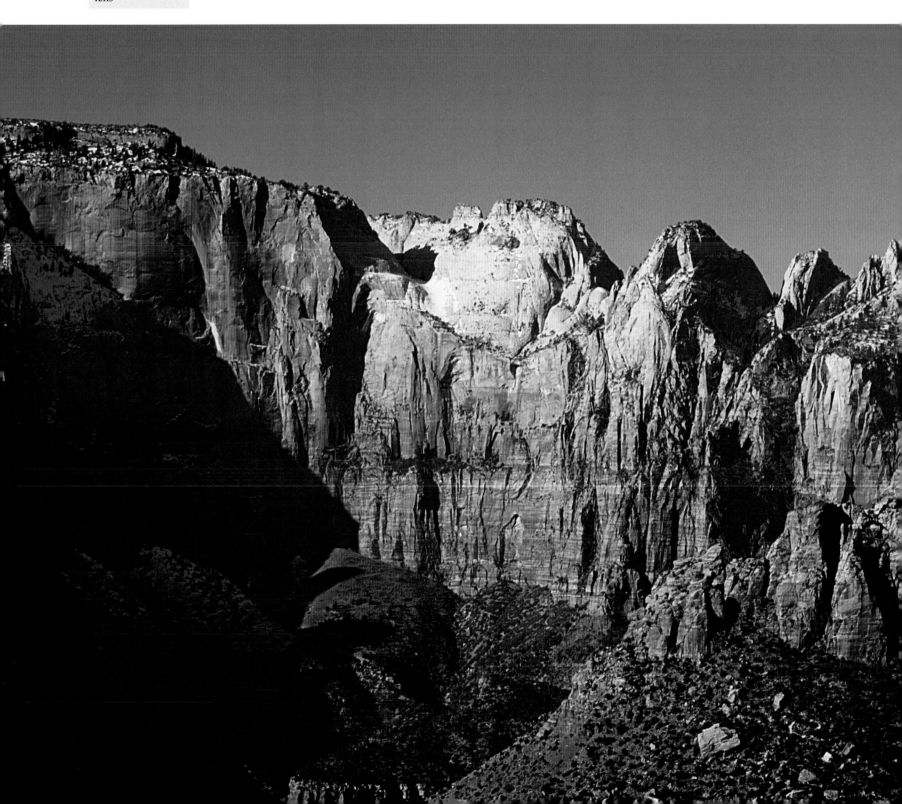

Rugged Landscapes

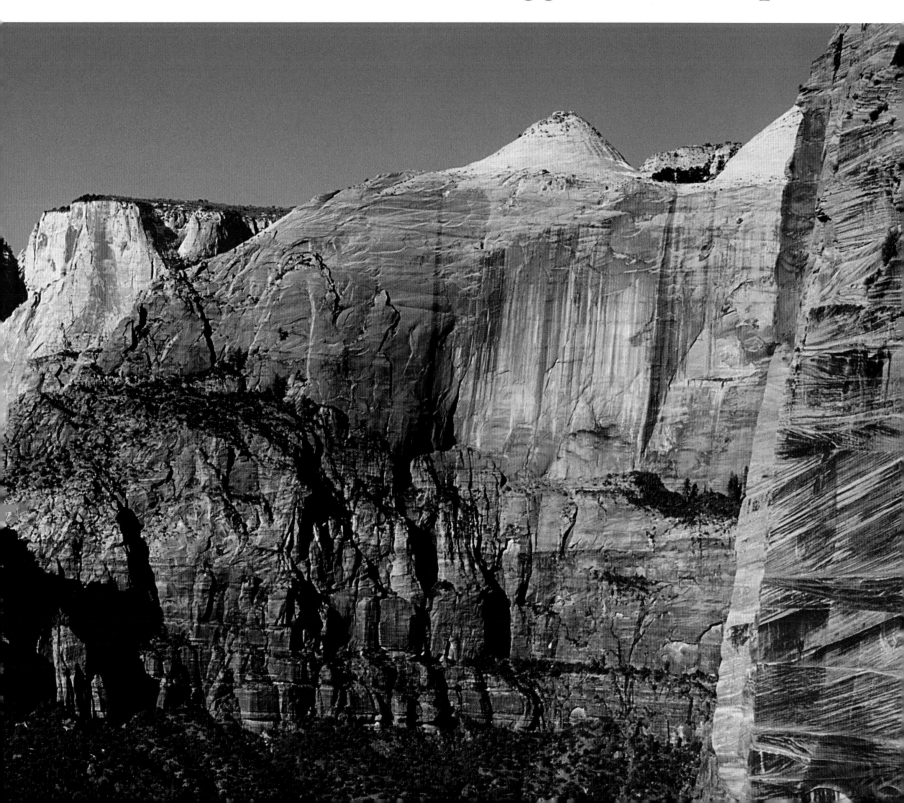

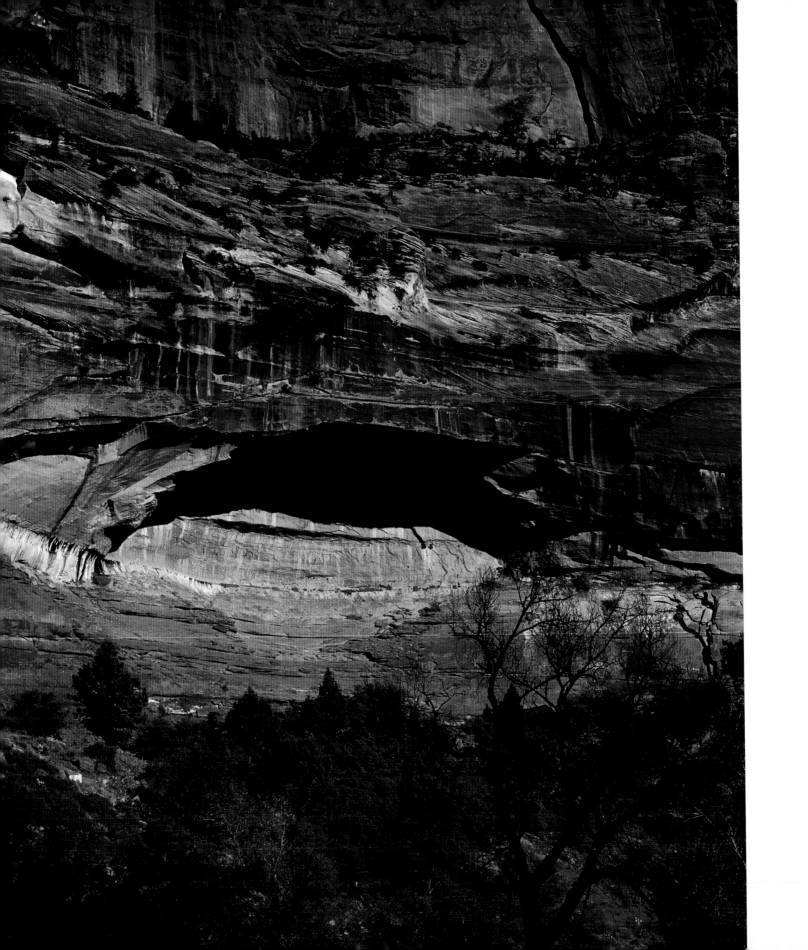

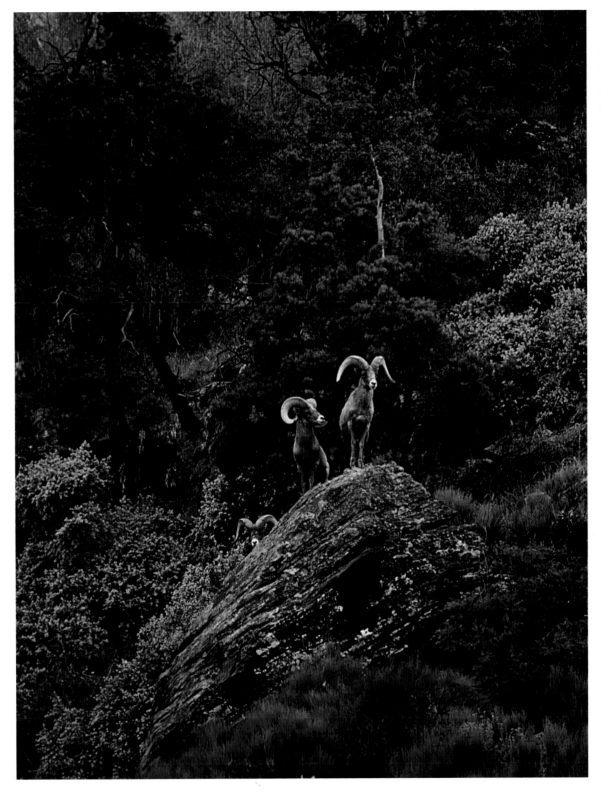

Rarely seen in Zion National Park, Bighorn Sheep take up position on a large boulder high above the switch-back on the Zion-Mt. Carmel highway.

Nikon N90s camera with 80-200 mm f/2.8 Nikkor lens

Left: Massive Navajo sandstone stretches hundreds of feet above a natural arch.

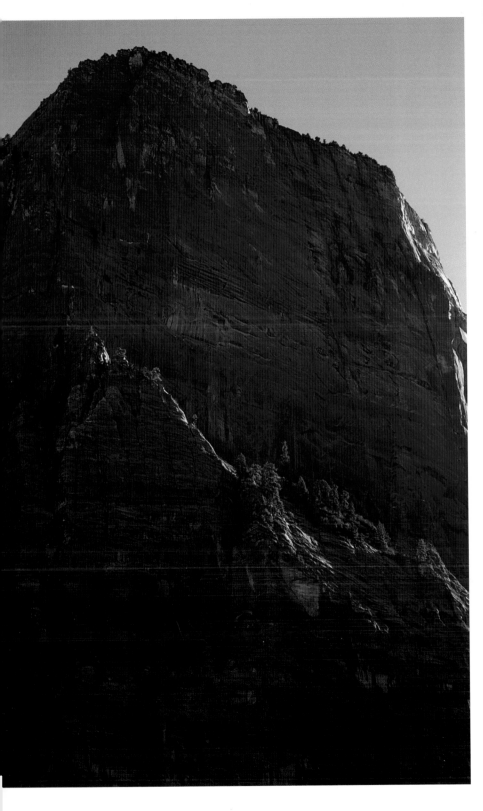

Mamiya 7 camera
with 80mm f/4
lens

The Great White Throne towers high above the
Virgin river at 6,744 feet.

Tracing for sixteen miles through Zion National Park, the powerful
Virgin River continues to cut deep canyons into the vibrant Navajo
sandstone of The Narrows.

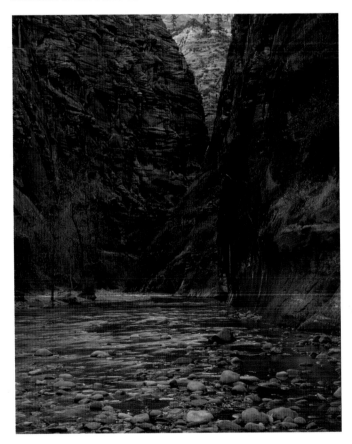

Right: Formed millions of years ago, massive Navajo sandstone
stretches skyward hundreds of feet above the Canyon Overlook.

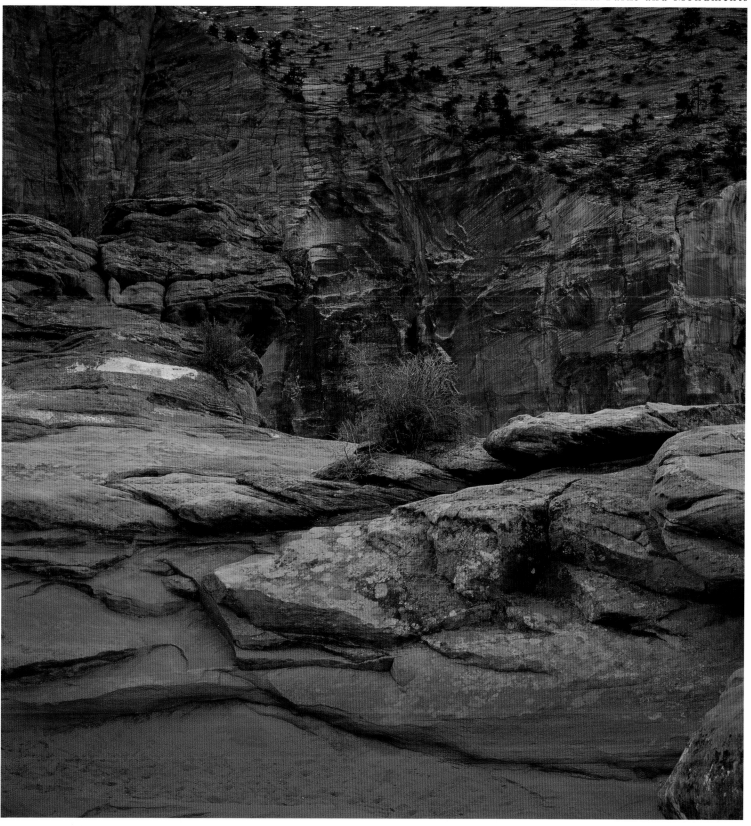

Epilogue

Across the United States and throughout the world there are millions of acres of unspoiled lands, unique geologic features, and tremendously diverse eco-systems. Without active steps to protect and conserve these areas, these pristine lands and wildlife can, and often do, soon vanish. Without the protection of our national parks and wildlife refuges these unique areas could have been lost forever.

From the uplifting of the Rockies and Blue Ridge Mountains to the drying of ancient sea beds, our environment has been in continual and significant change over the last 4 billion years. Even relatively recent events, such as during the Pleistocene Period, carved sandstone and shale canyons have remained to this day, in part due to the protection afforded by our park systems.

Likewise, with the expansion of urban and farmland development over the last 100 years, our National Wildlife Refuge System is playing a key role in providing habitat for thousands of displaced species. Without these protected areas, Bald Eagles, herons, egrets, loons, and many, many other highly valued species may have perished.

Symbolizing America, our National Park System also has conserved and protected key natural resources. These areas today are known worldwide for their amazing landscapes and diverse wildlife.

Despite these advances, many challenges remain. Today, encroaching development is threatening wildlife and natural resources on the boundaries of some of our most cherished national parks. Likewise naturally occurring, or intentionally set, forest fires now threaten nearby housing developments. Protected wildlife from our state, national park and wildlife refuges occasionally encroach into urban areas ultimately resulting in death for the wolf, mountain lion, or bear.

Our state parks offer many the opportunity to interact with our environment on smaller scales. They are microcosms of wildlife and geology. They provide habitat, recreation, and protection of natural resources. Still today however, there are millions of acres of unprotected land supporting key species such as the Bald Eagle along the shores of the Mississippi in Minnesota. Conservation and preservation extends well beyond park and national borders.

Our national parks and wildlife refuges are more than just vacation destinations. They in fact are preserving our past for future generations to study, appreciate, and enjoy. These protected areas continue to unravel the past, such as the unique paleontology finds within the Badlands National Park. These working field labs are helping geologists and paleontologists refine, and in some cases redefine, our understanding of the past.

Unfortunately, being designated a national park or monument can also be a curse. Streams of visitors, traffic jams, crime, and disturbed lands can bring attention to fragile environments further threatening their future.

So many of the photographs shown within these pages were collected when I was the only one on the trail. On many occasions I have hiked and photographed all day without ever running into another visitor. Sometimes that is not always the case. At key times, such as autumn, I simply have left or stopped photographing because there were just too many people on the trail.

However, those are times to enjoy the moment for what it is, a nation recognizing the importance of their environment. It reminds me that these lands do in fact belong to all of us and we all share in the responsibility of good stewardship. Our national parks, wildlife refuges, and environment bind us together as a civilization.

Places like Yellowstone, Tetons, and others simply are beyond description. The diversity and complexity of these eco-systems are extraordinary and is what draws us to these areas. Standing atop an overlook at the Badlands National Park or the Blue Ridge Parkway, I am amazed at how unforgiving the landscape is today and how difficult it must have been for early settlers or Native Americans.

The protection of these natural areas has occurred in just the last seconds of a timeline extending for millions of years. When compared to the formation of White Sands, the uplifting of the Rockies, or the draining of ancient seas in the Upper Plains, twenty seconds of film is a mere blink of an eye in geologic time to capture millenniums of change.

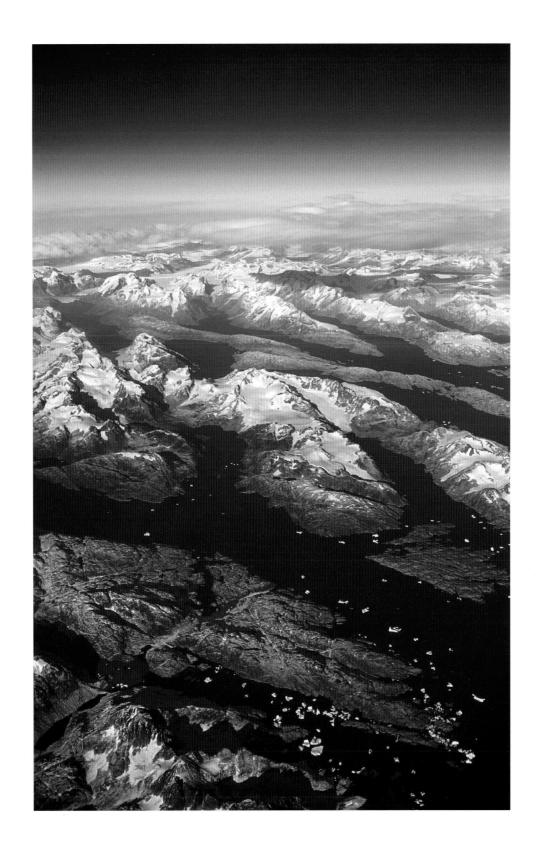

About the Author

When I entered college, I had ambitions of a career in petroleum geology. My interest was in exploration. This career desire came out of my natural interest in the environment, science, and long days spent exploring the Indiana Dunes National Lakeshore. After a few semesters I transferred into engineering focusing more on my technical skills, a career I have been fortunate to enjoy for many years. However, I still long for the thoughts of exploring our environment and uncovering the mysteries of geology.

During my career as an engineer I was awarded numerous US Patents and participated in a number of design efforts for some of the world's most advanced systems and programs. With all of that focus on the technical, I've always held close an interest in developing and using my artistic skills as well. First as a hobby and then professionally, photography has consumed my thoughts. I have had numerous personal and corporate clients over the years and have had my work featured in a number of photographic contests, magazines and newspapers.

In 2003, I produced my first book featuring my photography, *Bosque del Apache National Wildlife Refuge, 48 Hours of Flight*, published by ImageStream Press, Publishing a book was a scary proposition and looking back on it, hard to imagine the amount of effort that went into it. Yet here I am again publishing another book on the environment through film. I guess in some way I've never really left my roots in the environment and exploration. Photography is a way for me to reconnect with the environment and unravel the past through light and landscape.

I have had the opportunity to not only visit a number of our key and sometimes overlooked national resources, I've also had the chance to work with really great photographic equipment. More often than not, the majority of my landscape photographic work has been accomplished with a medium format camera. Four times larger than 35mm, and significantly heavier, medium format offers a capability I simply cannot achieve with 35mm. I notice this most readily when looking through the huge viewfinder. This allows me to see the environment much as I see the world, composing images I often struggle with using 35mm.

For my medium format work, the Mamiya RZ67 Pro II is the

king. I only use three lenses, a 65mm f/4, a 140mm f/4.5m and the giant 500mm f/6 APO. These incredible lenses have allowed me to explore the world and return confident in the results time after time.

When I am photographing wildlife, 35mm is by far and away the ticket. For years I have utilized a Nikon N90s, and now a F100, with a 500mm f/4 lens. This, coupled with 1.4x and 2x teleconverters, allows me to achieve 750mm or 1000mm capability.

Like many, I've recently started to include digital photography into my workflow with a Nikon D2H. Like any tool, film or digital can offer specific benefits for the task at hand. When I find myself in freezing temperatures and needing ultra-fine resolution, film still rules.

Having taken a significant number of photographs in my career, I also have experimented with a number of different films. Today, my work is exclusively conducted on Fujichrome Velvia or Provia 100F films. These films are truly exceptional and almost void of grain on the final images. When light gets too dim, I simply stop shooting. For me the quality of the final image in terms of composition, color, and grain is paramount.

Recently I have begun to also work with large format and the incredible 17-35mm Nikon f/2.8 lens for my 35mm system. Both approaches offer stunning, distortion free wide angle views of the world.

Photography has allowed me to blend my technical and environmental interests. I look forward to many more years of recording on film the wonders of our national parks and wildlife refuges for generations to enjoy.